IMAGES
of America

MOVIE THEATERS OF WASHINGTON, DC

IMAGES
of America

MOVIE THEATERS OF WASHINGTON, DC

Robert K. Headley and Pat Padua

ARCADIA
PUBLISHING

Copyright © 2018 by Robert K. Headley and Pat Padua
ISBN 978-1-4671-2948-0

Published by Arcadia Publishing
Charleston, South Carolina

Printed in the United States of America

Library of Congress Control Number: 2018932245

For all general information, please contact Arcadia Publishing:
Telephone 843-853-2070
Fax 843-853-0044
E-mail sales@arcadiapublishing.com
For customer service and orders:
Toll-Free 1-888-313-2665

Visit us on the Internet at www.arcadiapublishing.com

*To our wives, Anne and Veronica, who tolerated us,
gave us support, and corrected our errors*

CONTENTS

ACKNOWLEDGMENTS

The authors are indebted to many people and institutions for information, images, and support in the compilation of this book. We are especially indebted to the Prints & Photographs Division of the Library of Congress; Ray Barker, Michele Casto, and Lauren Martino of the Washingtoniana Division of the DC Public Library; Jerry McCoy of the Peabody Room of the DC Public Library; and Jeff Krulik, Ryan Shepard, and Paul Sanchez. We hope the reader will find photographs here that will bring back pleasant memories of moviegoing with family, friends, and sweethearts. We also ask that any inaccuracies be brought to our attention. All of the photographs not otherwise attributed are from the Robert K. Headley Theater Collection.

INTRODUCTION

Over the past 110 years, there have been more than 100 movie theaters in Washington and its suburbs, from tiny nickelodeons and mini-auditoriums seating fewer than 100 people to mammoth palaces and megaplexes seating thousands. Some were ornate, with elaborate facades and gaudy light displays that stood out like jewels in the night. Others were so plain and tucked away in shopping centers that one could hardly find them. In this book, we will address the many varieties of the moviegoing experience.

The first short, flickering movies were shown in 1894 in the Kinetoscopes installed in the Columbia Phonograph Company at 919 Pennsylvania Avenue NW. These early motion pictures featured dancing women, a barbershop, a barroom, and a Scotch dance. The movies got good reviews, but only one person at a time could watch them. By 1897, inventors in France, England, and the United States had worked out a way to project movies onto a screen. The first examples in Washington were exhibited at Willard's Hall on F Street NW, on the first day of 1897.

As soon as people became familiar with the new medium, its popularity grew quickly. Within a few years, larger, legitimate vaudeville and burlesque theaters and even churches were exhibiting movies. Things really took off after 1905. The first movie theater in Washington, the Star, opened in the Hutchins Building at the corner of Tenth and D Streets NW. It was opened by Thomas Armat, one of the inventors of film projection equipment.

By the fall of 1910, there were at least 73 venues in Washington that showed movies, just short of Baltimore's roster of 77 and well behind Philadelphia with 181. Chicago had a whopping 341, but the whole state of Virginia only had 85. These early theaters were tiny and seated only around 100 people, but with the increasing popularity of the movies, exhibitors knew they could build larger, more elaborate theaters. They built them, and people came.

The Central, on Ninth Street NW—Washington's "Great White Way"—opened in 1911 and seated around 850. Harry Crandall, Tom Moore, and Aaron Brylawski opened theaters throughout downtown. By 1917, there were 75 theaters in the city, but the total seating capacity was only 27,796. In those segregated days, 63 theaters were white only, seven were African American only, and five admitted both races, separating audiences with a wall that ran down the middle of the auditorium.

Theaters got bigger and bigger. The ill-fated Knickerbocker, seating 1,700, opened in 1917, and the Rialto, which opened in 1918, seated just under 2,000. Loew's came to town and opened the 2,423-seat Palace in late 1918. In 1927, the Fox (later called the Capitol) opened. It was the biggest and gaudiest theater in town, seating over 3,000 people, but that did not save it from demolition in just over 30 years.

By the 1920s, the local situation had stabilized. Big first-run theaters operated by Hollywood production companies reigned supreme downtown, primarily on F Street NW. Neighborhood theaters—smaller venues that seated fewer than 1,000 people—lit up other areas of the city. Nearly every neighborhood had its own theater or was within walking distance of one, an arrangement that lasted until the 1950s. Warner Bros. was the big first-run player in town, and K-B Theaters was king of the neighborhoods. Among the major neighborhood theaters were the Atlas, Newton, Langston, Jesse, and Sheridan in Northeast; the Apex, MacArthur, Avalon, Uptown, Lincoln, Republic, and Tivoli in Northwest; and the Senator, Fairlawn, and Anacostia in Southeast.

After the government broke the connection between the Hollywood production companies and their theater businesses in the Paramount Consent Decree in 1948, the downtown theaters suffered. Theaters in general began closing at an alarming rate. The main theaters built in the

1950s were drive-ins. The movie business suffered terribly in the 1950s and early 1960s in spite of new technologies like 3-D films and wide screens.

Movie theaters had a brief renaissance in the 1960s. Several large, appealing theaters such as the Riverdale Plaza, Annandale, Fairfax Circle, and New Carrollton were built, but this was the end of the single-screen theater. Shortly thereafter, the twin, triplex, multiplex, and finally the megaplex appeared. IMAX was developed, 3-D returned to the big screen, and in recent years, even 70-millimeter has come back to the multiplex for such prestige pictures as *The Hateful Eight* and *Dunkirk*. The 21st century promises even more developments. We have come a long way from peering into a box and watching five-minute films of dancing cats. Although, dancing cats still fascinate.

One

EARLY THEATERS

The first movies in Washington were short Kinetoscope films exhibited at the showroom of the Columbia Phonograph Company at 919 Pennsylvania Avenue NW in the fall of 1894. These films were viewed by one patron at a time by looking into a peephole in a large wooden cabinet. Early movies favored such subjects as dancing cats, a jolly blacksmith, a skirt dancer, the working of coke ovens, boxing matches, and news subjects such as the Spanish-American War. Moving picture programs were so successful that a second Kinetoscope parlor opened on Fifteenth Street NW, followed by Mutoscope parlors, which featured machines that contained a series of cards flipped to create the illusion of movement. By 1896, several inventors, including local man Thomas Armat, had developed machines that could project movies onto a screen, making it possible for them to be viewed by many people at a time.

The first public exhibition of projected movies in Washington took place in January 1897 at Willard's Hall on F Street NW. Soon, movies were being shown all over town at existing theaters, halls, and churches. Movies were shown at Vitascope Hall at 1116 F Street NW in February 1897. They cost 25¢ and lasted about an hour. For a showing of *The Horitz Passion Play* at the Columbia Theater in December 1897, an organ was installed onstage to provide music. This is one of the first instances of musical accompaniment for a movie in Washington.

After the battleship *Maine* was blown up in Havana harbor in February 1898, movies showing actual or sometimes faked scenes of military action in Cuba appeared in theaters downtown. Travelogues were extremely popular, and the well-known lecturer Burton Holmes appeared with his traveling show several times. Chase's (formerly Albaugh's) Grand Opera House at Fifteenth and F Streets NW had numerous movie exhibitions starting in 1902. Movies continued to be part of vaudeville programs for many years well into the 20th century, but by then, purpose-built movie theaters had taken over the business of film exhibition.

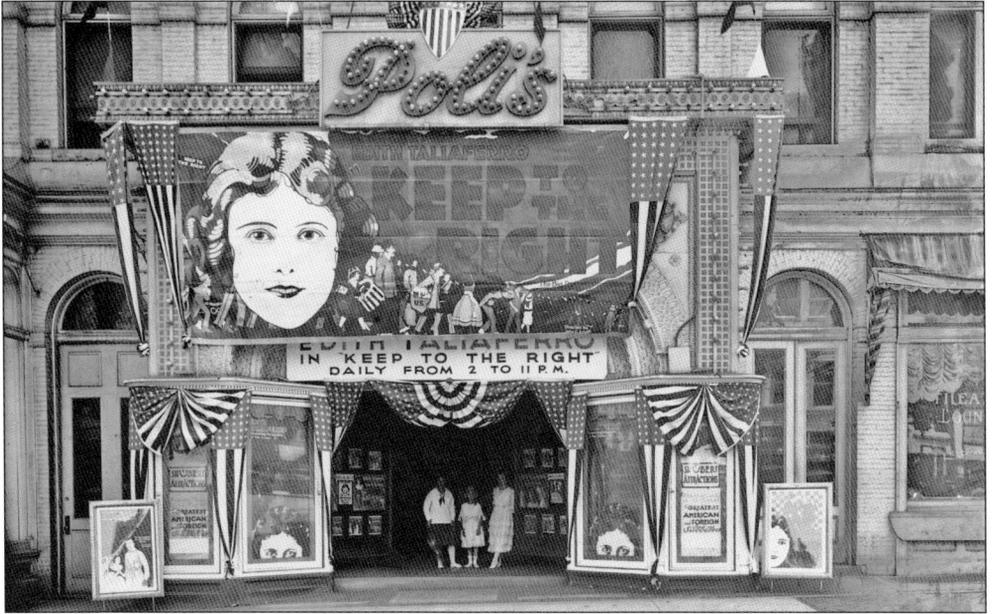

Poli's Theater, at 1424 Pennsylvania Avenue NW, started life in 1884 as Albaugh's Grand Opera House, but it was built by the Washington Light Infantry Rifles. John W. Albaugh leased the building as a legitimate theater. It opened with actress Emma Abbott in *Semiramide* on November 10; Pres. Chester A. Arthur attended the opening. After a succession of owners, Sylvester Z. Poli leased it in 1912 and completely remodeled it. It was torn down to build part of Federal Triangle in 1930. (Courtesy of the Library of Congress, Prints & Photographs Division, National Photo Company Collection, LC-F82-4466.)

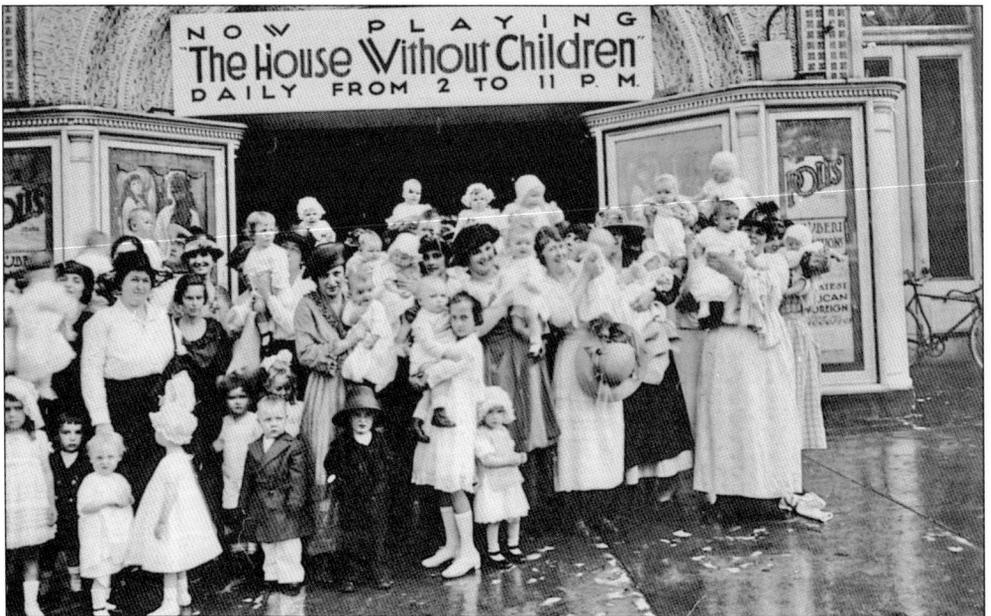

The entrance to Poli's Theater is pictured at a showing of *The House Without Children* in 1919. (Courtesy of the Library of Congress, Prints & Photographs Division, National Photo Company Collection, LOT 12342-10.)

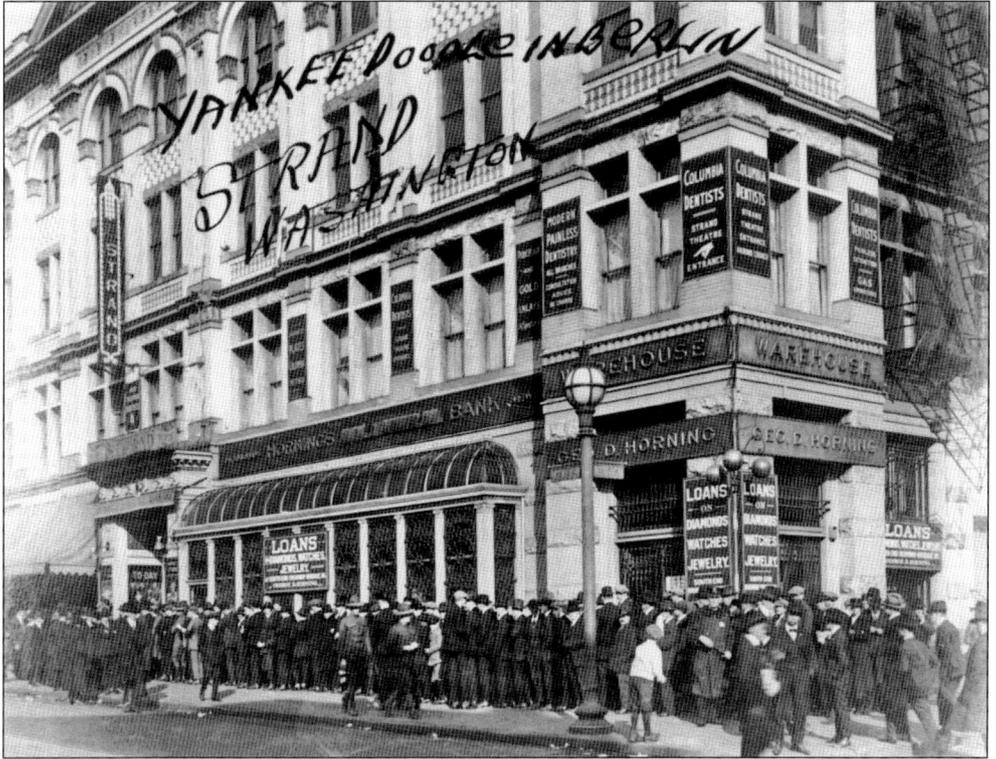

Built in 1889 on the site of Lincoln Hall, where the Second National Woman Suffrage Convention was held in 1870 and the first phonograph in Washington was introduced in 1878, the Lincoln Music Hall (401 Ninth Street NW) had many names, including Herzog's Ninth Street Opera House, Academy of Music, Orpheum, and Strand. Here, a long line of men waits to see *Yankee Doodle in Berlin* in 1919. The theater closed in 1949. (Courtesy of Paul Sanchez.)

Built in 1891, Metzerott Music Hall was designed by William S. Plager, and it was remodeled in 1896 by Appleton P. Clark Jr. as the Columbia Theater. Very early movie exhibitions were held here. In its long history, it presented stage shows, operas, burlesques, and finally movies.

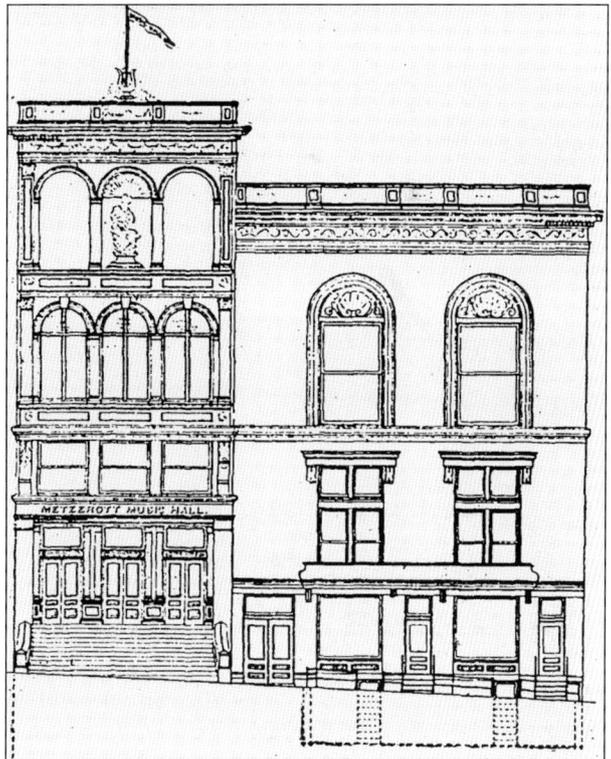

The Columbia Theater (1112 F Street NW) opened in 1891 as the Metzerott Music Hall. It was the first theater acquired by Marcus Loew when he began moving into the Washington area in 1915. It was demolished in 1959. (Courtesy of the Library of Congress, Prints & Photographs Division, National Photo Company Collection, LC-F82-4758.)

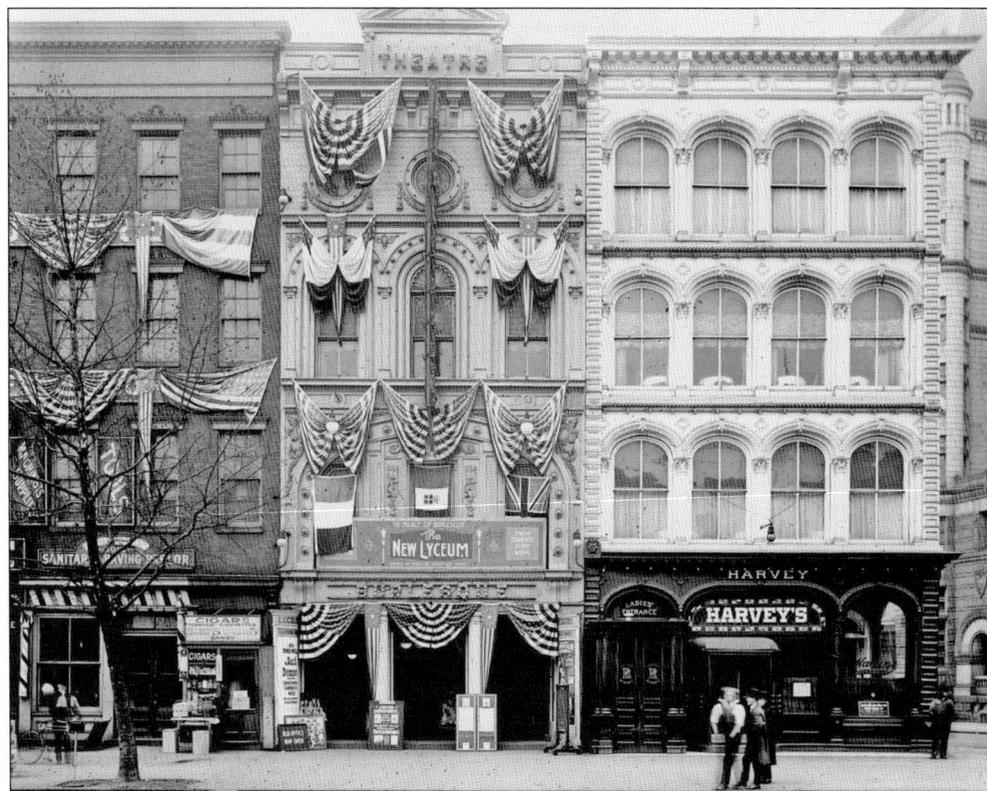

First opening in 1822, the historic Lyceum Theater (1014 Pennsylvania Avenue NW) was, in a variety of different guises, the site of several presidential balls, a post office, boxing matches, and a theater. In September 1886, Baltimore theater impresario James L. Kernan ran it as the Lyceum. The theater closed in 1929, and two beautiful buildings, the Lyceum and adjacent Harvey's Restaurant, were demolished to build yet another drab grey building. (Courtesy of the Library of Congress, Prints & Photographs Division, National Photo Company Collection, LC-F82-2539.)

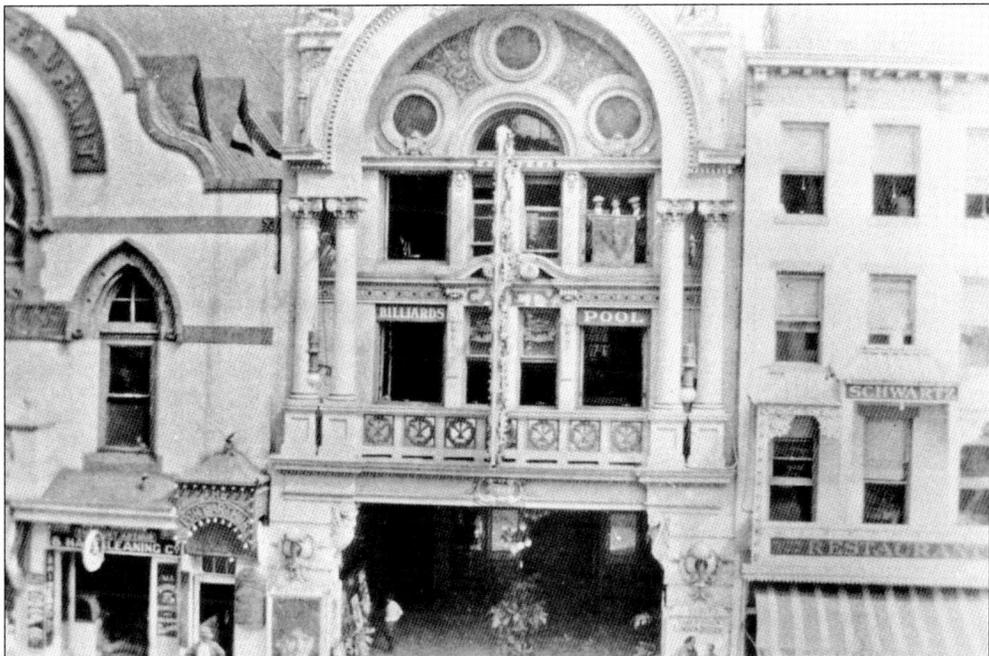

As its name suggests, the Gayety (513 Ninth Street NW) was a burlesque theater for most of its life. It was designed by well-known theater architect William H. McElfatrick and opened in August 1907. Supreme Court justice Oliver Wendell Holmes, who considered himself a "man of low taste," attended shows there. After a dispute about segregation closed the National Theater, the Gayety was used for live plays. It was torn down in the early 1960s.

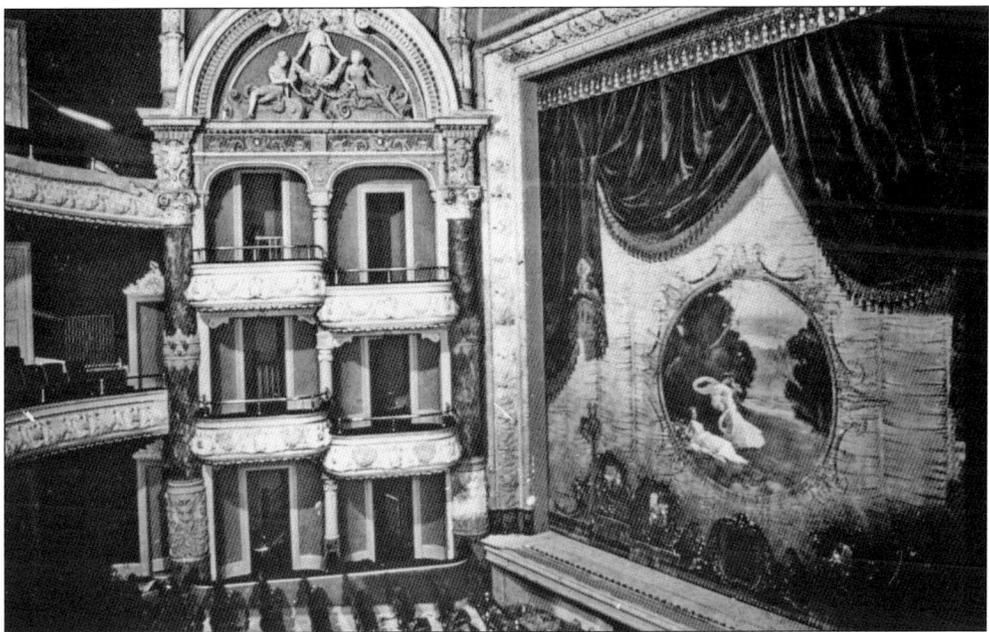

The ornate interior of the Gayety auditorium is shown here with views of the fire curtain, the runway, the orchestra pit, and three levels of box seats. (Courtesy of the Library of Congress, Prints & Photographs Division, National Photo Company Collection, LC-F82-9112.)

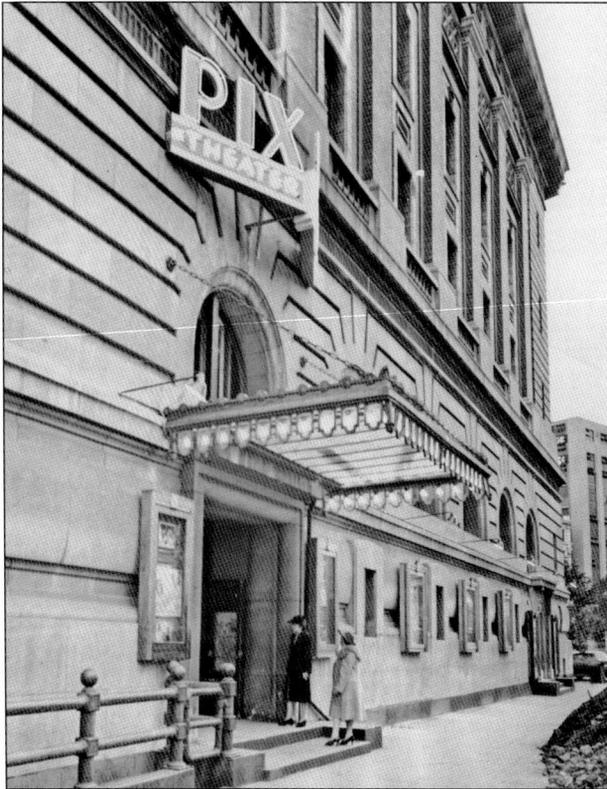

The Masonic Temple (Thirteenth Street and New York Avenue NW) was designed by Wood, Donn & Deming. It had an auditorium on the fifth floor and one on the first floor where movies were shown from 1908 to 1919, 1942 to 1952, and 1959 to 1983. It was remodeled extensively in 1983 and now houses the National Museum of Women in the Arts.

A movie theater called the Pix was located on the first floor of the Masonic Temple in the 1940s and early 1950s. (Reprinted with permission of the DC Public Library, Star Collection © *Washington Post*.)

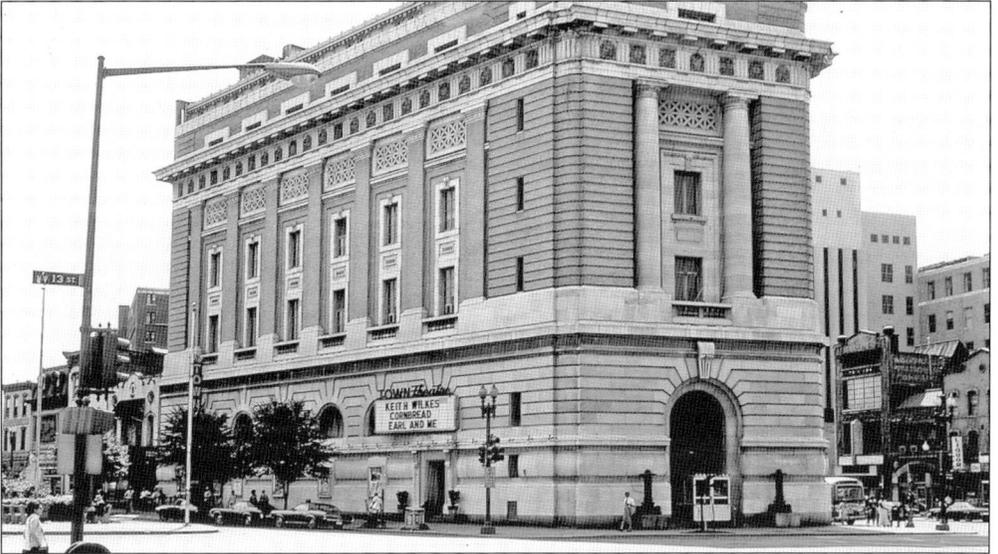

Don King (no relation to the boxing promoter) ran the Masonic auditorium as the Towne for nearly 30 years. It was showing blaxploitation films in 1975 but earlier had hosted the local premiere of *Psycho*.

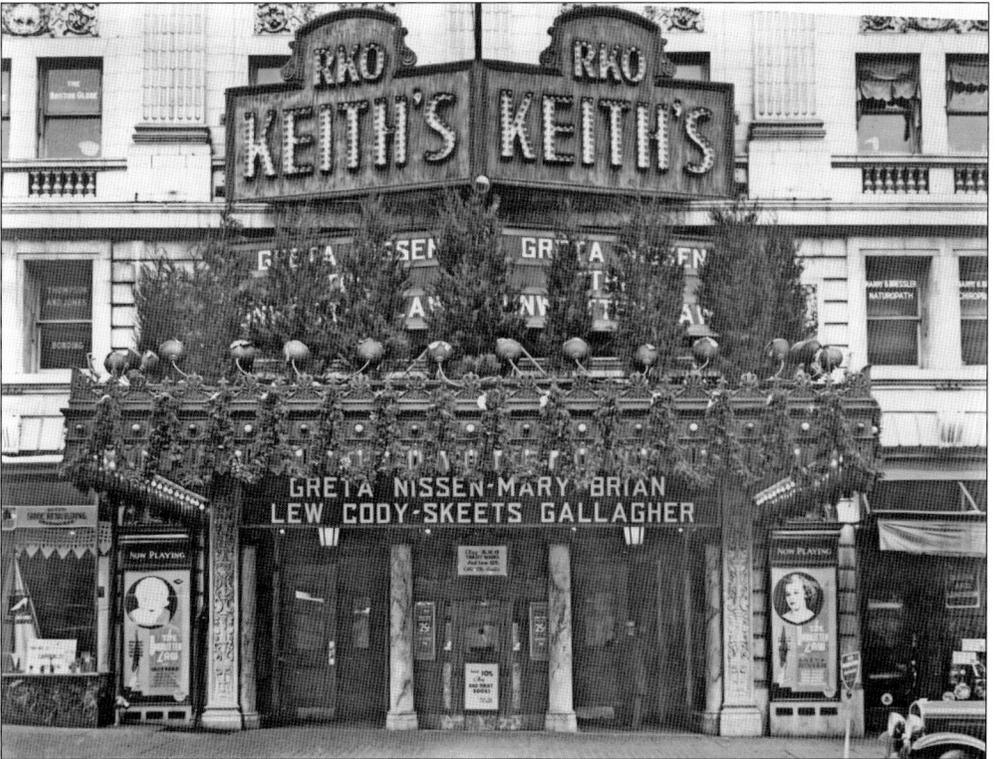

The 1,800-seat Keith's Theatre (619 Fifteenth Street NW) started its life as a vaudeville venue. Designed by Jules Henri de Sibour for Plimpton B. Chase, it opened as Chase's Theater on August 19, 1912, and changed its name to Keith's when it was sold to B.F. Keith in 1913. Many presidents, including Woodrow Wilson, attended performances at Keith's.

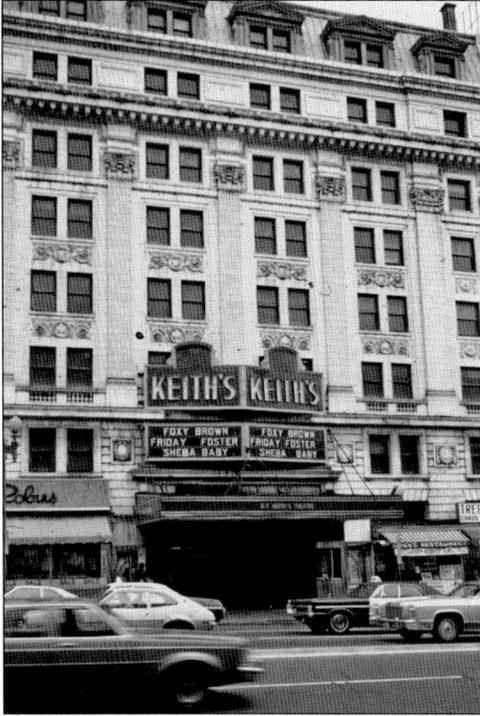

The wonderful Albee Building, in which Keith's Theatre was built, had Turkish baths in the basement and was furnished throughout with marble and luxurious wood paneling. It was gutted by Oliver T. Carr in the late 1970s, even though it had been designated a national landmark.

Keith's lobby was richly paneled and floored with several kinds of marble and tile. The walls were of multi-hued Siena marble, and its interiors featured brass trim and palatial amounts of additional marble. (Courtesy of the Library of Congress, Prints & Photographs Division, Harris & Ewing Collection, LC-H25-91141 DB.)

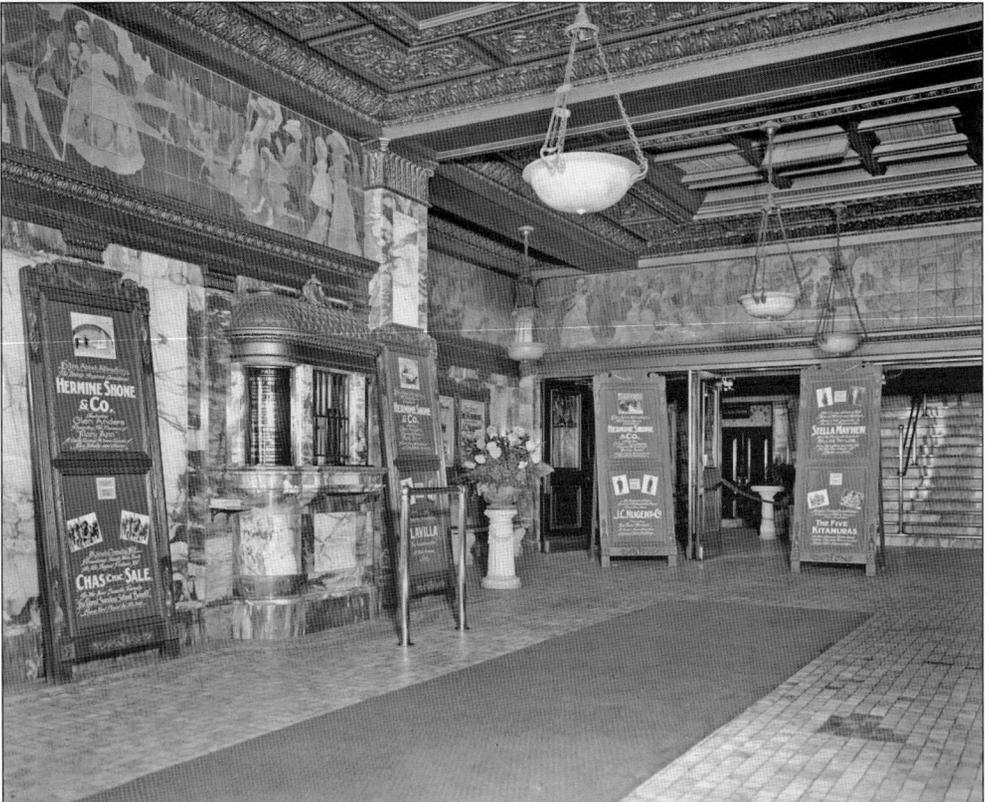

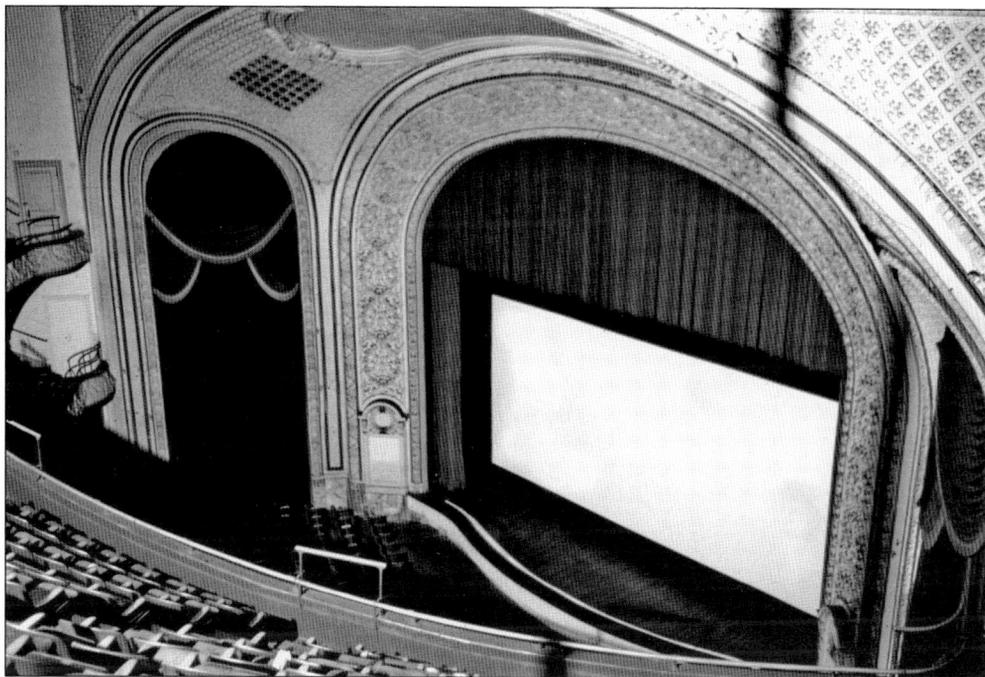

The steep slope of the balcony in Keith's auditorium signals its use as a vaudeville theater. In this photograph, just to the right of the screen, one can see the annunciator, which had cards that would pop up to identify the current act on the vaudeville bill.

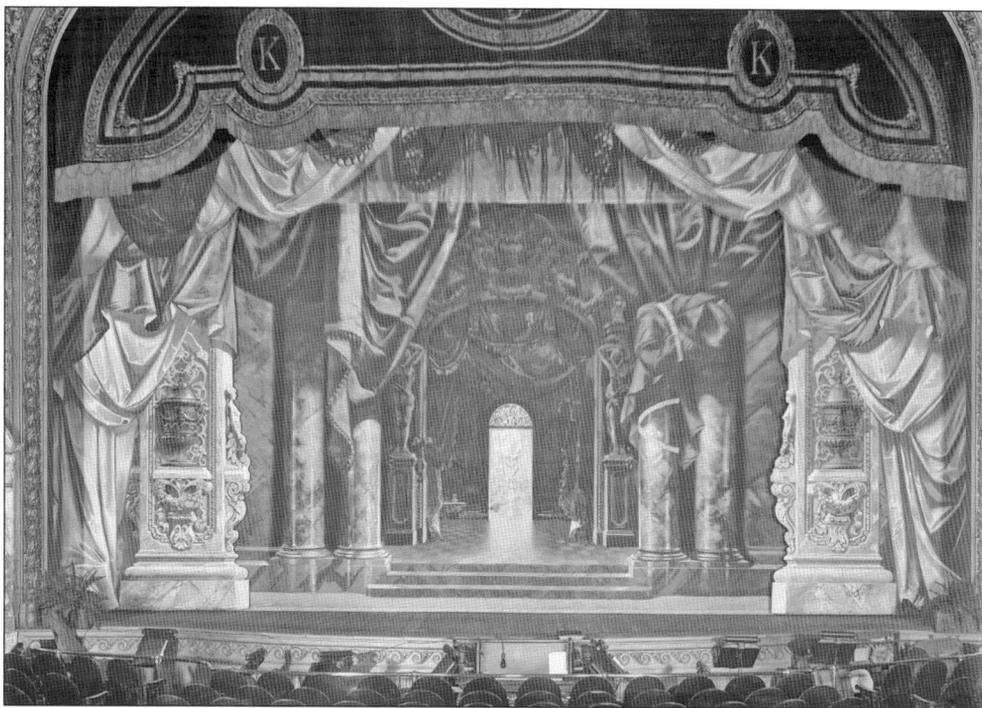

Keith's curtain featured a trompe l'oeil scene of a grand hall. (Courtesy of the Library of Congress, Prints & Photographs Division, Harris & Ewing Collection LC-H25-91141-BC.)

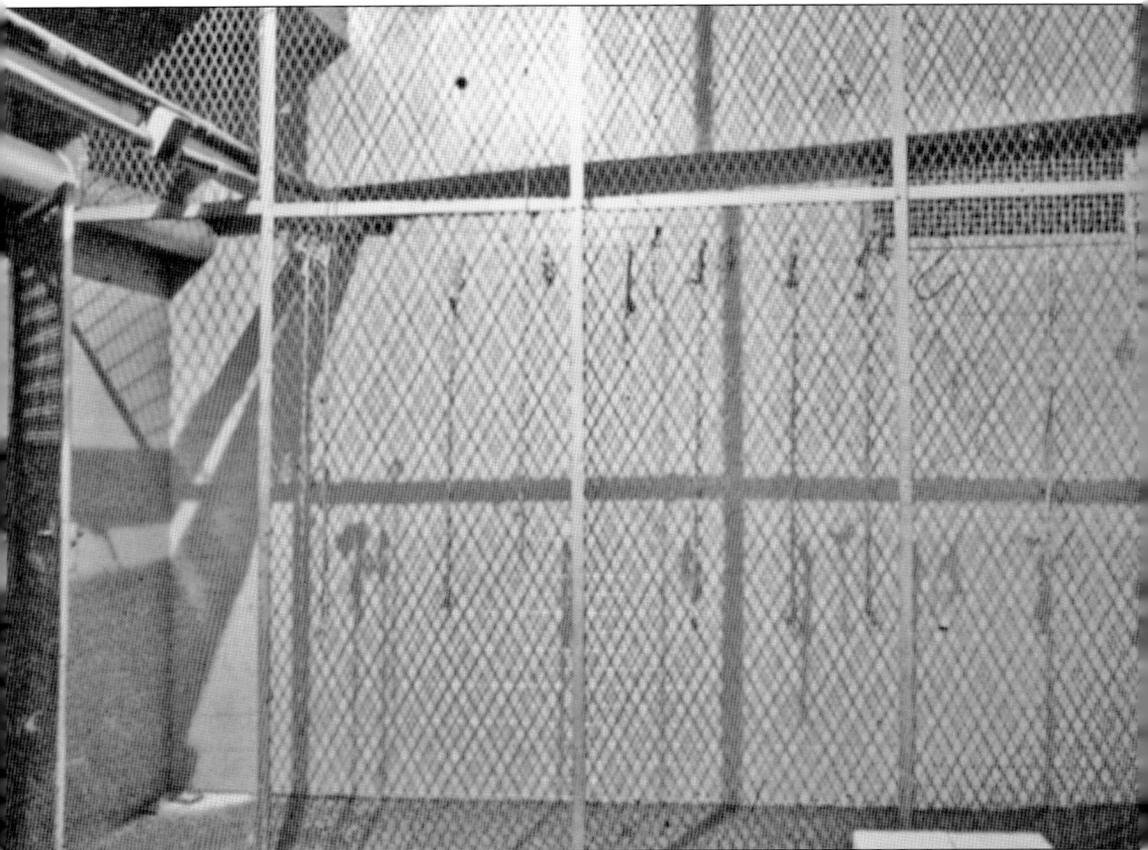

This is not a holding cell for criminals or a torture chamber, but a basement cage built to house the live animals that appeared in vaudeville acts at Keith's Theatre.

Two

THE FIRST
MOVIE THEATERS

The movie theater era began in 1906 in Washington and in many other cities around the nation. Thomas Armat opened his Star Theater at Tenth and D Streets NW. Louis J. Simonds opened his Unique Theater on D Street a few doors east of the Star. Other openings included the Cosmos (Pennsylvania Avenue NW), Happyland (Seventh Street NW), the Palace (Ninth Street NW), Crandall's Casino (East Capitol Street SE), and the Pickwick (Pennsylvania Avenue NW).

Entrepreneurs saw movies as a way to get rich quick with little investment. There was a huge surge in nickelodeons opening in 1908, and by 1910, Washington had 73 places exhibiting movies, compared to 77 in Baltimore and 181 in Philadelphia. The little theaters' names evoked comfort or high-class enterprises like Pastime, Idle Hour, Empire, Senate, Acme, Avenue Grand, and Majestic. Most of these tiny theaters were built in remodeled stores and operated by people without any experience. Many failed after one or two years.

Movie theaters of the early 20th century were tiny, seating 100 people or fewer, furnished with benches or occasionally church pews and a makeshift projection booth at the rear. The movies were projected onto a white sheet or a wall painted white. There was always the fear of fire because of the highly flammable nature of nitrate film, and projection booths were hot and dangerous places to work. The first unions for projectionists were organized during this time. B.A. Spellbring and several other members of the local stagehands' union organized a projectionists' union, granted Charter No. 224 in 1911. The projectionists' union was important in getting better and safer working conditions.

Before air-conditioning, there were limited ways to keep cool in the hot, sultry Washington summers. Some theaters bought large blocks of ice and directed fans to blow over them onto the audience. Larger legitimate theaters closed for the summer, but the smaller movie theaters tried a different method—they built open-air theaters, like walk-in drive-ins. These were cheap and easily constructed and only required a vacant lot, a high board fence, a wooden booth and entrance, several rows of benches, and a screen. Some, like the Apollo on H Street NE and the Savoy on Fourteenth Street NW, were built next to and operated in tandem with hardtop theaters.

In October 1912, the major early exhibitors organized. Aaron Brylawski and his sons Fulton and Julian, William "Doc" Herbst, Ira LaMotte, Marcus Notes, Tom Moore, Joe Morgan, and Harry Crandall came together and formed the Motion Picture Exhibitors League of Washington, DC, and Herbst, who ran the Circle Theater, was elected its first president. The exhibitors' union worked against efforts to censor films and served as a buffer between the exhibitors and the distributors.

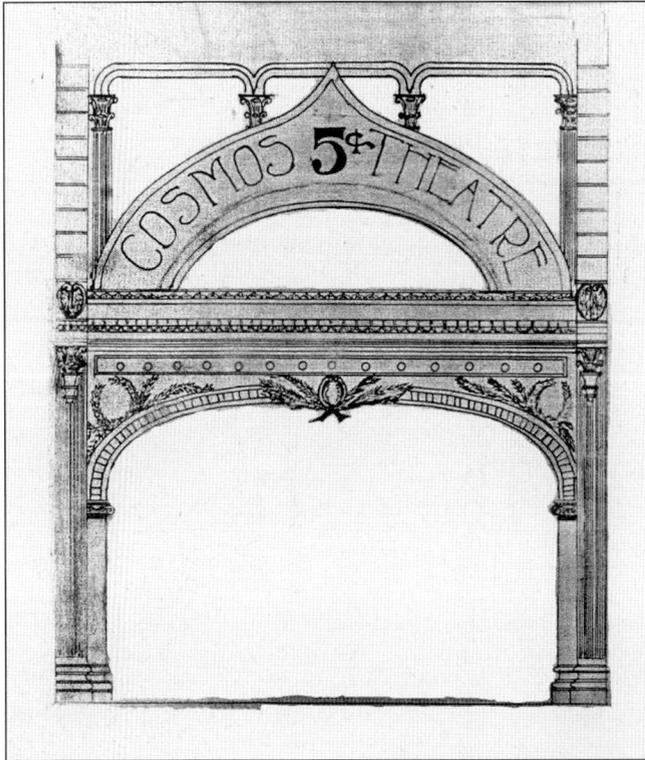

The first Cosmos Theater (919 Pennsylvania Avenue NW), as seen the year it opened in 1907, featured a plain facade designed by Medford & Lepley. It was so successful that it was enlarged and remodeled in 1909. (Courtesy of the National Archives and Records Administration [NARA], RG351, DC Building Permits, permit 1082, September 30, 1907.)

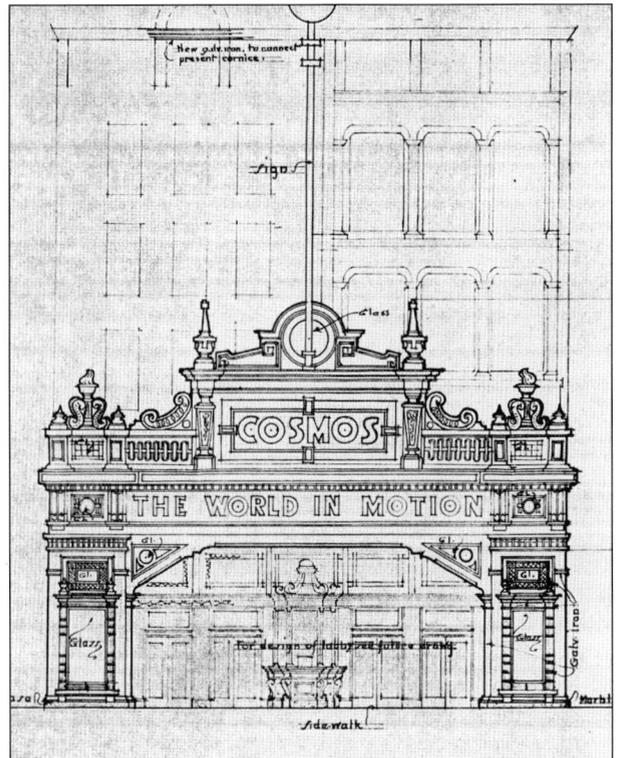

The planned facade of the second Cosmos Theater was much more elaborate than its predecessor. There is some doubt that it was actually built according to this plan. (Courtesy of NARA, RG351, DC Building Permits, permit 35872, December 1909.)

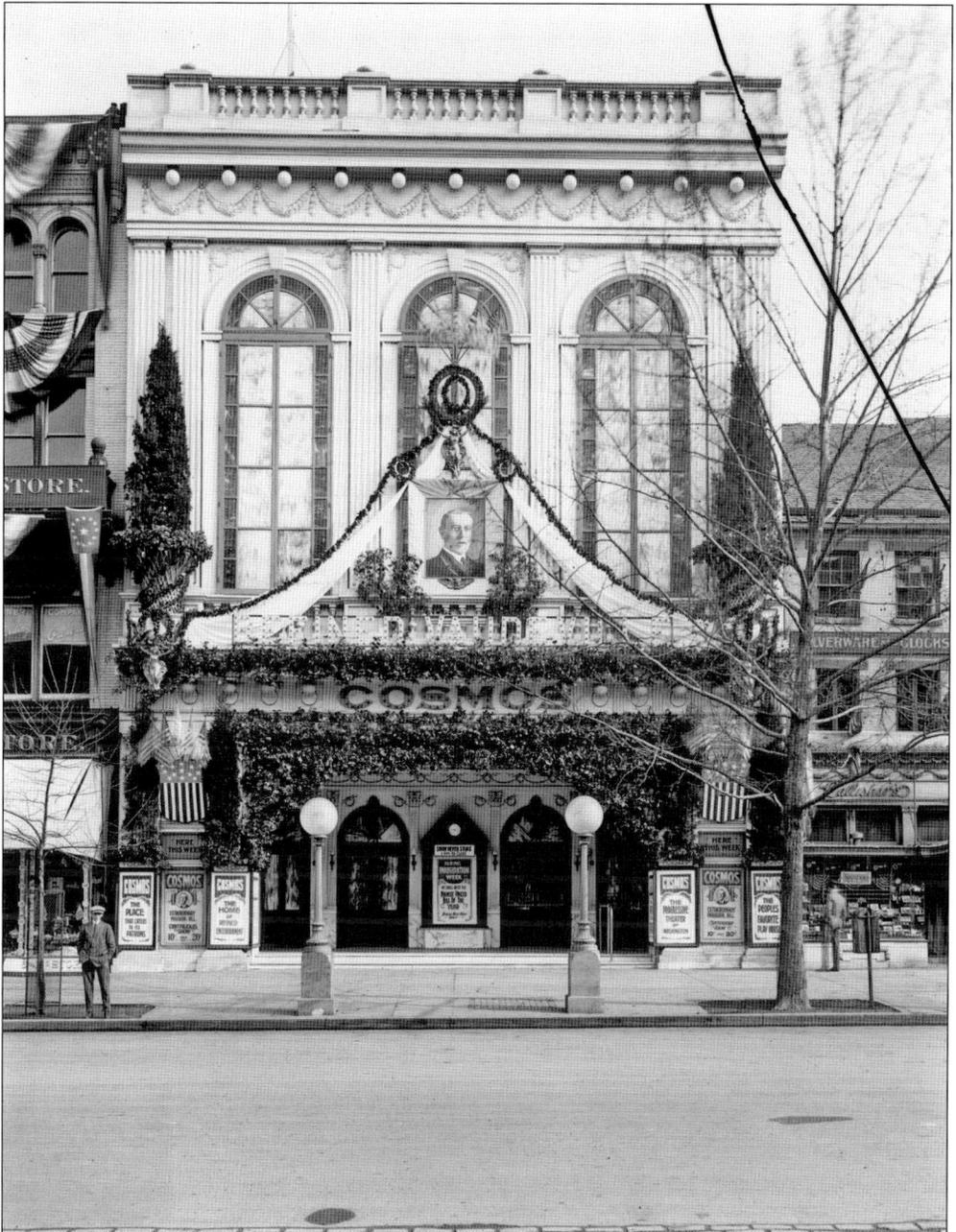

The Cosmos proved so popular that within two years the Cosmos Theater Company of Thomas Armat, Aaron Brylawski, Alexander Wolf, and Maurice Rosenberg had it completely rebuilt with a more elaborate facade by Harding & Upman. It reopened in 1909 and lasted until the late 1920s, when it was known as the Mutual. (Courtesy of the Library of Congress, Prints & Photographs Division, National Photo Company Collection, LC-F82-320.)

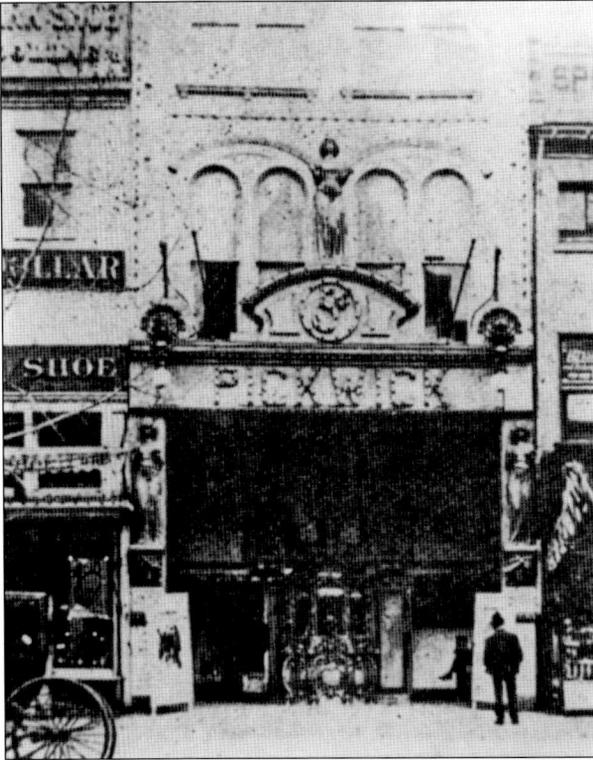

The Pickwick Theater (911 Pennsylvania Avenue NW) opened in 1907 and was designed by Franz Carl Koenig, who also did theaters for early movie producer Sigmund Lubin. Early theater designers loved elaborate fronts featuring caryatids, as this early photograph shows. It was short-lived, closing in 1915.

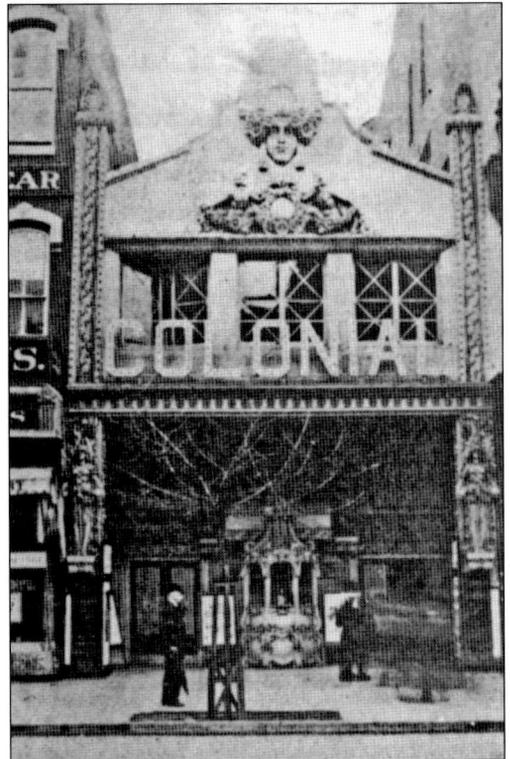

Another Franz Koenig design, the Colonial Theater (927–929 Pennsylvania Avenue NW), which opened in 1909, also featured caryatids. Similar to Koenig's New Pickwick Theater (later the Howard) in Baltimore, the Colonial was one of the earliest theaters in town to have a pipe organ. It too was short-lived, closing in 1916.

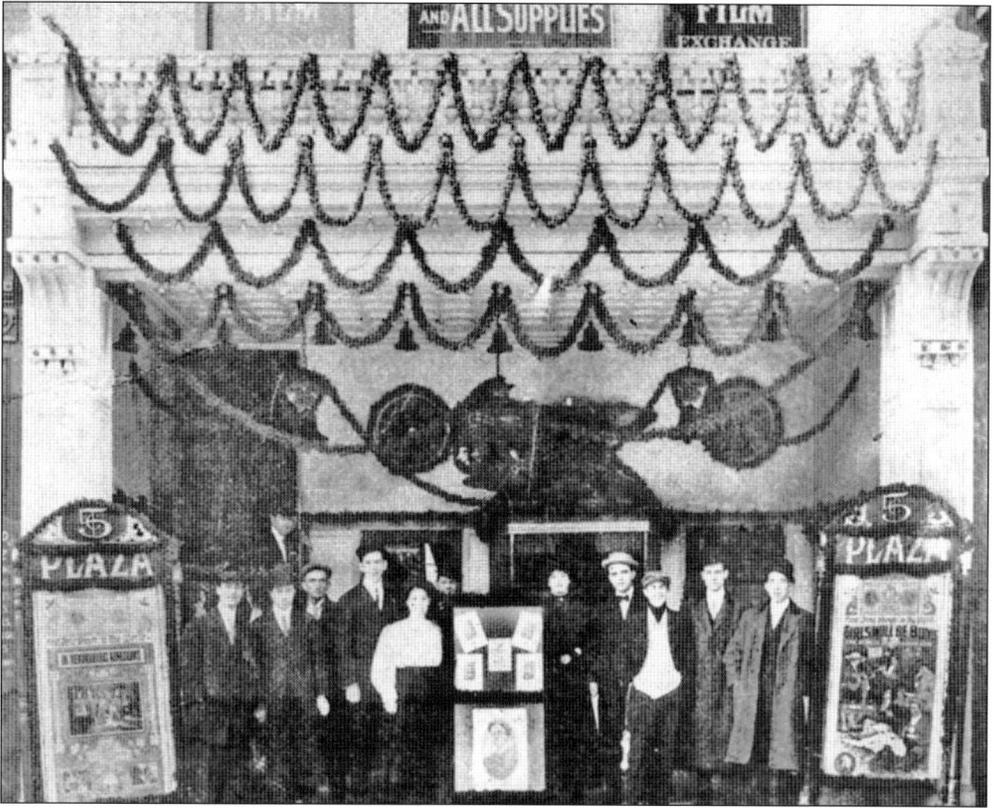

Even without caryatids, the Plaza Theater (434 Ninth Street NW), which opened in 1908, was quite successful. Tom Moore purchased it from the original owners and turned it into a lucrative moneymaking theater, although it closed around 1923.

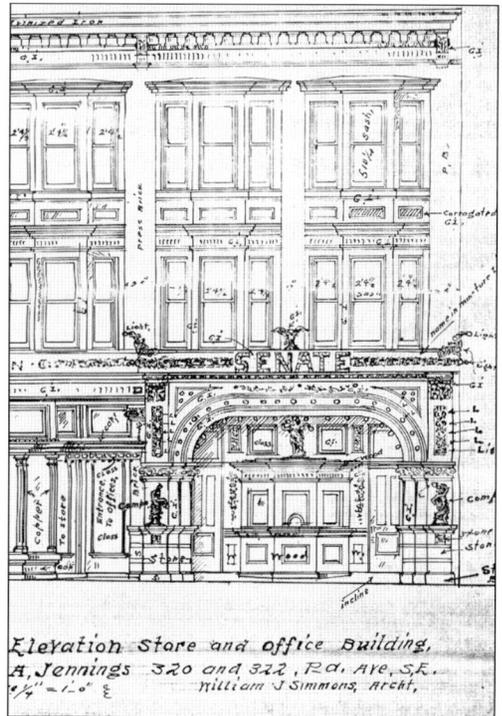

Elevation Store and office Building.
A. Jennings 320 and 322, Pa. Ave, S.E.
William J Simmons, Archt.

This architect's rendering is for the front of the Senate Theater (320–322 Pennsylvania Avenue SE), which was open from 1909 to about 1926. (Courtesy of NARA, RG351, DC Building Permits, permit 5073, June 24, 1909.)

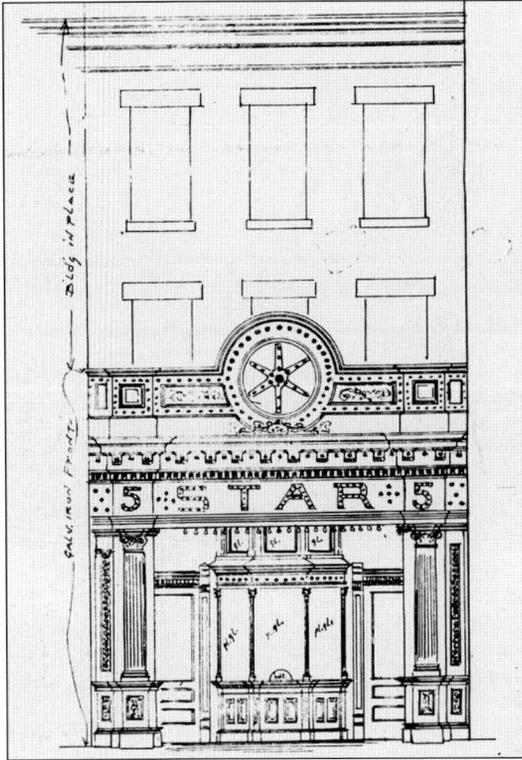

This is how the architect for the Star Theater (2008 Fourteenth Street NW), N.R. Grimm, envisioned the front of his theater in 1909, the year it opened. Small electric lightbulbs were common ornaments for these theaters, and Grimm did not scrimp on them. The theater closed just four years later. (Courtesy of NARA, RG351, DC Building Permits, permit 634, July 29, 1909.)

The entertainment page for the Sunday, July 25, 1909, Washington Herald provides photographs of several early movie theaters, including the only known picture of the Happyland. Note the several "air domes" or open-air theaters on H Street NE. Louis J. Simons was one of the earliest exhibitors and suppliers of motion picture equipment in Washington.

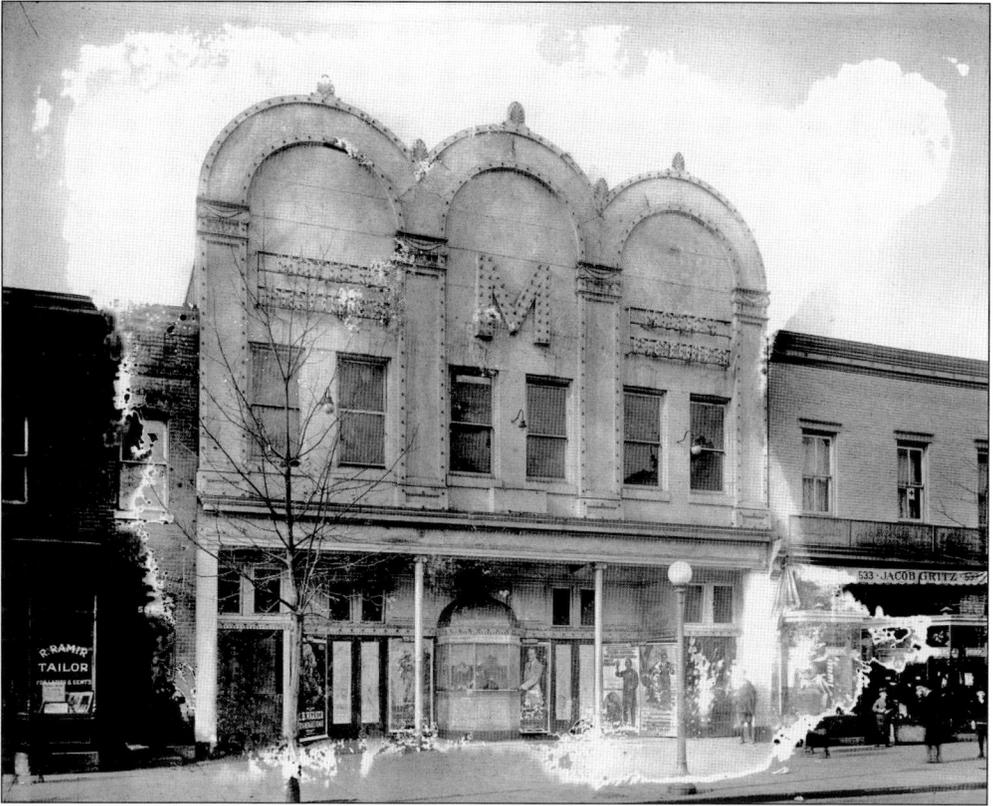

Above, Meaders Theater (535–537 Eighth Street SE) was designed by C. E. Webb for the Brylawski family and operated from 1910 to about 1961. The design is rather top-heavy but has the requisite hundreds of lightbulbs. It featured live shows as well as movies. After the Stanley-Crandall Company took it over in 1927, it was completely remodeled. (Courtesy of the Library of Congress, Prints & Photographs Division, National Photo Company Collection, LC-F82-3570.)

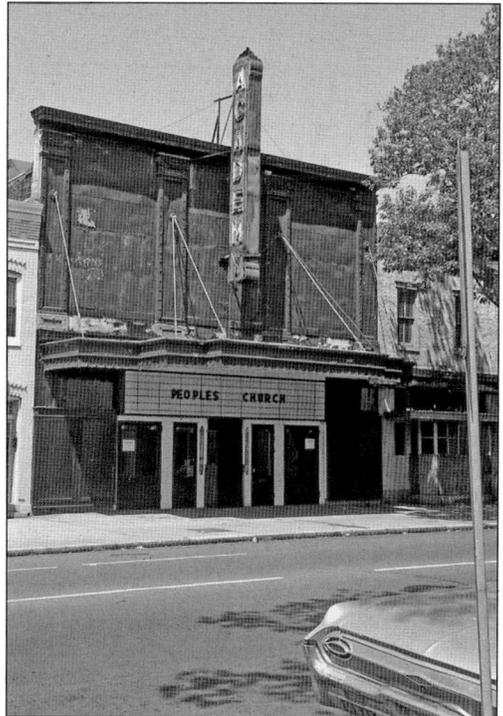

Meaders Theater opened in 1910 and was renamed Academy in 1933. It closed around 1961 and was used as a church for many years but returned to showing films in 2016.

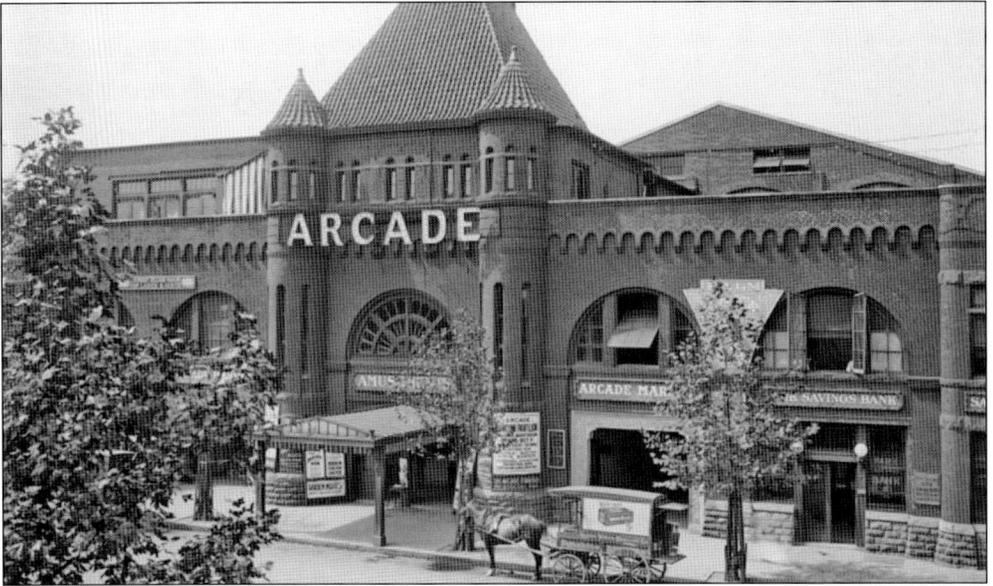

Originally a carbarn, the Arcade (3134 Park Road NW) was converted into an amusement complex in 1910. It had a 300-seat movie theater, 14 bowling alleys, pool halls, a midway—like an indoor carnival—a skating rink, and a dancing pavilion on the roof. The US Army Signal Corps headquarters were on the third floor. Movies were shown in the theater until around 1919. (Courtesy of the Library of Congress, Prints & Photographs Division, National Photo Company Collection, LC-F82-556A.)

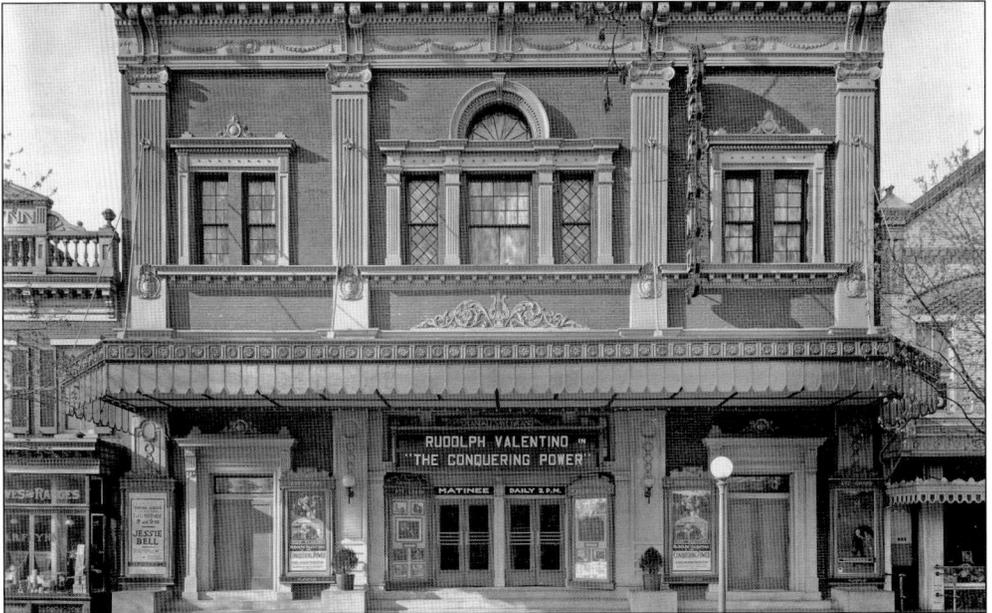

Designed by William C. Allard, the Avenue Grand (645 Pennsylvania Avenue SE) opened in 1910. It had one of the nicest facades in town and one of the longest lives. The Avenue Grand was a popular theater for many years in spite of its rather odd interior shape. In its last years, it was operated by Don King as the Capitol Hill Theater. A fire gutted the theater in 1970, and it was torn down soon after.

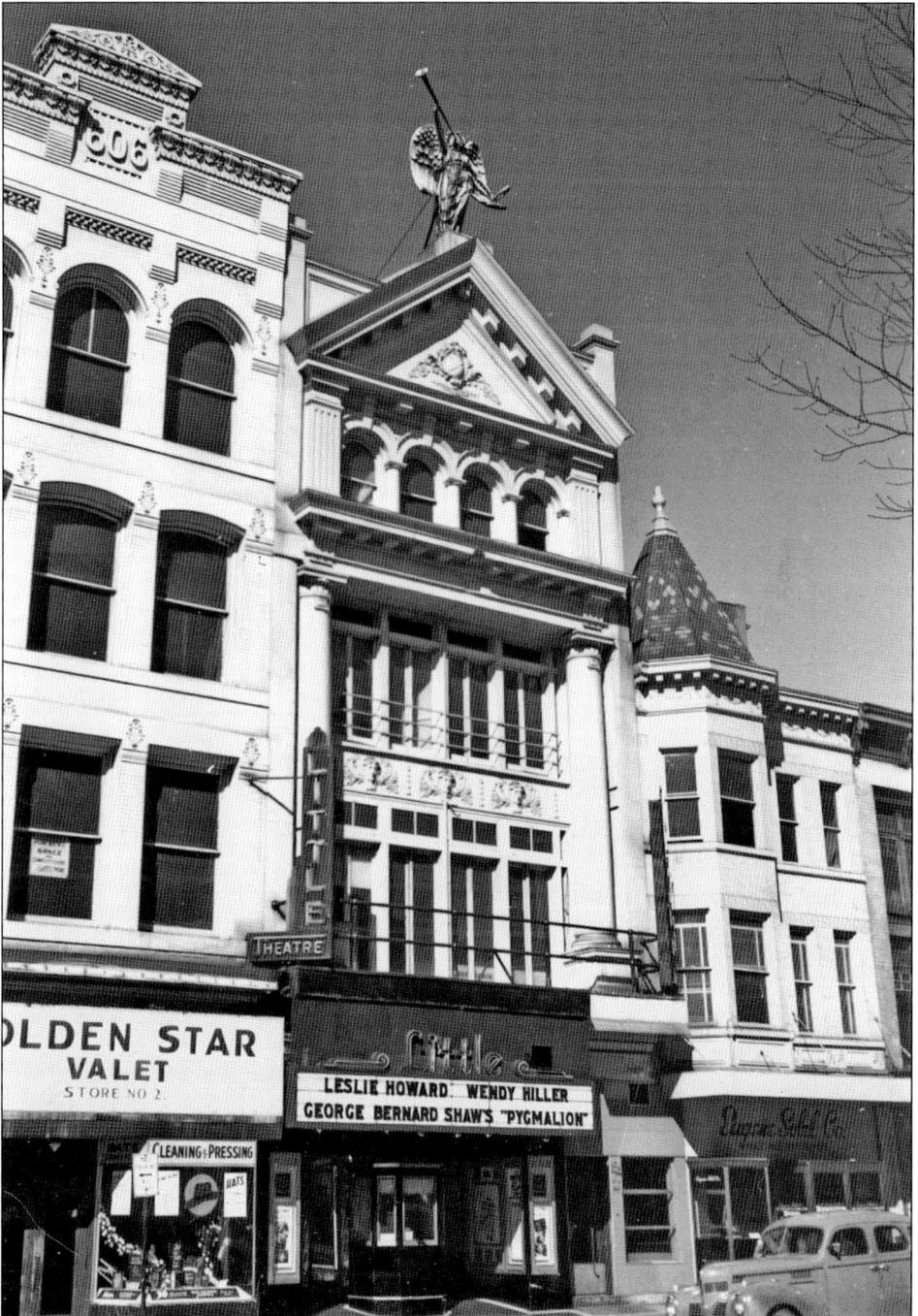

The Little Theater (606–609 Ninth Street NW) opened in 1909 as the Virginia. It was acquired by Nathan Machat's Motion Picture Guild in 1927, remodeled, and reopened as an art theater called the Little. The 1927 remodeling was designed by Julius Wenig. Machat's guild also opened the Little Theater on Howard Street in Baltimore the same year. This 1949 photograph shows that much of the original ornamentation remained many years later. It closed in 1956. (Courtesy of the Library of Congress, Prints & Photographs Division, Joseph S. Allen Collection, LC-AV7-3984.)

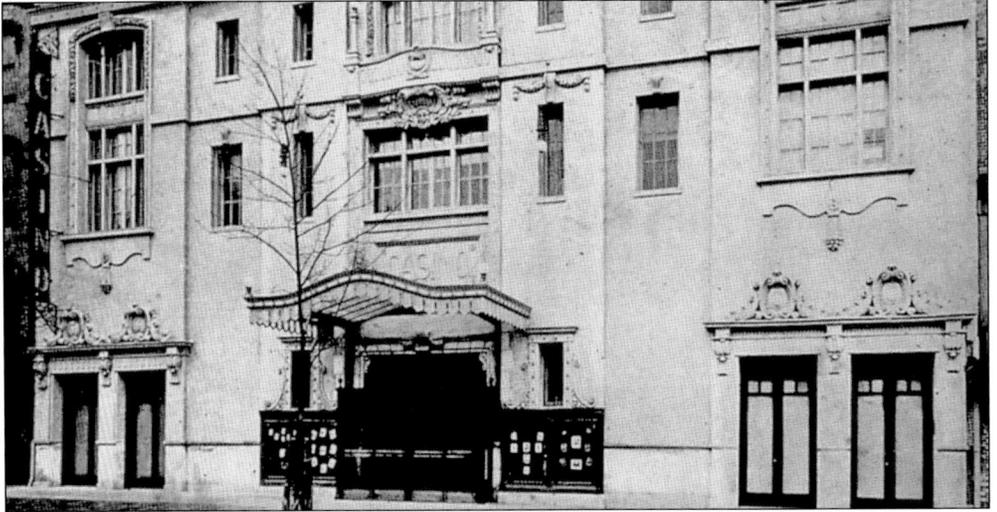

B. Stanley Simmons designed the Casino Theater (632 F Street NW) for the Mayer Amusement Company. It opened in January 1910 as a vaudeville theater. It was located out of the main entertainment section of Washington and never did very good business. The Casino closed in the mid-1920s.

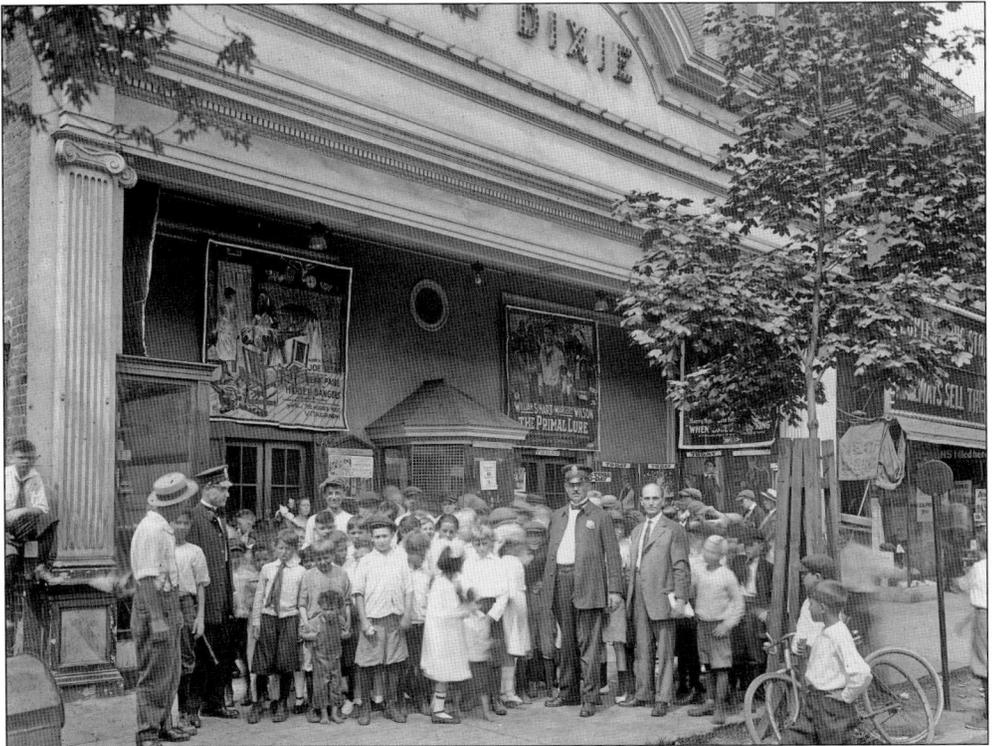

The Dixie Theater (800–802 H Street NE, 1910–c. 1921) was designed by Clark Jones and Seward Charles. For a short time, it was the largest theater in Northeast Washington, seating nearly 400. Children formed a major part of the early theaters' clientele, as this 1916 photograph shows. (Courtesy of the Library of Congress, Prints & Photographs Division, National Photo Company Collection, LOT 12342-10.)

The Empress Theater (416 Ninth Street NW, 1910–c. 1945) had a longer life than most of its neighbors. It was operated by Marcus Notes for many years and was well known for the music played during movies. (Courtesy of the Library of Congress, Prints & Photographs Division, National Photo Company Collection, LC-F82-5201.)

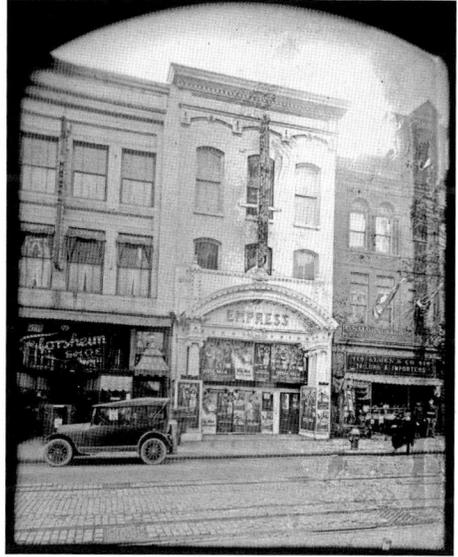

The Howard Theater (622 T Street NW, 1910–c. 1970, 1975, and 2012–present) has had a long, up-and-down history. It was opened in 1910 by the National Amusement Company and was one of the earliest African American theaters in the country. It was not very successful until Abe Lichtman took it over in 1927. Later, Shep Allen was brought in as manager, and he brought in such top talent as Pearl Bailey, Sarah Vaughn, Lena Horne, Artie Shaw, the Platters, and Abbott and Costello. After several years of decline and false starts, the Howard reopened in 2012 as a performing arts venue and is still going strong.

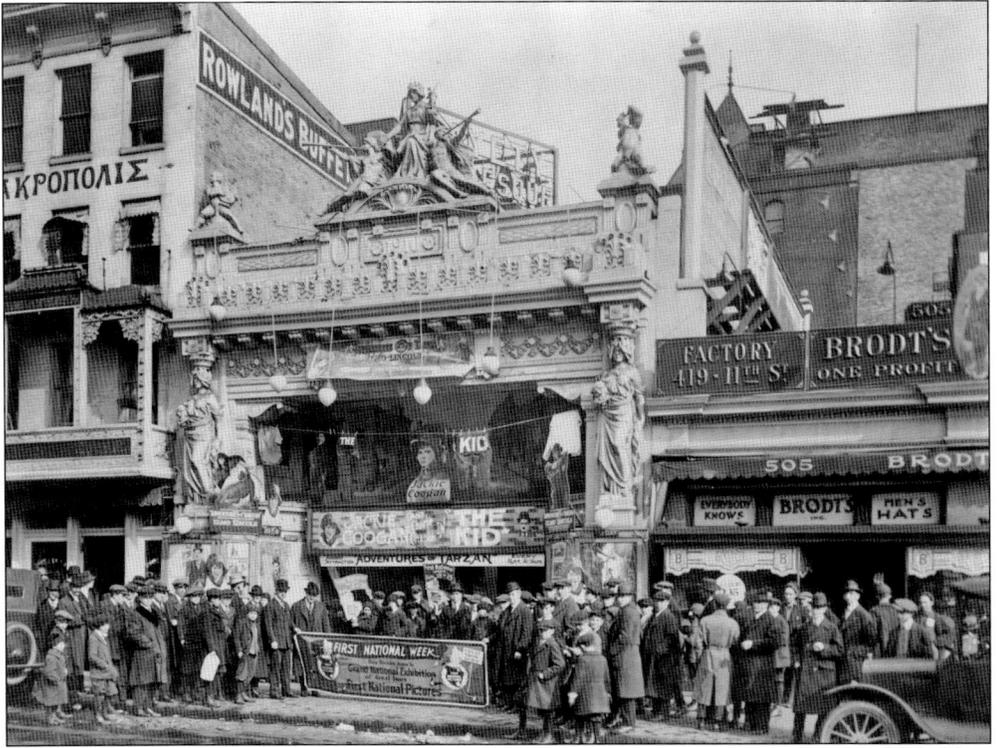

This 1921 photograph shows the entire facade of Sidney Lust's Leader Theater, including the marvelous statues on the top. Compare this with the cover photograph. (Courtesy of the Library of Congress, Prints & Photographs Division, National Photo Company Collection, LOT 12359-6-C.)

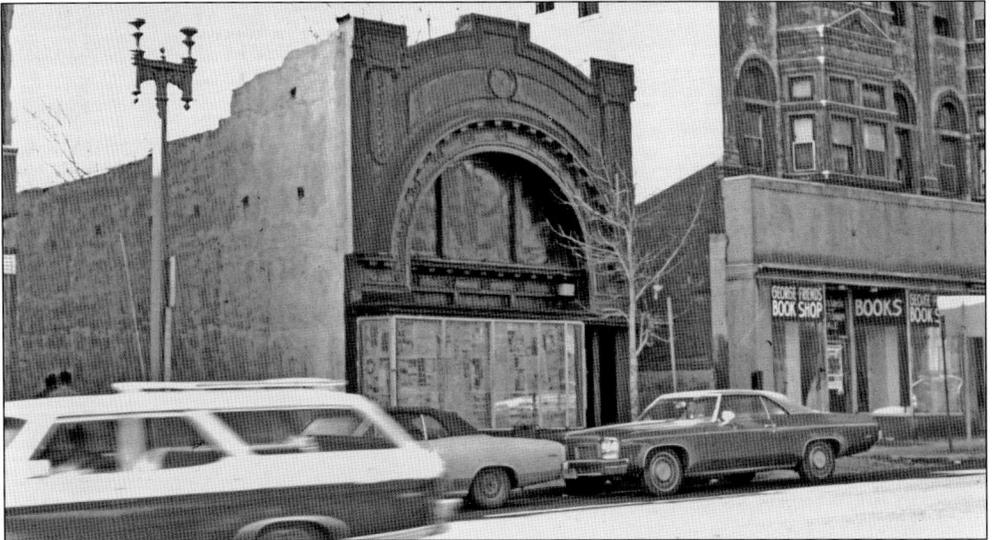

The Mount Vernon (918 Ninth Street NW) was open only from 1910 to 1913. This 1970 photograph shows a fossilized theater; much of the facade was still visible even after almost 70 years. The building was later demolished, but the pressed-metal front was saved and sent to the Children's Museum on H Street NE.

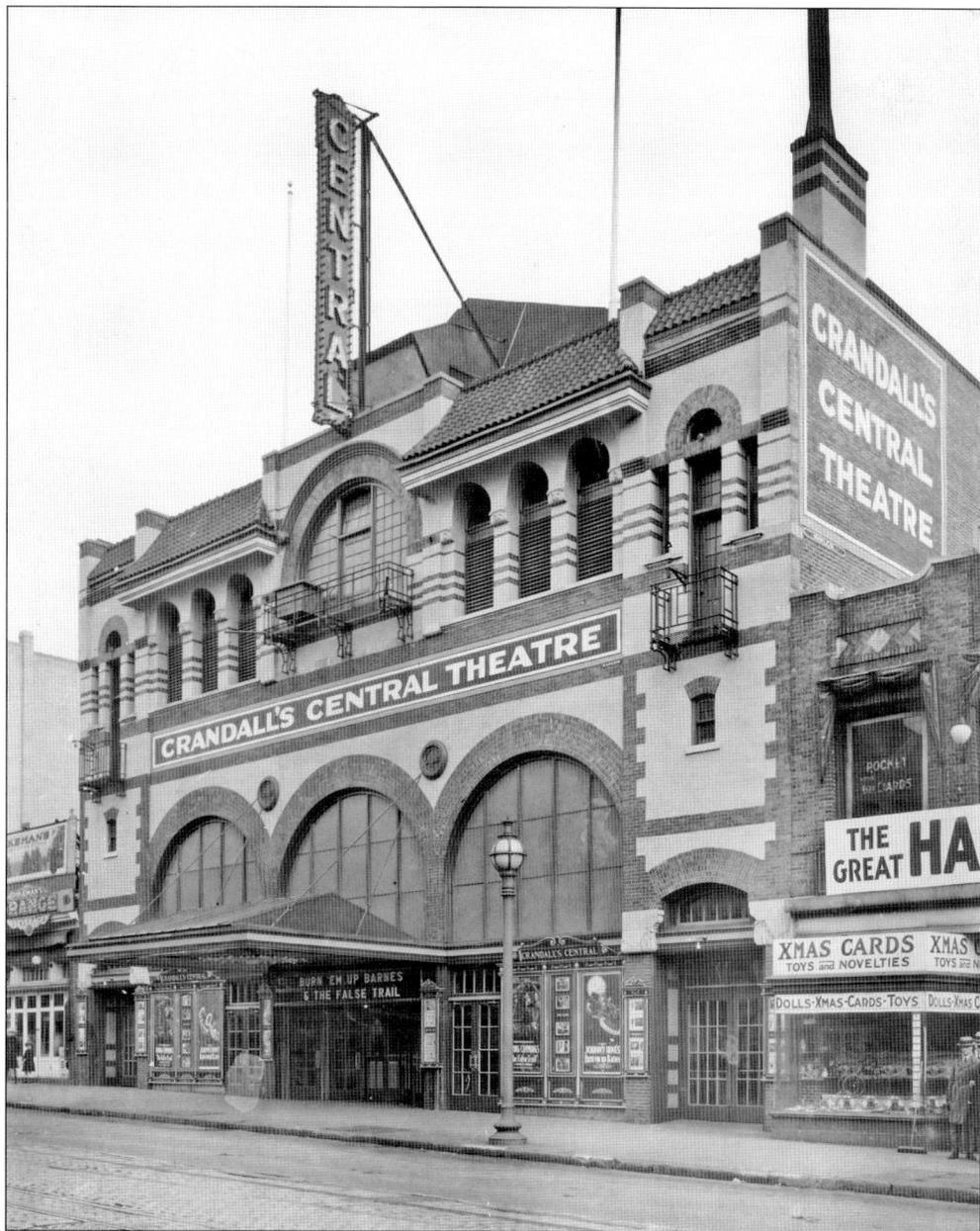

Designed by C.W. Summerville, the Central Theatre (433 Ninth Street NW) opened as the Imperial in November 1911 as a combination vaudeville and movie theater. Tom Moore acquired it in 1913 and changed the name to Moore's Garden, operating it successfully until 1922, when his rival Harry Crandall purchased it and renamed it the Central. When the Gayety Theater up the street shifted to legitimate theater, the name and the shows were moved down to the Central. It was demolished in 1973.

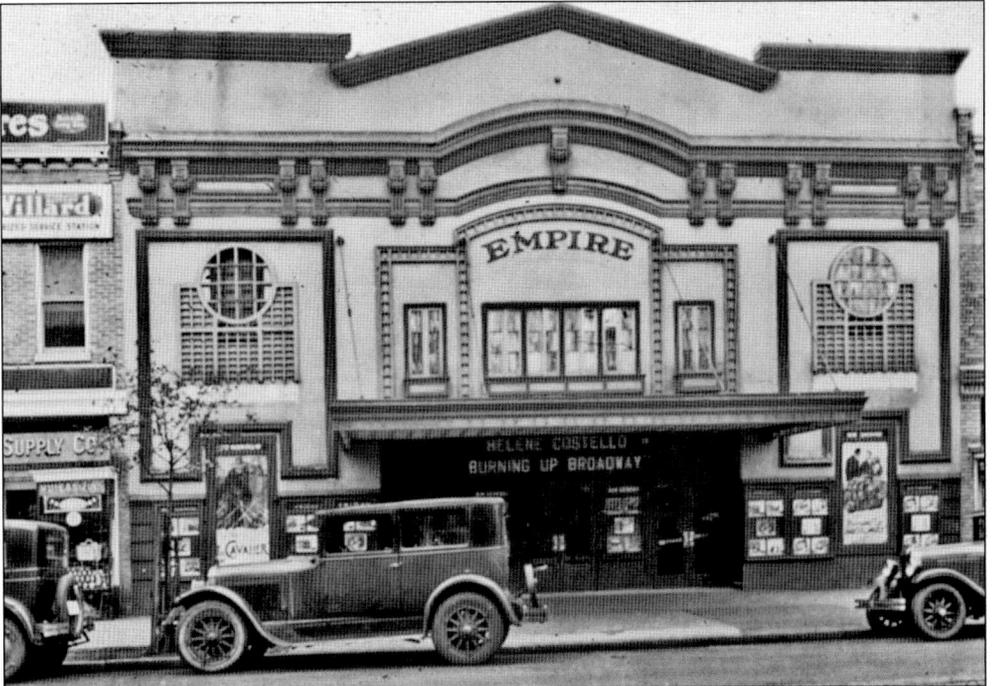

The Empire (911 H Street NE) lasted from 1913 until about 1929. It was designed by W.R. Talbot and could seat 500 people. It featured a five-piece orchestra. It has been demolished. The space at the rear of the auditorium was called the "baby carriage garage" because of the large number of carriages parked there when women brought their babies to the movies.

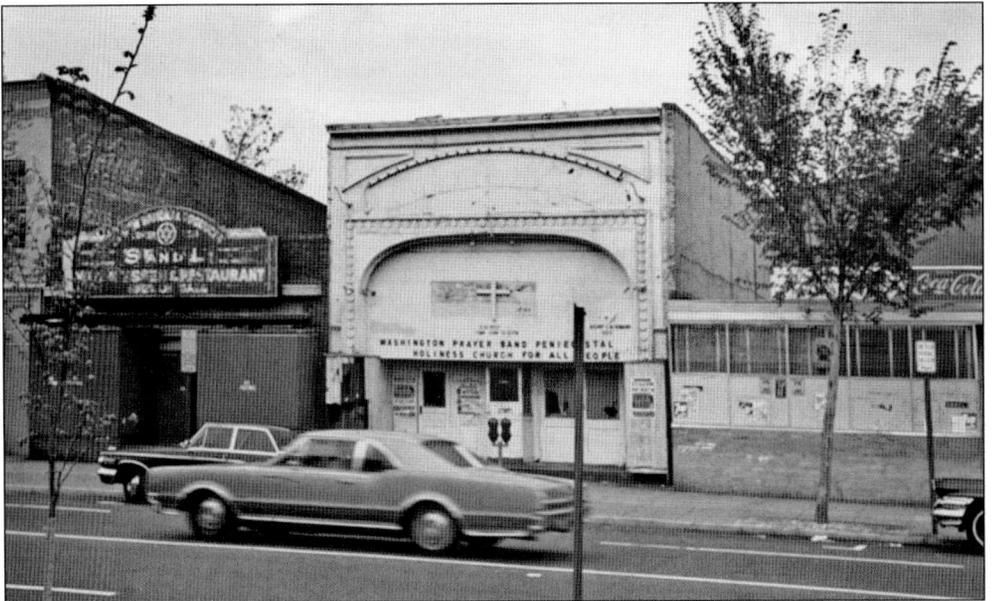

The Alamo Theater (1203 Seventh Street NW) was one of the little storefront nickelodeons on the commercial strip of Seventh Street NW. It began life as a white theater, but by 1921, it had become an African American theater. It lasted until around 1965 and became a church before it was demolished.

Three

BECOMING PALACES

The 1910s were a time of great changes in the movie industry. The theater exchange men organized, ticket prices were moving up from 5¢ to 10¢, censorship loomed on the horizon, projection equipment improved, and experiments in talking movies began. Movie theaters also grew larger during this period. Exhibitors from outside the city, seeing Washington as a lucrative market, began moving in, and the first-run system began to develop. Ninth Street NW, north of Pennsylvania Avenue, was Washington's "Great White Way," and by 1913, it was the address for such movie theaters as the Palace, Plaza, Maryland, Virginia, Empress, Leader, Garden, and Gayety. In addition, four film exchanges were located on Ninth Street. The tiny nickelodeons would not last much longer, and many of these theaters would close in the next few years, to be replaced by larger theaters. Harry Crandall opened his 500-seat Joy Theater on the southeast corner of Ninth and E Streets in 1913. Tom Moore acquired the old Academy of Music on Ninth Street in 1914, remodeled it, and reopened it as the Strand, whose more than 1,000 seats made it the largest movie theater in the city at the time. The 800-plus-seat Savoy Theater opened on Fourteenth Street between Columbia Road and Park Road NW in 1914.

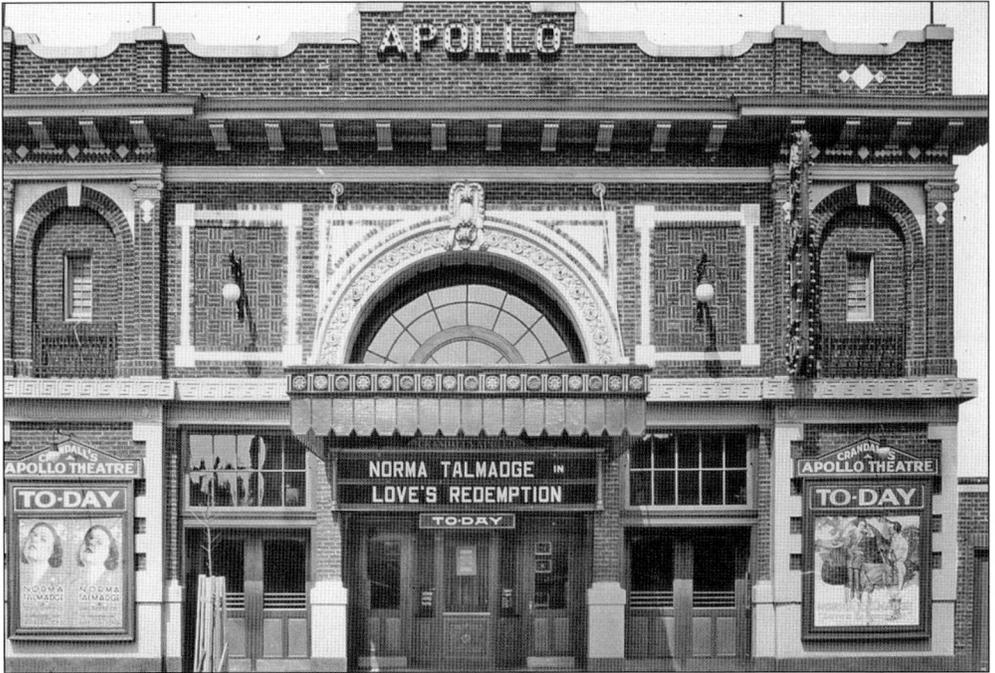

The Apollo Theatre (624 H Street NE, 1913–1955) was designed by C. Clark Jones and built adjacent to an open-air theater where patrons could go on hot, rain-free evenings. The Apollo was regarded as the high-class theater on H Street NE.

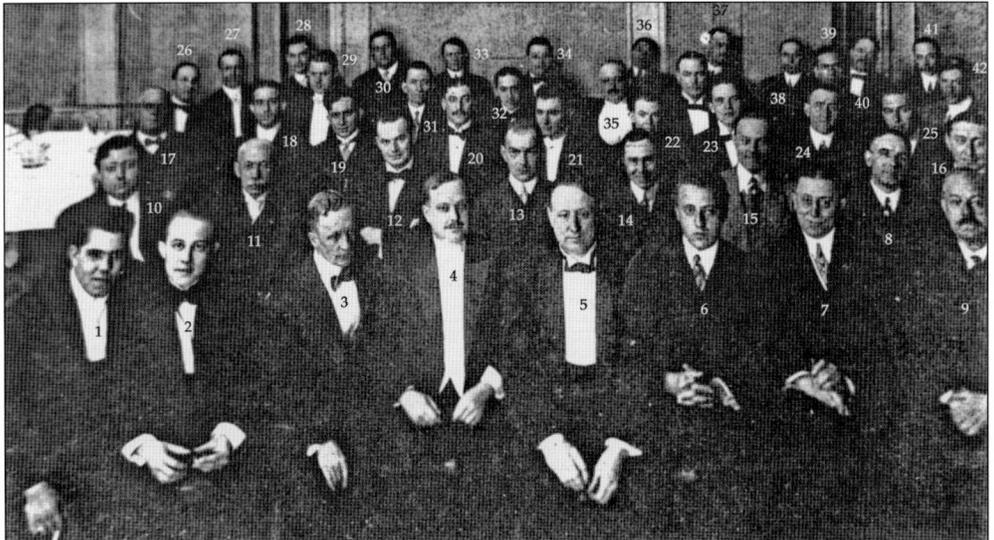

Washington exhibitors pose for a group photograph in 1913. Among those who can be identified are Frank Durkee (1, from Baltimore), Marion Pearce (4, from Baltimore), William P. "Doc" Herbst (5), Harry Crandall (8), Julian Brylawski (10), Aaron Brylawski (11), and possibly Joe Morgan (14).

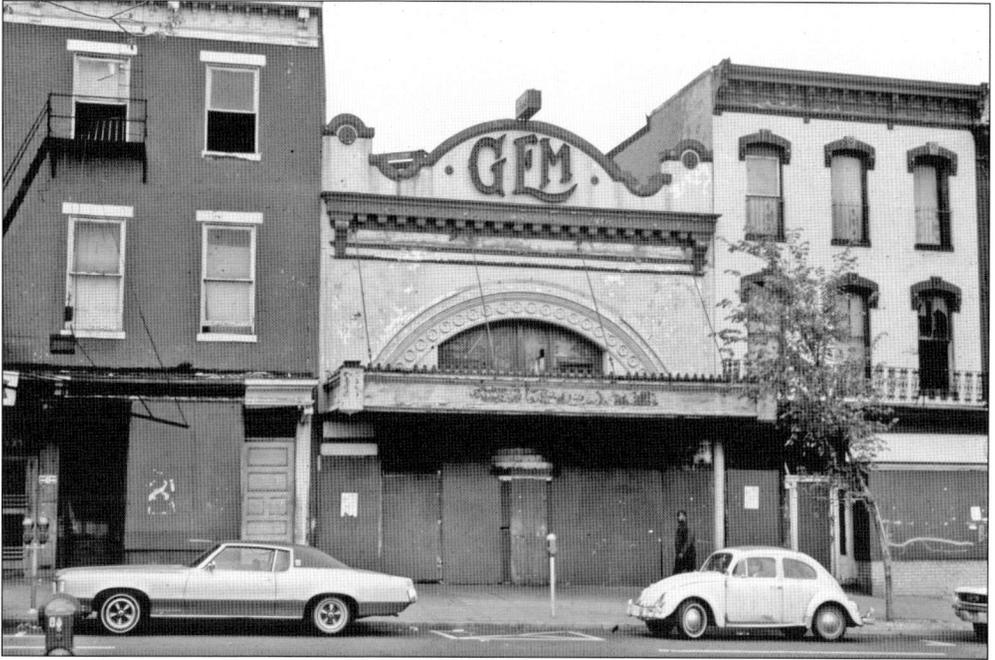

The little Gem Theater (1131 Seventh Street NW), which opened in May 1914, had scarcely changed by the late 1960s, when this photograph was taken. Designed by William L. and Albert Speiden, it was a segregated theater when it opened, with whites sitting on one side of the divided auditorium and blacks on the other. The Gem was razed for the urban renewal of Seventh Street.

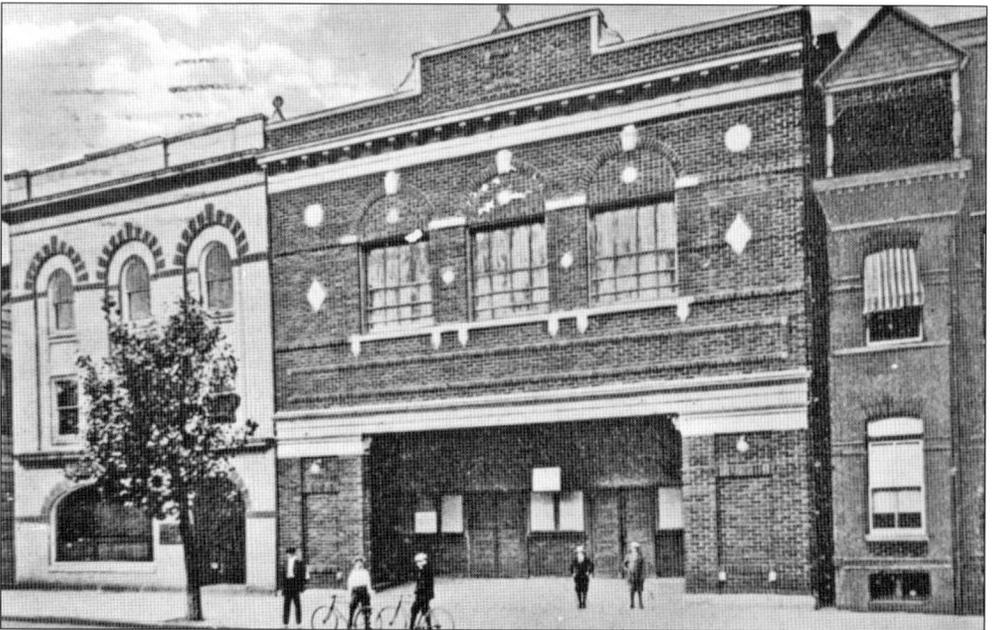

Alexandria, Virginia, was home to several early movie theaters. The Richmond (815 King Street, 1914–2014) was remodeled and opened and closed many times in its long history. In the 1930s, the owners installed a primitive air-conditioning system that involved a large block of ice.

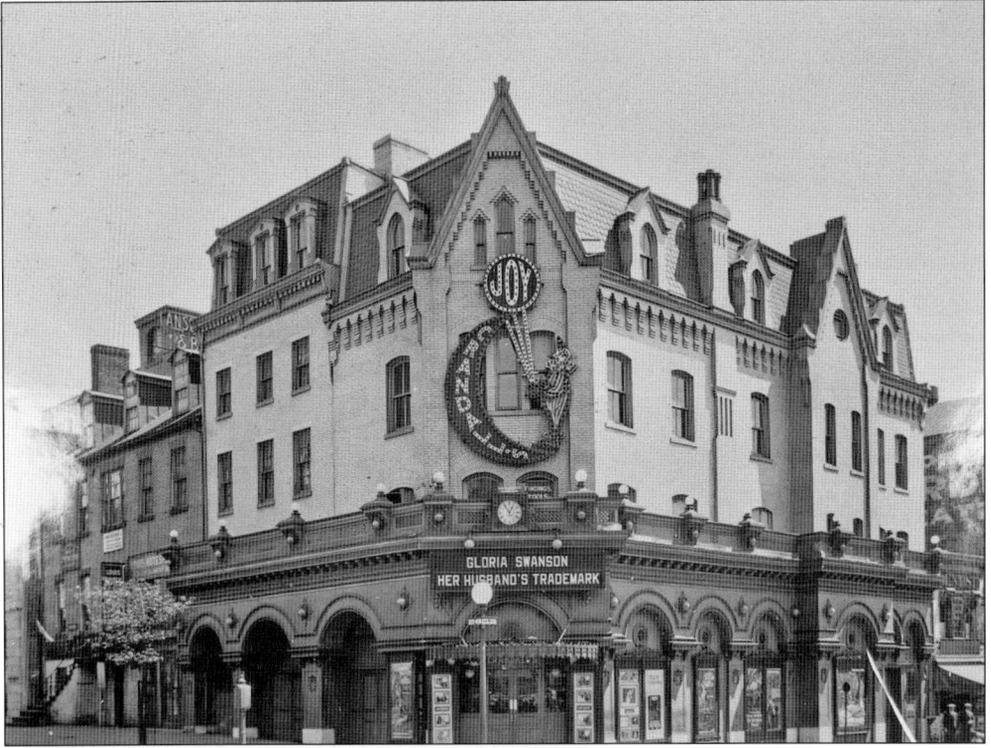

Harry Crandall's wildly successful Joy Theater (437–439 Ninth Street NW, 1913–c. 1924) was designed by W.S. Plager and touted for its modern Typhoon Cooling System. Rival Tom Moore's Garden Theater was a few doors south on Ninth Street.

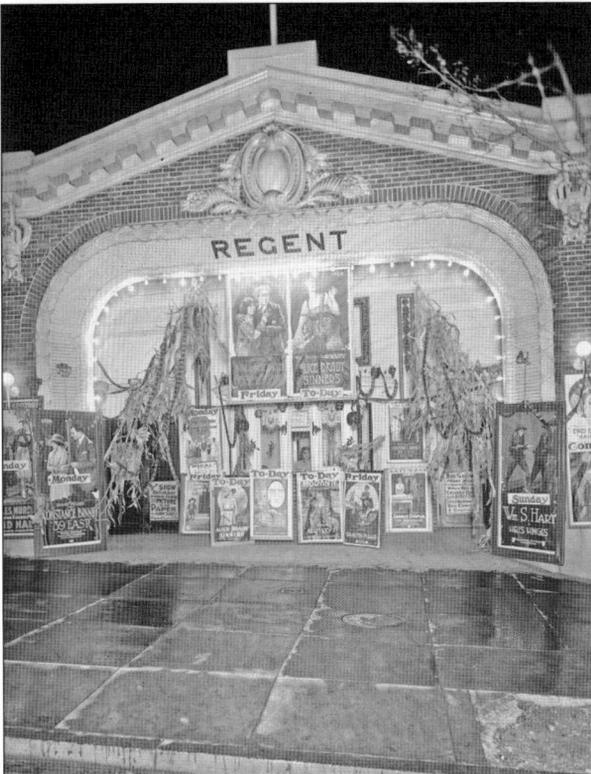

Designed by MacNeil & MacNeil, the Regent Theater (2021 Eighteenth Street NW, 1913–c. 1923) and the Washington Theater were separated by a vacant lot but operated together, showing the same movies at different times. The cluttered array of posters from 1920 was typical of early theaters. (Courtesy of the Library of Congress, Prints & Photographs Division, National Photo Company Collection, LC-F82-5081.)

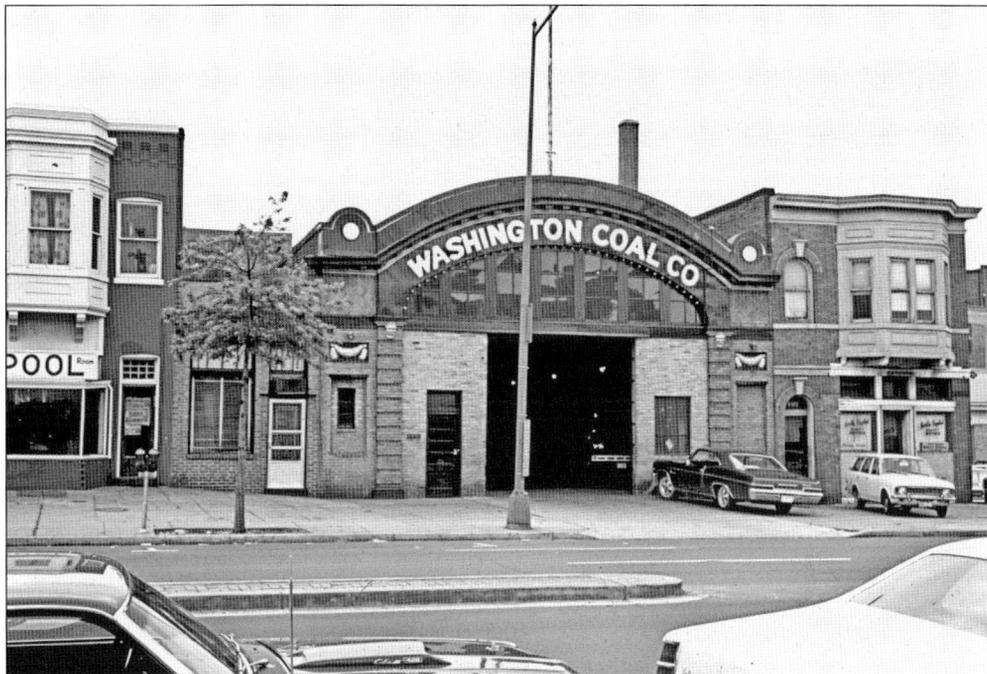

The Liberty Theater (1419 North Capitol Street NE, 1914–1931) was designed by B. Frank Meyers. The Washington Coal Company, which used the building after the theater closed, maintained much of the fine exterior until the building was torn down in 1988.

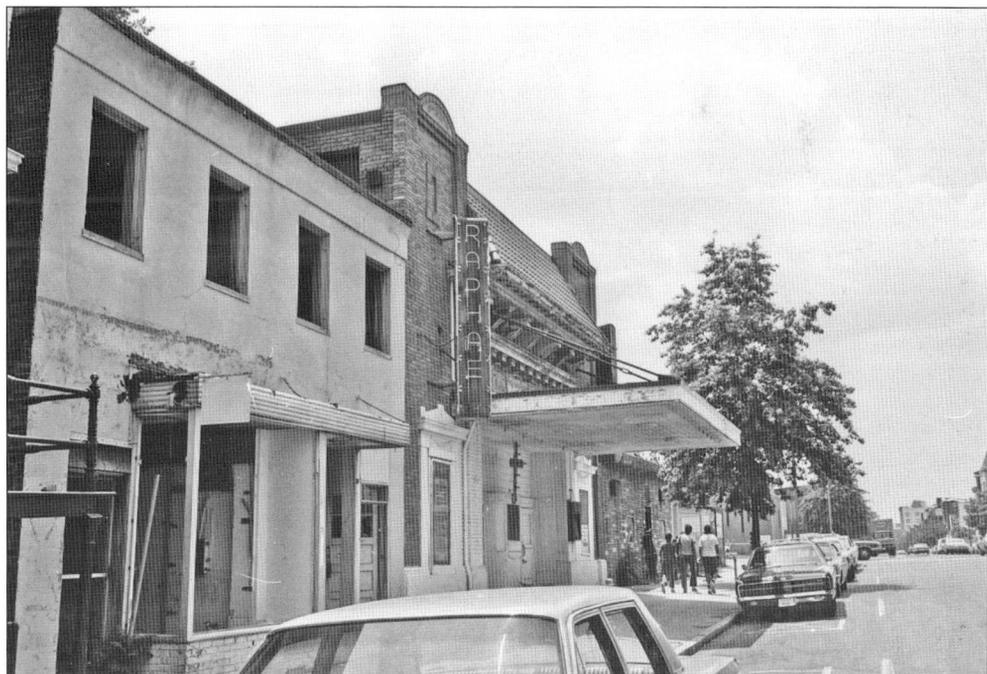

Designed by J. William Downing for Dr. Louis Kolipinski, the Raphael (1409 Ninth Street NW) was an African American theater that opened in 1914. After the theater closed in 1969, the structure was used as a church.

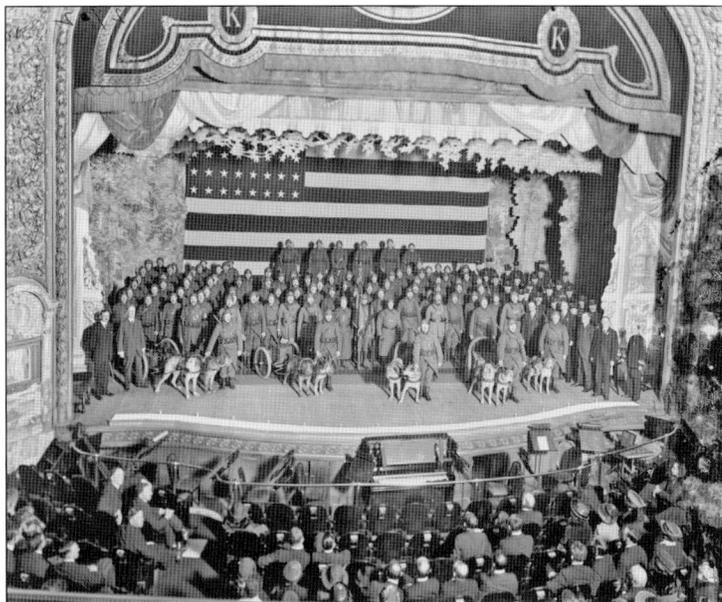

There were many exhibits at movie theaters related to World War I. Here, Belgian army soldiers pose on the stage of Keith's Theatre in April 1919. (Courtesy of the Library of Congress, Prints & Photographs Division, National Photo Company Collection, LC-H25-2902.)

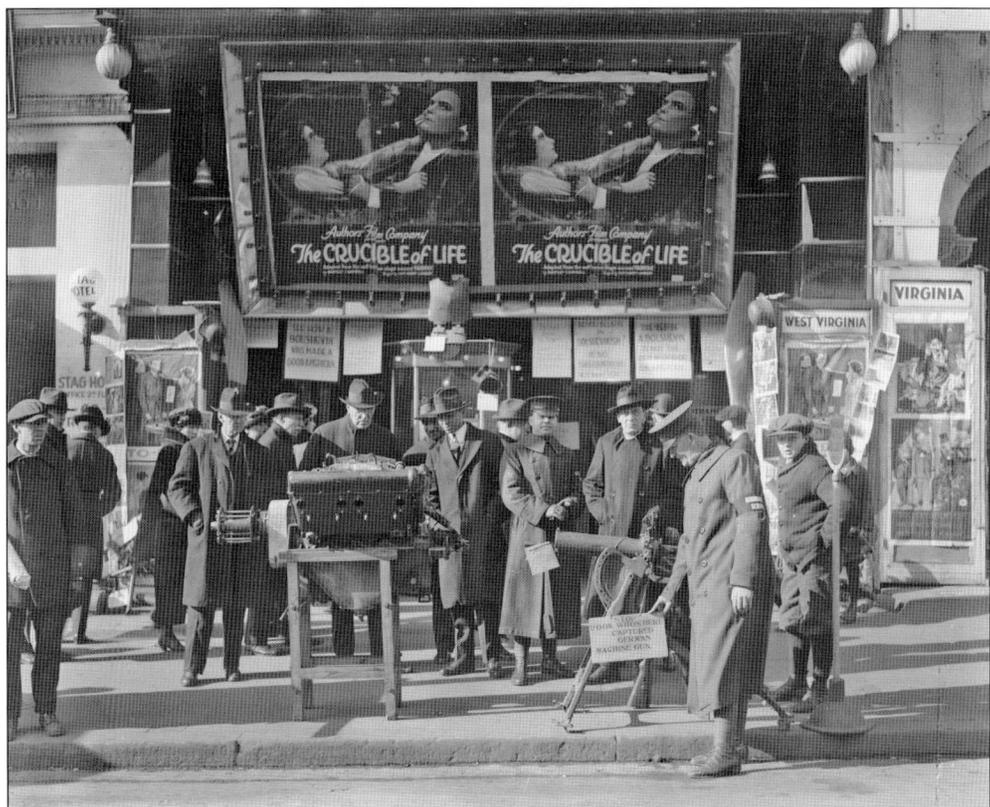

Part of a triumvirate of small theaters in the 600 block of Ninth Street NW, the West Virginia did not last very long. In 1918, it presented a war movie and had an exhibition of weapons used in World War I. It closed just two years later. (Courtesy of the Library of Congress, Prints & Photographs Division, National Photo Company Collection, LC-F8-6637.)

Four

PALACES AND TALKIES

The great movie palace peaked between 1918 and 1930. Typically, first-run theaters downtown seated over 2,000 and were filled with extravagant decorations. Major theater architects such as John Eberson, Thomas Lamb, and C. Howard Crane found jobs in cities throughout the nation where they could work their magic. In Washington, Crane and Kenneth Franzheim designed the Earle (later Warner) Theater, and Lamb designed the Palace, Tivoli, Ambassador, and Trans-Lux. Sadly, Eberson did not get a chance to design any of his famous atmospheric theaters here, but he was active in the 1930s with smaller theaters.

In the 1920s, the rise of the movie palace coincided with a game-changing development in movie technology. Inventors had been struggling to develop sound movies and finally succeeded after various cumbersome failures.

There were two main methods of making sound films: sound on disk and sound on film. The sound-on-disk method involved a kind of record player on which large, one-sided records were played in synchronization with the film. Such programs were easily knocked out of synch by such distractions as a passing bus or large truck, which might jiggle the needle and throw it into another track.

On the other hand, sound on film worked perfectly. In this process, a sound track was printed on a film reel alongside the image, so the two were always in perfect synch. The first successful sound films in Washington were shown at the Metropolitan Theater on F Street NW in 1927, and within a few years, nearly every theater in town had been wired for sound.

Another development addressed audience comfort: improved air-conditioning. Movie theaters with cutout icicles hanging from their marquees provided welcome relief from the Washington summers.

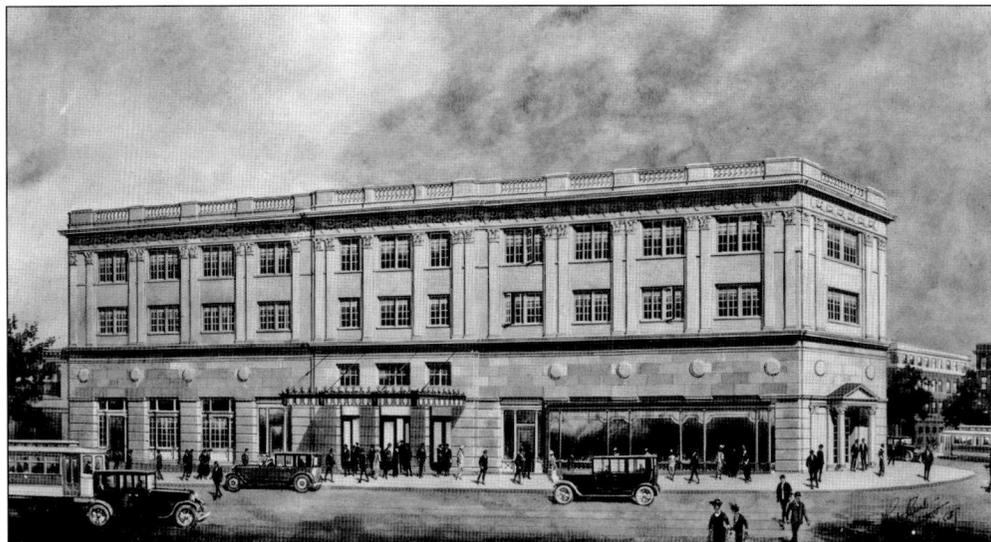

After the terrible disaster at the Knickerbocker (see page 42), Harry Crandall brought in architect Thomas Lamb to design a new theater within the shell of the old one. The Ambassador (2554 Eighteenth Street NW), opened in 1923, often played first-run movies on the same day and date as the Earle Theater when it was operated by Warner Bros.

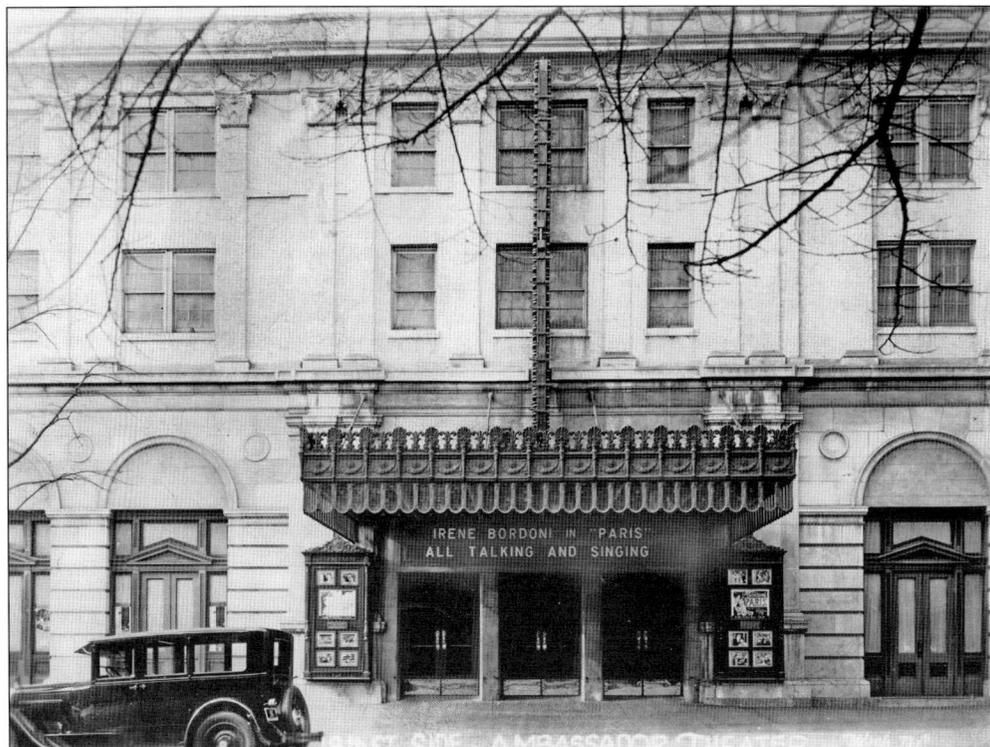

The Ambassador's entrance was located in the same spot where the Knickerbocker entrance had been. In its last days, it was a psychedelic music hall, featuring such rising stars as Jimi Hendrix, and the theater was the meeting point for an antiwar march on the Pentagon that featured Norman Mailer. The Ambassador was demolished in 1969.

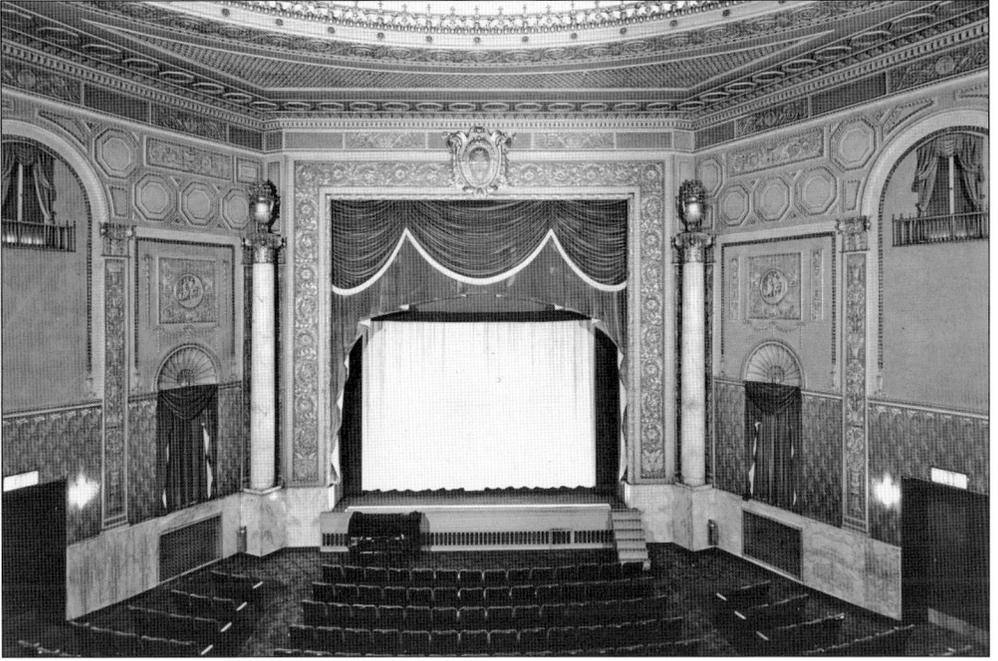

The rebuilt auditorium of the Ambassador was somewhat more extravagant than the Knickerbocker, perhaps to take the patrons' minds away from their uneasiness in coming back to the building after the devastating collapse a few years earlier.

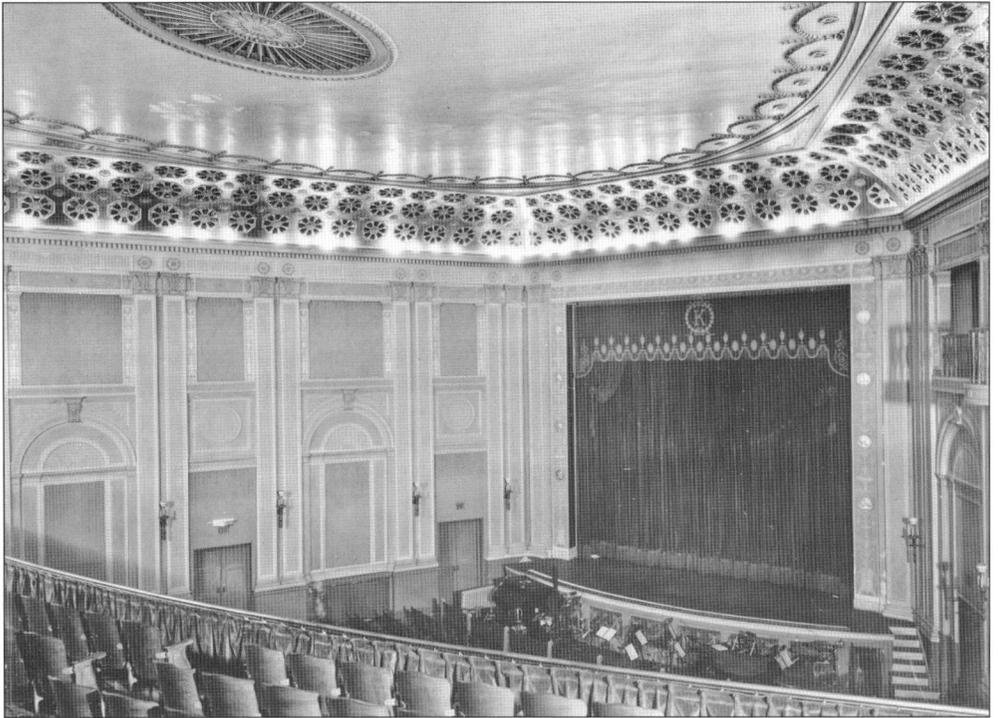

The Knickerbocker auditorium is pictured around the time it opened in 1917. Just five years later, this beautiful space would be filled with the rubble of the collapsed roof.

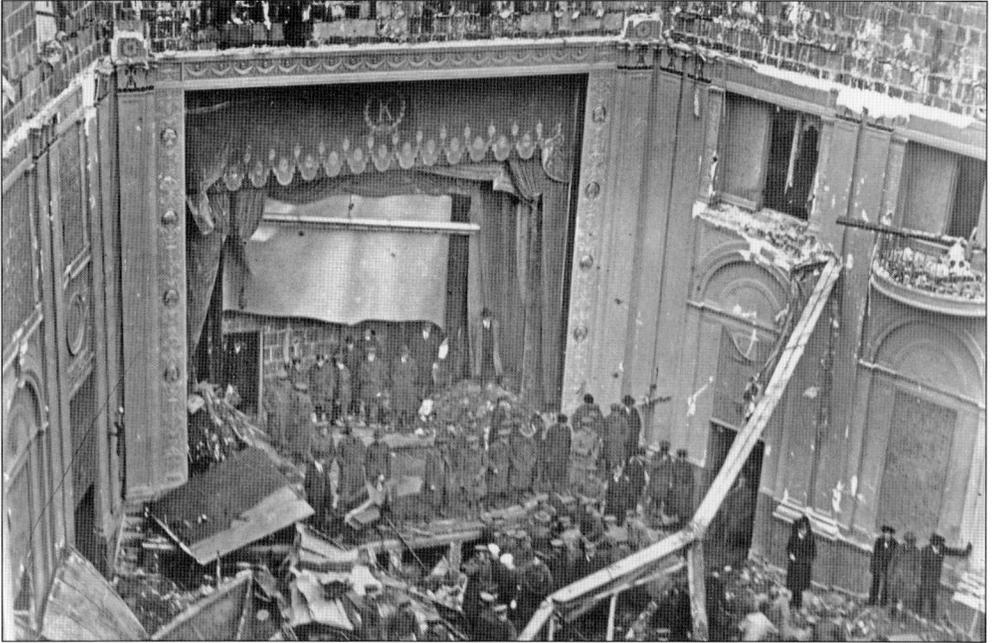

After a heavy snow on the night of January 28, 1922, the roof of the Knickerbocker collapsed, killing 98 people and injuring many more. The design by architect Reginald Geare was believed to be responsible. Many thought that a main steel beam that was not fastened securely to the wall was the cause.

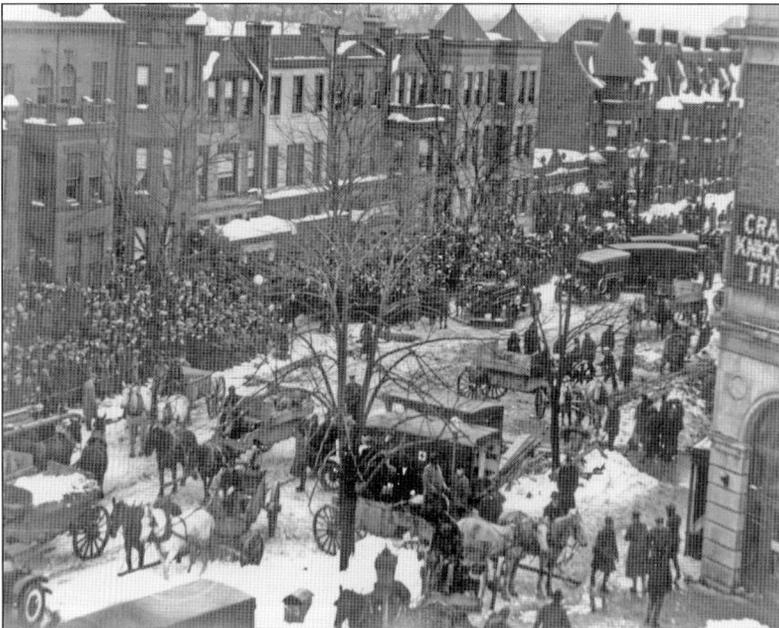

Huge crowds gathered outside the ruined Knickerbocker to gawk at the debris hauled out of the theater. Troops were brought in to assist, and cars were broken into to get jacks to raise up heavy beams and sheets of concrete.

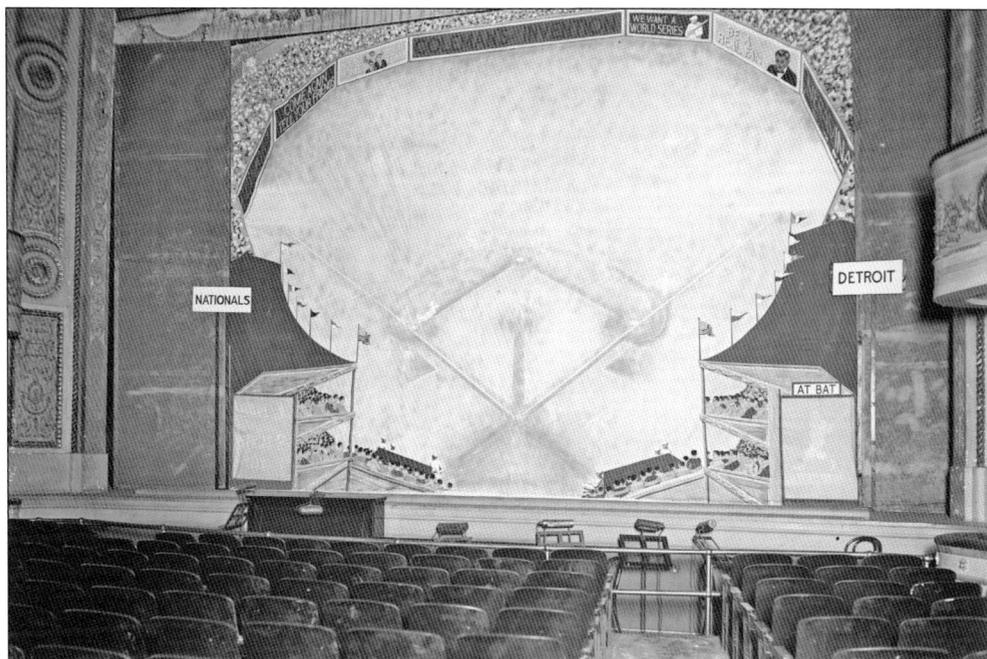

The Coleman Baseball Scoreboard, developed by George Coleman in 1912, was an early gimmick to draw people into theaters. The movement of lights on the scoreboard showed the movements of the players. (Courtesy of the Library of Congress, Prints & Photographs Division, National Photo Company Collection, LC-F81-31667.)

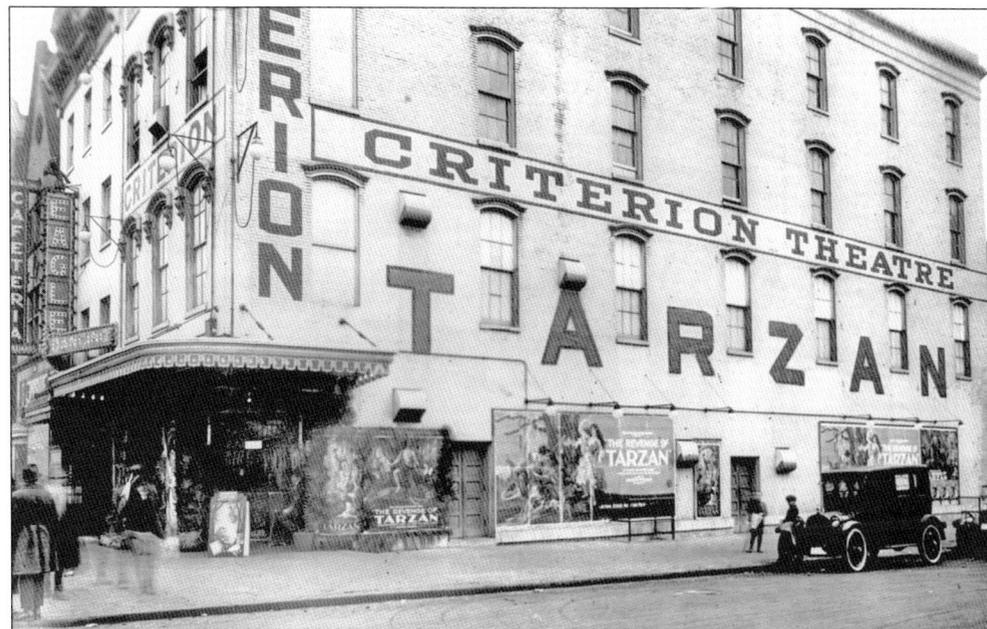

Rather plain on the outside, the Criterion (318 Ninth Street NW, 1918–c. 1945) had an entrance lined with black Italian marble. It was designed for Marcus Notes by Frank G. Pierson. (Courtesy of the Library of Congress, Prints & Photographs Division, National Photo Company Collection, LC-F82-5526.)

The Savoy Theater (3030 Fourteenth Street NW, 1914–1968) was a large and popular theater. Harry Crandall acquired it in 1916, remodeled it, and increased the seating from 800 to 1,400. When the Tivoli Theater was built two blocks north, the Savoy was relegated to showing action films and second-run features. It was damaged in the 1968 riots and never reopened.

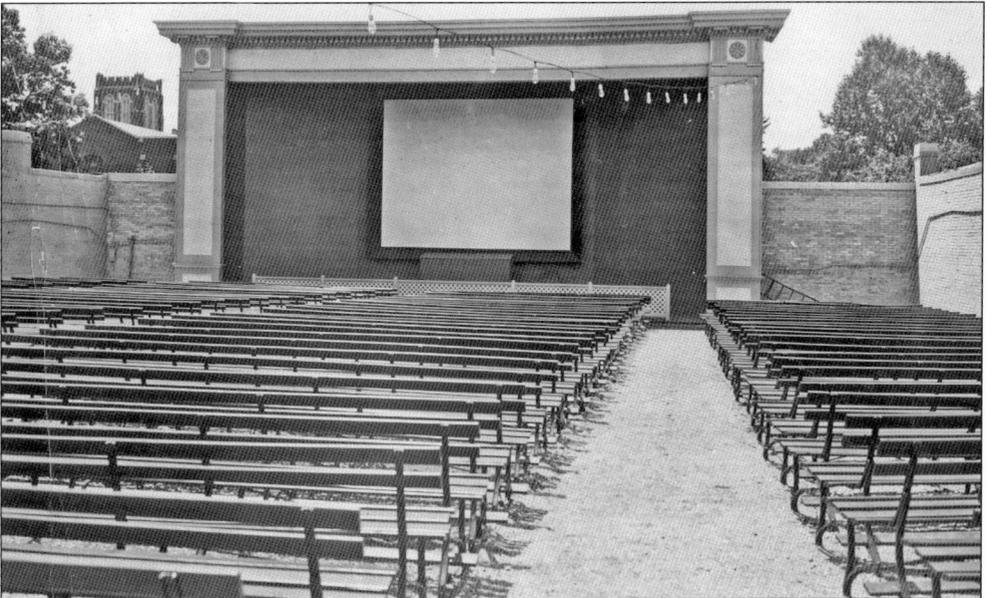

Open-air theaters, or "air domes," were very popular in Washington. The Savoy Theater had one located behind the hardtop theater and ran in tandem with it, sharing the same projection booth. If a storm came up during the showing at the Savoy Garden, the patrons could run around and see the rest of the movie in the Savoy Theater.

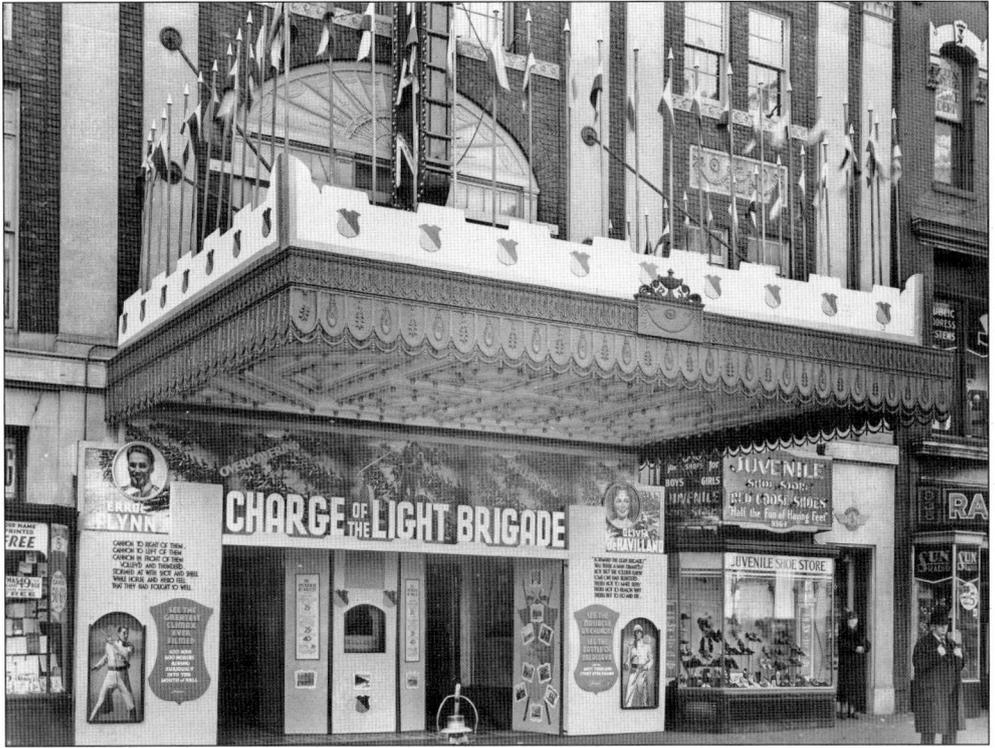

Along with the Columbia and Palace, the Metropolitan Theater (932–936 F Street NW, 1918–1966) was one of the "Big Three" theaters on F Street. It was designed by Reginald W. Geare and was the flagship of Crandall Theaters when it opened. The first Vitaphone film in Washington, *Don Juan*, was shown at the Metropolitan in February 1927.

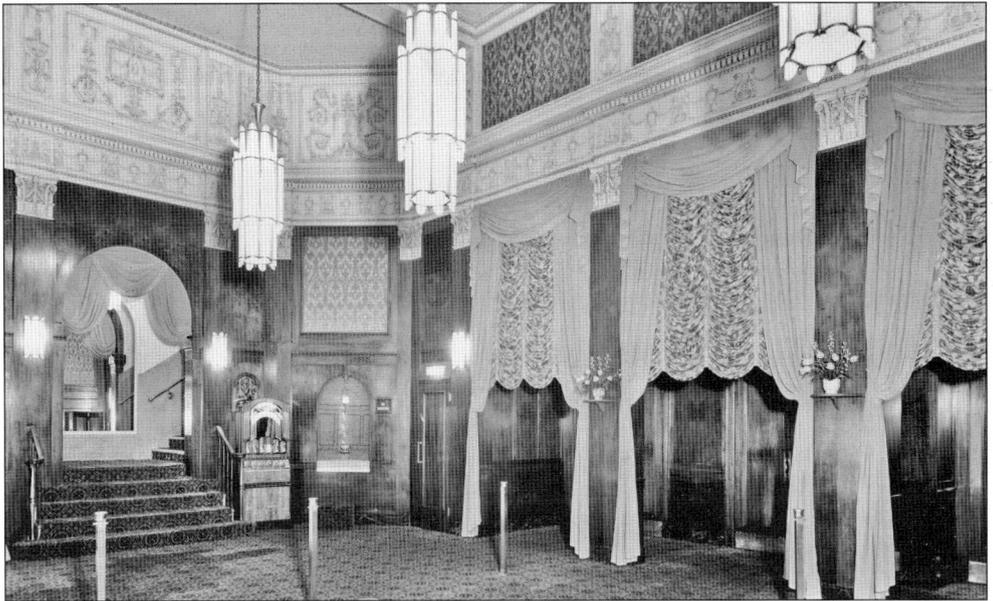

In the days before concession stands, candy machines, much like this one in the lobby of the Metropolitan, provided treats for theater patrons.

45

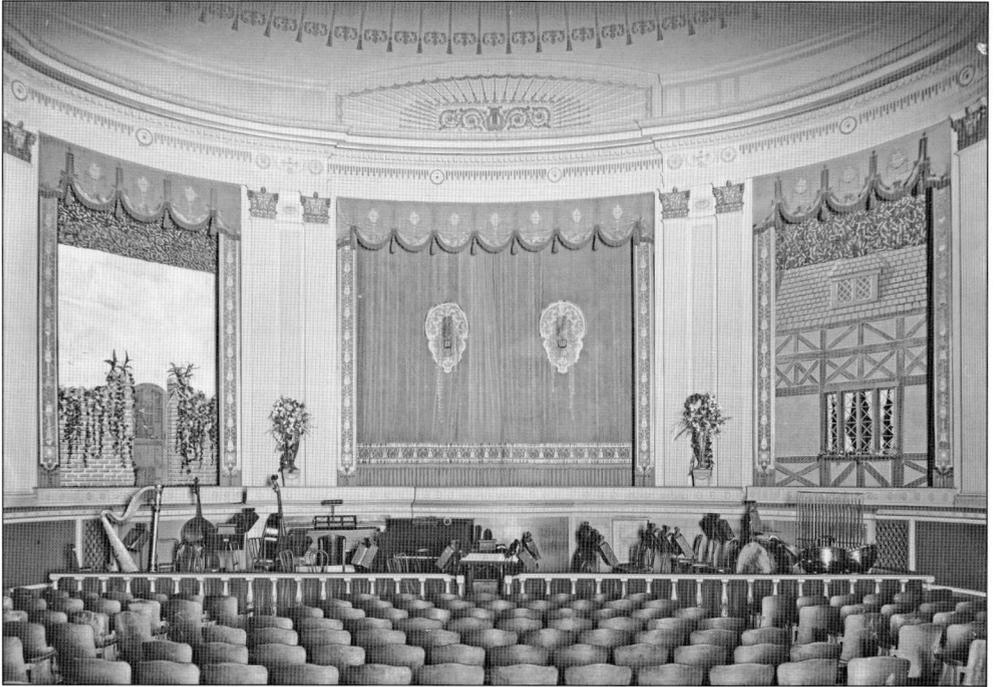

The Metropolitan had a large stage with an elegant curved proscenium and an orchestra. During the construction of the Metropolitan, part of the roof collapsed due to the weight of snow on it. Ironically, the same fate had befallen another Geare design, the Knickerbocker.

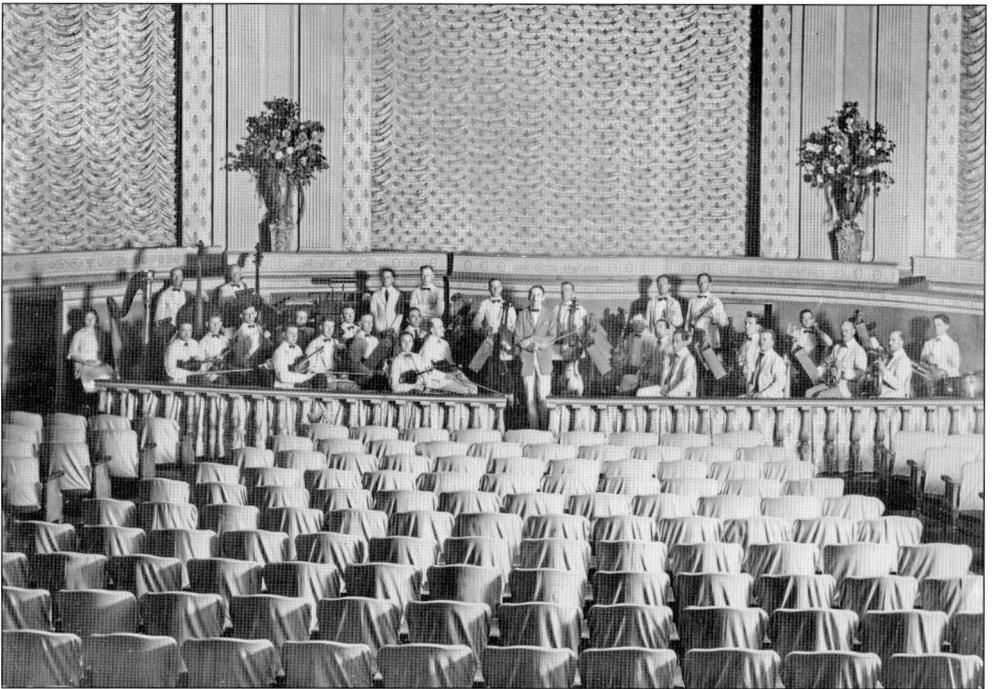

In the days before sound, theater orchestras, many of which rivaled large symphony orchestras, performed music to accompany films. This one at the Metropolitan was typical.

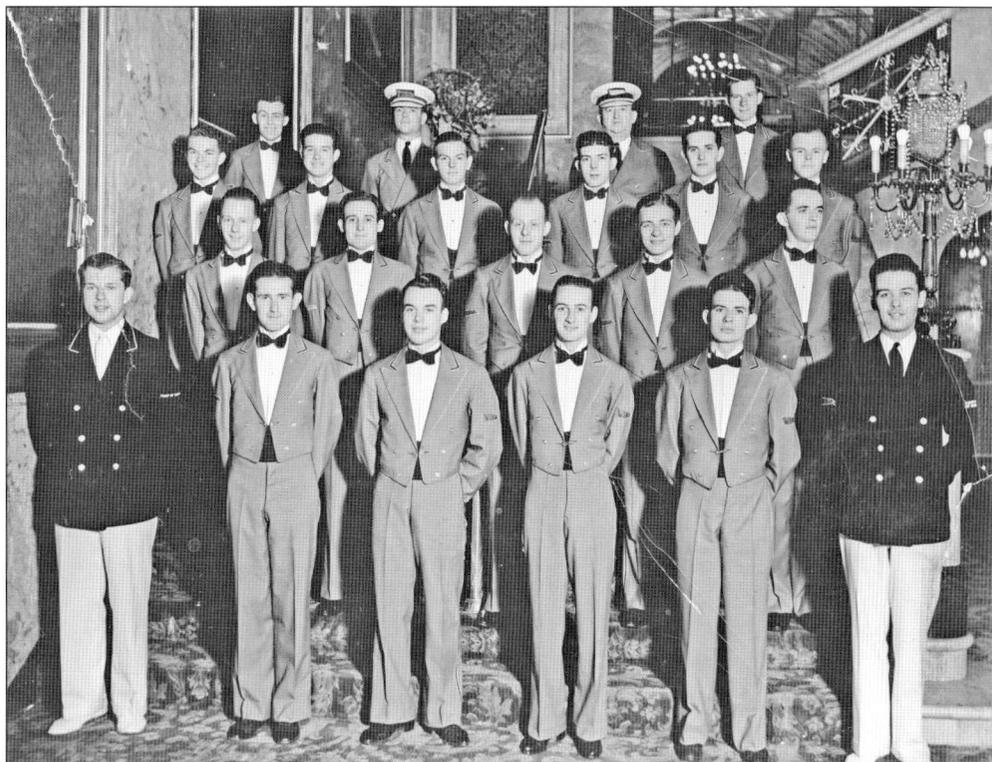

Big downtown theaters required large corps of ushers. Notice the several different uniforms in this photograph of ushers at the Metropolitan, probably in the 1930s or 1940s. (Courtesy of Sidney Hoffman.)

Orangelo "Angie" Ratto (in the dark suit) maintained a well-trained staff of ushers at the Palace Theater. Ushers in the first-run theaters were governed by strict, military-like rules to deal with any eventuality—from women's ruined nylons to a customer dying in the theater.

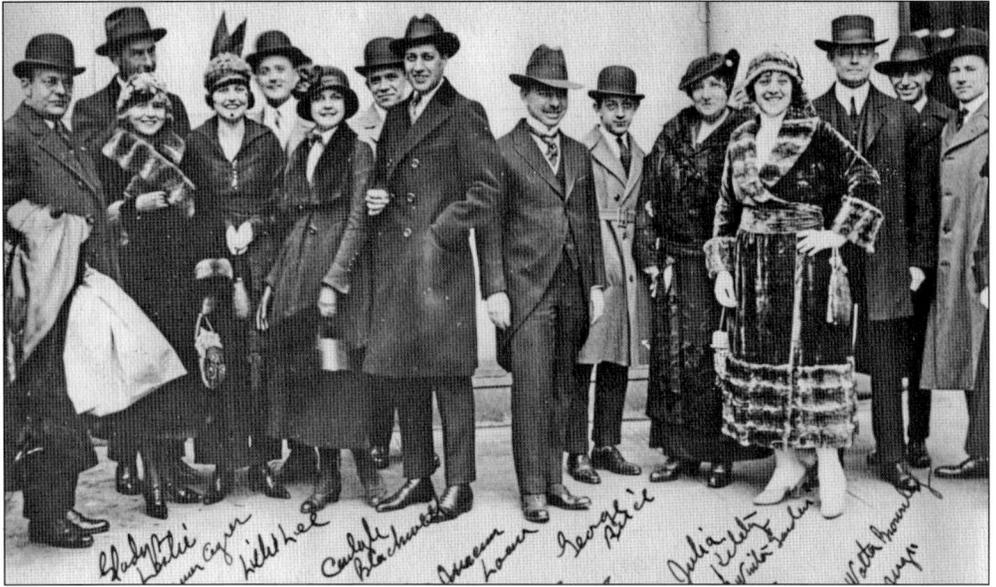

Marcus Loew poses with a group of Hollywood actors and actresses at the opening of his Palace Theater on November 5, 1918. With Loew is a group of Hollywood personalities including actresses Gladys Leslie and Agnes Ayres and actor-director Carlyle Blackwell.

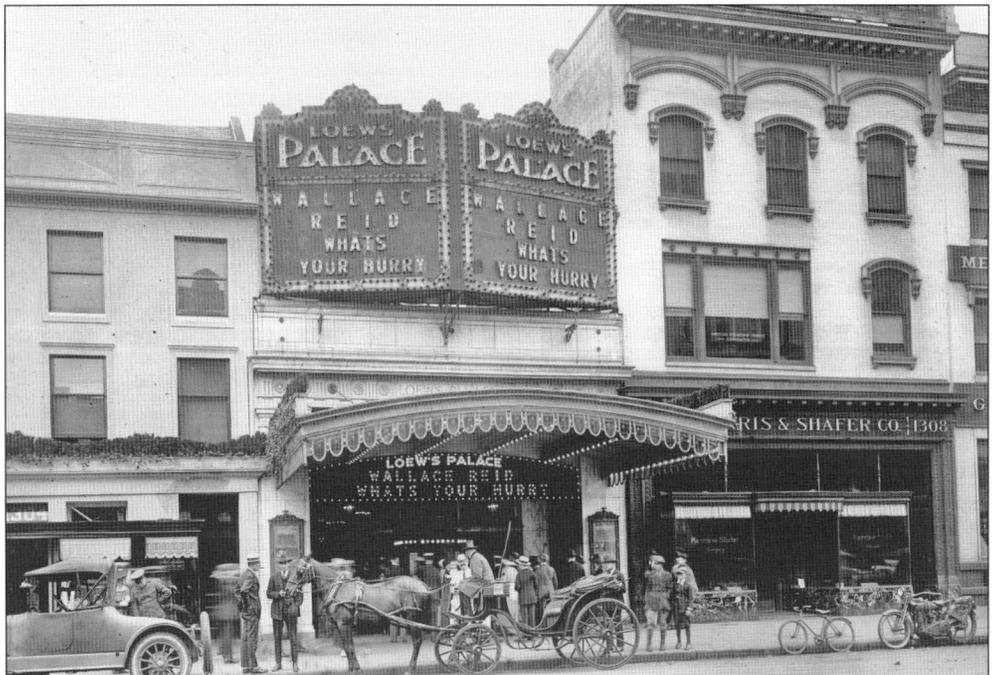

The Palace Theater (1306 F Street NW) was the first movie palace in Washington by only a few months. It was designed by Thomas W. Lamb for Marcus Loew and opened on November 4, 1918. Under manager Angie Ratto, who took over in 1921, it became one of the most popular downtown theaters in Washington. The Palace closed in 1978 and was demolished several years later. (Courtesy of the Library of Congress, Prints & Photographs Division, National Photo Company Collection, LC-F82-4757.)

The Palace was still a beautiful theater many years after it opened. The only blemish was an auditorium painted a dreadful shade of red that made it look like the devil could walk in at any moment.

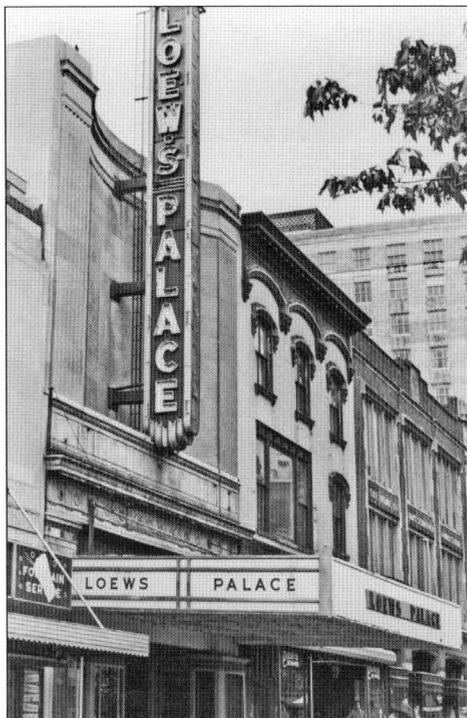

The Rialto (713–717 Ninth Street NW, 1918–1940) was an example of the right theater in the wrong place. It was built for Tom Moore to plans by Ewald Blanke and John J. Zink and seated about 2,000. Built too far from the entertainment center, the Rialto never did good business, despite early success. (Courtesy of Tom Moore.)

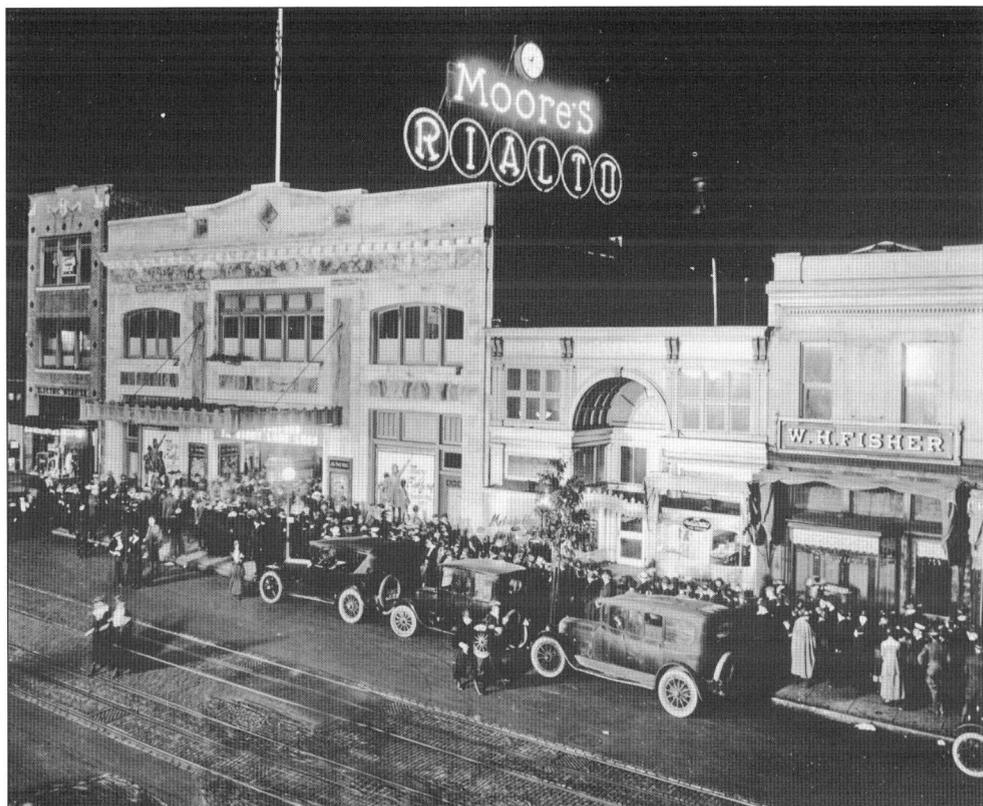

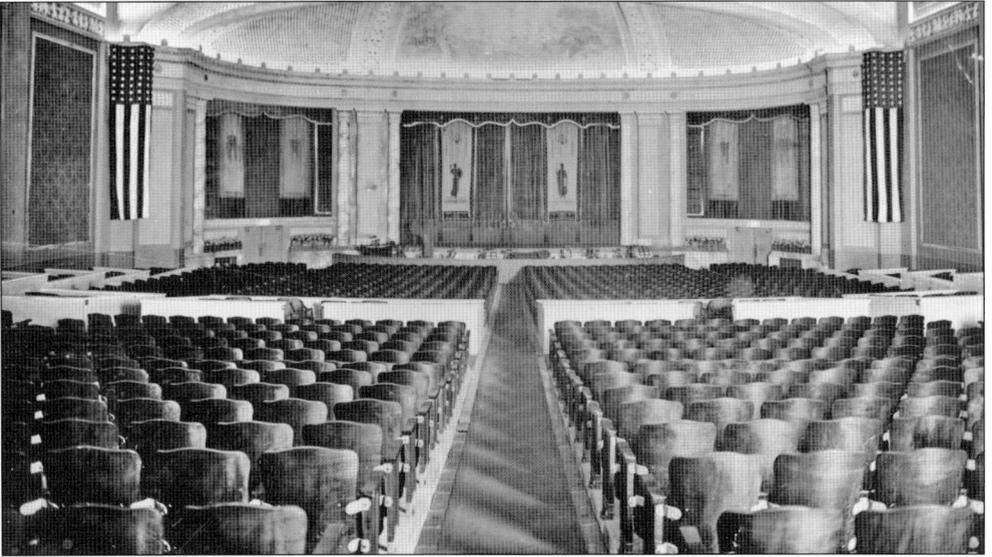

The concave proscenium of the Rialto is similar to that of the Metropolitan, although the theaters were designed by different architects. Unusual for a theater in Washington, the auditorium had a row of boxes just in front of the crossover aisle. (Courtesy of Tom Moore.)

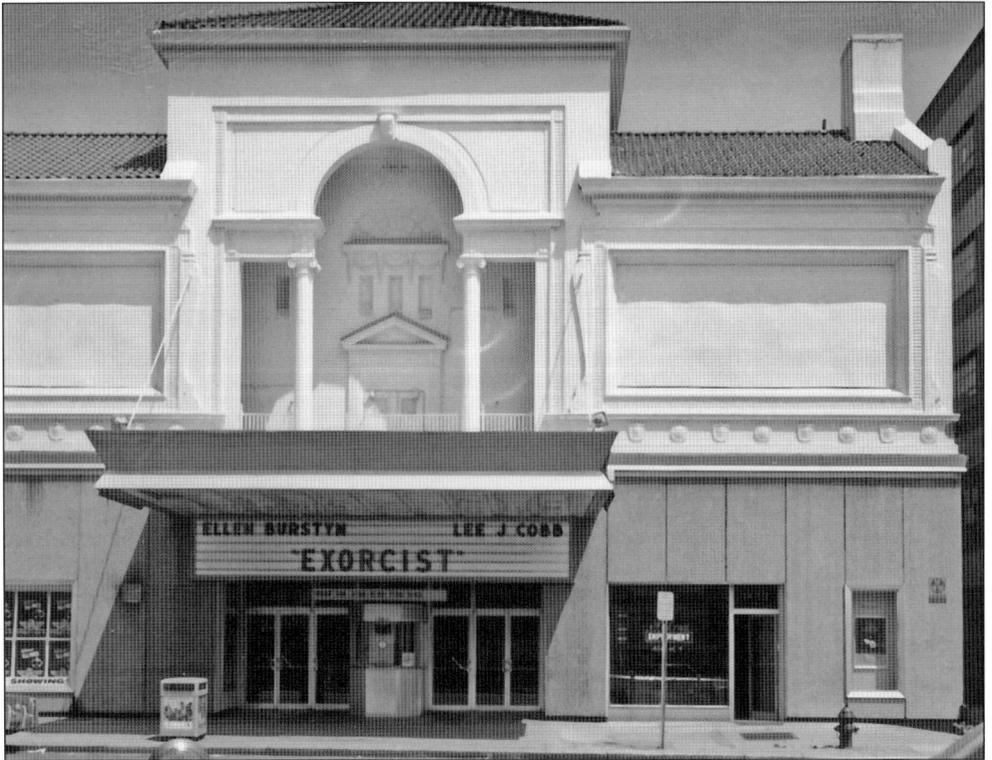

U Street NW was for many years the center of moviegoing for African Americans in Washington. The Republic, Lincoln, and Booker Theaters made up its Great White Way. Designed by Philip M. Julien, the Republic (1343–1349 U Street NW, 1921–1976) was one of the first theaters in town to have stadium seating.

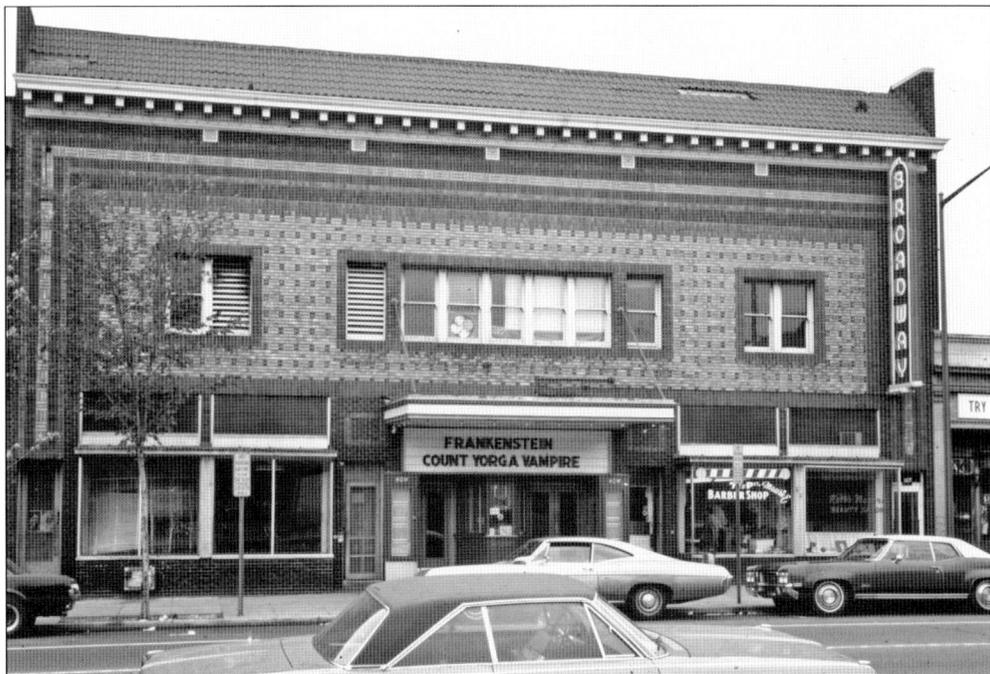

One of the few movie theaters built and owned by African Americans in Washington, the Broadway (1515 Seventh Street NW) was designed by Milburn, Heister & Company. It opened in 1921 and lasted until the 1970s. It was demolished about 10 years later.

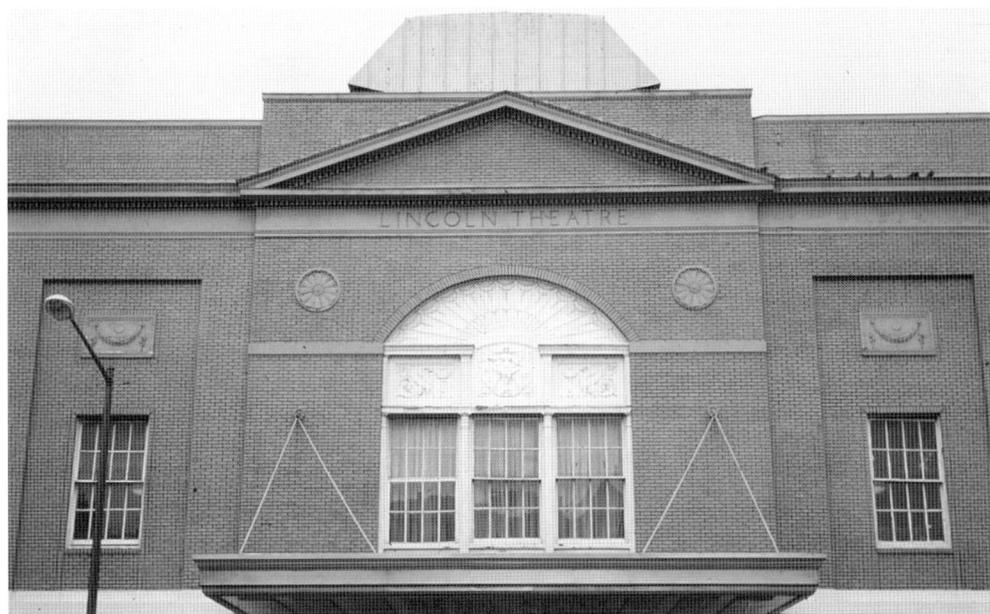

The Lincoln Theatre (1215 U Street NW, 1922–1983 and 1994–present) was the better known and larger of the two big theaters on U Street. It could hold 1,500 people, compared to the Republic's 1,300. The Lincoln was also one of the few local theaters to be preserved. After being closed for more than 10 years, it was rejuvenated and reopened as a performing arts theater and even briefly returned to exhibiting films, such as the 2011 thriller *Girl with the Dragon Tattoo*.

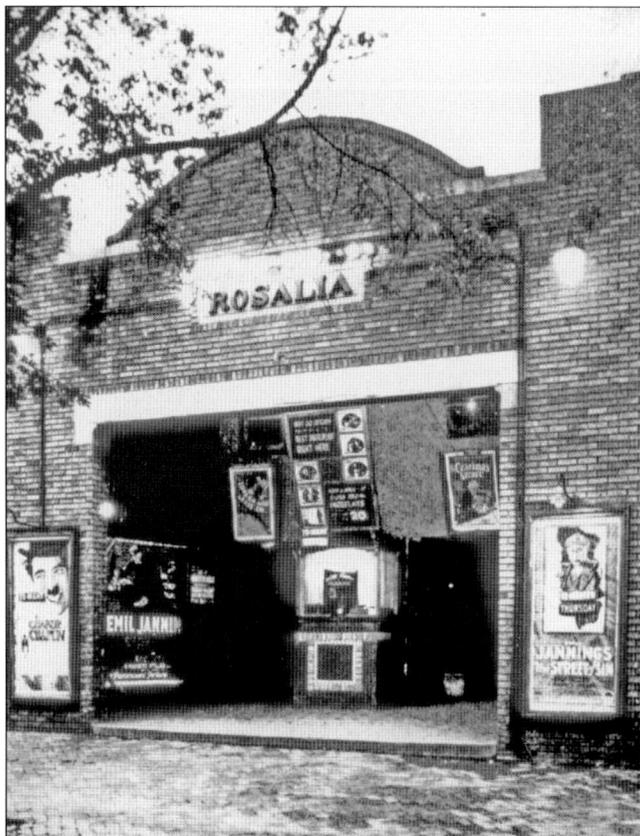

In addition to the African American theaters on U Street NW, several others were scattered about the city. The Rosalia (218–230 F Street SW, 1922–1951) was a small but well-known theater. Colloquially referred to as the "Rosa Lee," it was considered higher-class than the nearby Jewell Theater because it charged 20¢ as opposed to the Jewell's 15¢ admission.

Standing on high ground and looking like a medieval fortress, the Jesse Theater (3100 Eighteenth Street NE, 1927–c. 1990) had a long, checkered career. It was designed by George N. Bell for Jesse R. Sherwood, who named it after himself. In later years as the Stanton Art Theater, it showed X-rated movies.

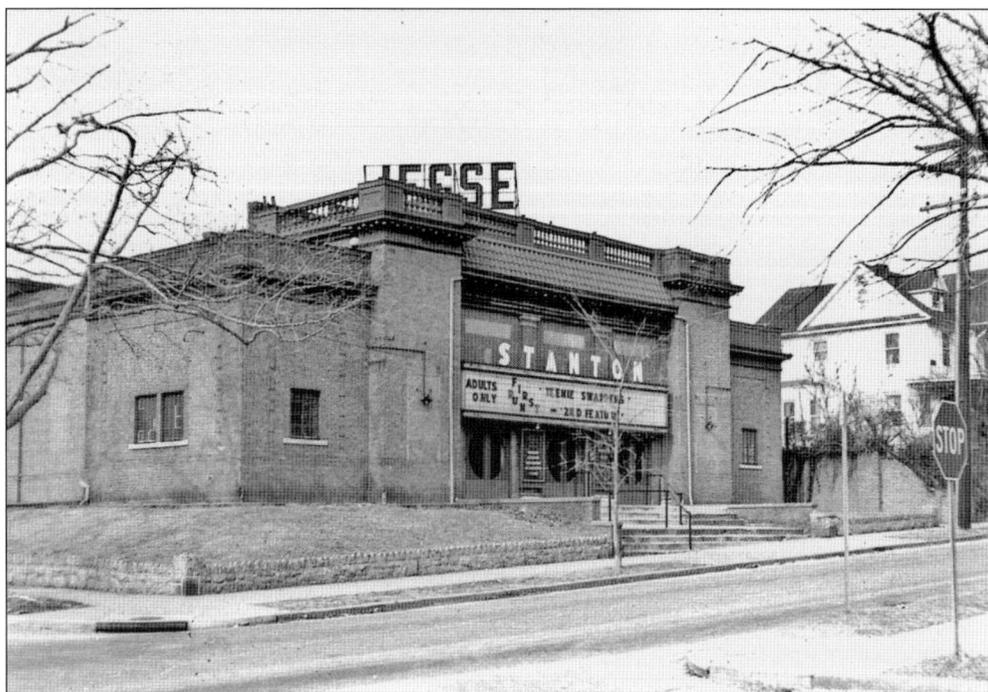

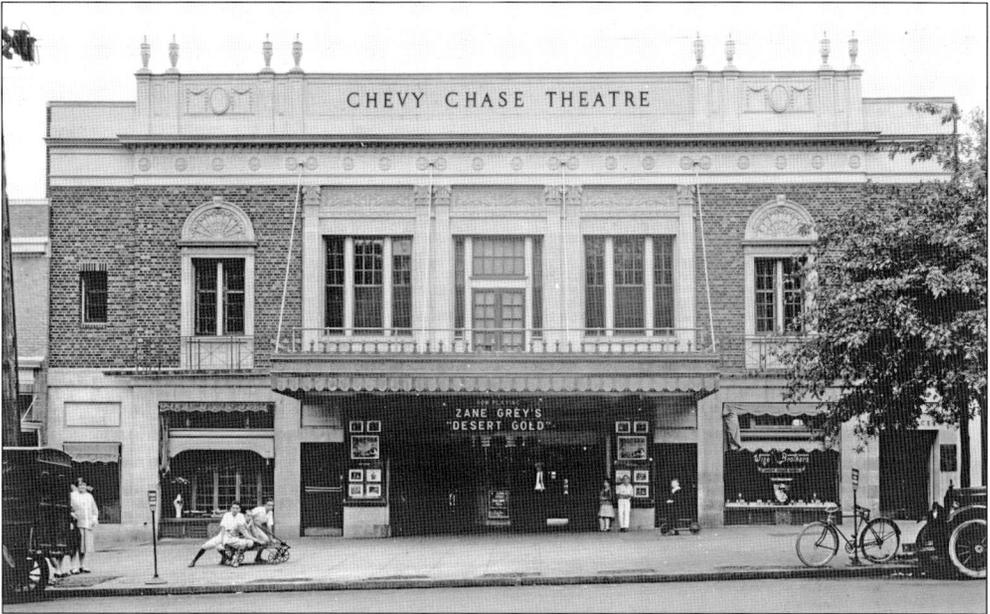

The Avalon (5612 Connecticut Avenue NW, 1922–present) opened as the Chevy Chase in 1922. Designed by Frank Upman and Percy C. Adams, it is one of the few movie theaters from the era to be preserved, thanks to the surrounding neighborhood's herculean efforts to save it. The theater's exterior and interior are nearly the same as when it opened.

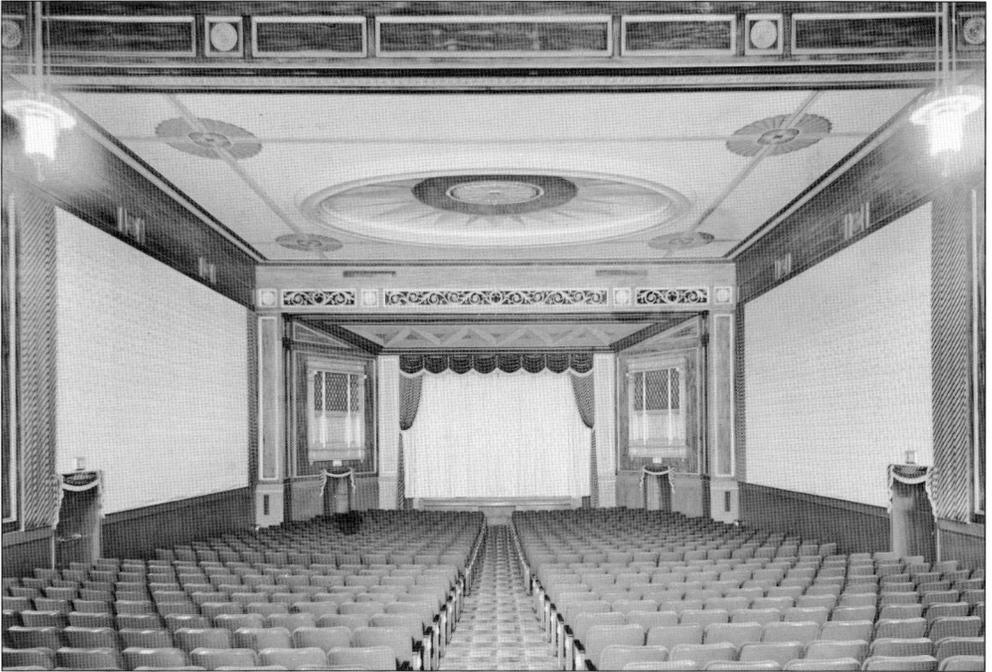

The Chevy Chase became the Avalon in 1929, after the Warner organization had acquired it. If a boy wore his Boy Scout uniform to the theater on Saturday afternoons, he could get in for free. The Pedas brothers remodeled the theater in 1985 and added a wonderful ceiling mural that paid homage to the movies.

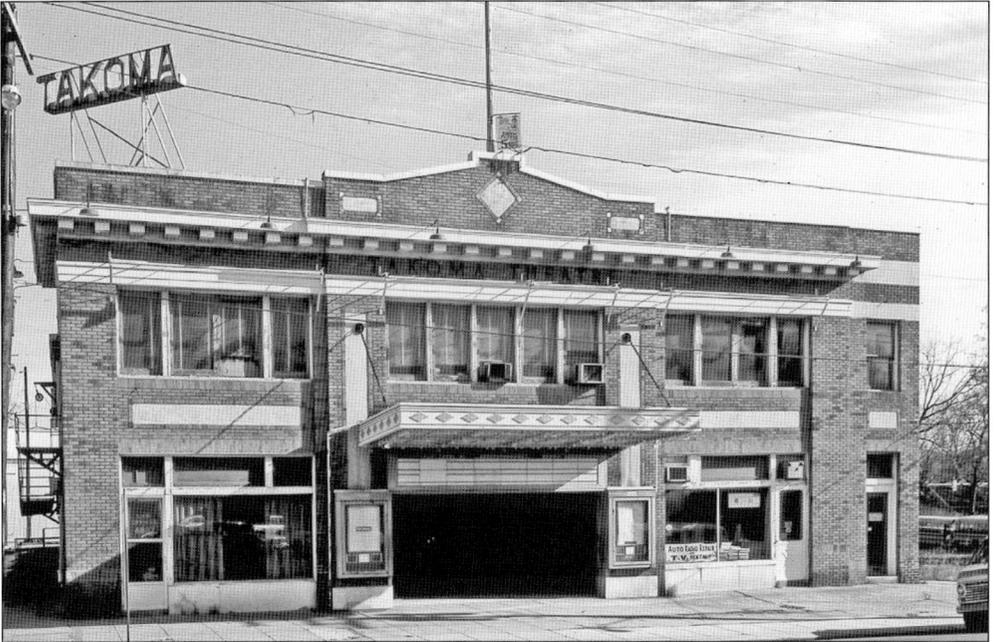

The Takoma Theater (6833 Fourth Street NW, 1923–c. 1980) was the first local neighborhood theater to install sound equipment. It was in almost pristine condition when it finally closed. A sad loss for the city, it is being turned into commercial space in 2018.

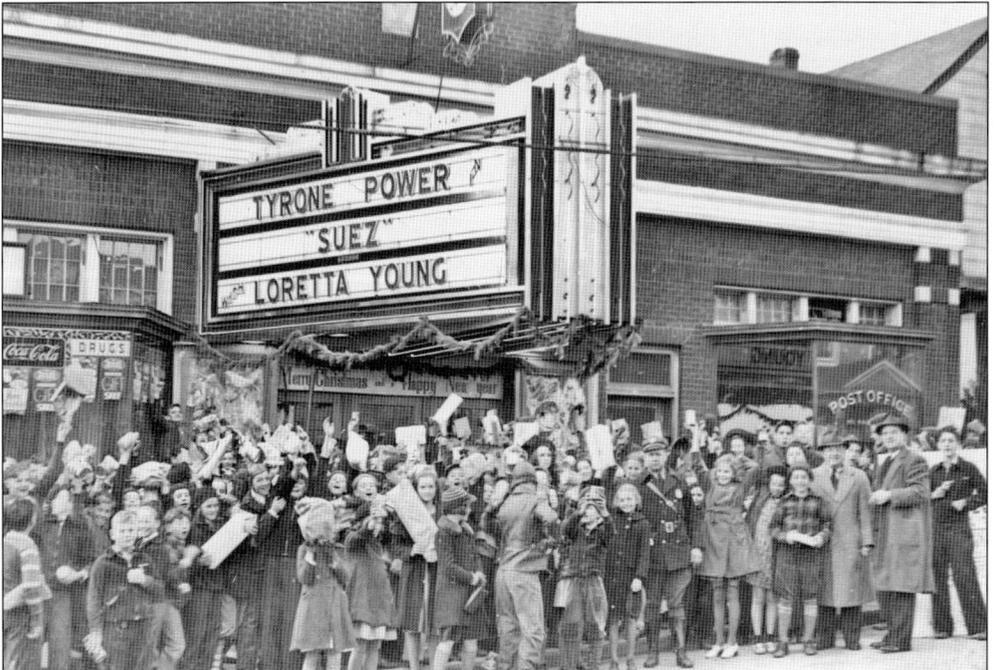

Many of the smaller suburban communities adjacent to Washington got movie theaters during the late 1910s and 1920s. The Cameo Theater (3820 Thirty-Fourth Street, Mount Rainier, Maryland, 1924–c. 1951) was located in a building that also housed Dr. William B. Spire's Pharmacy and a US Post Office. (Courtesy of Paul Sanchez.)

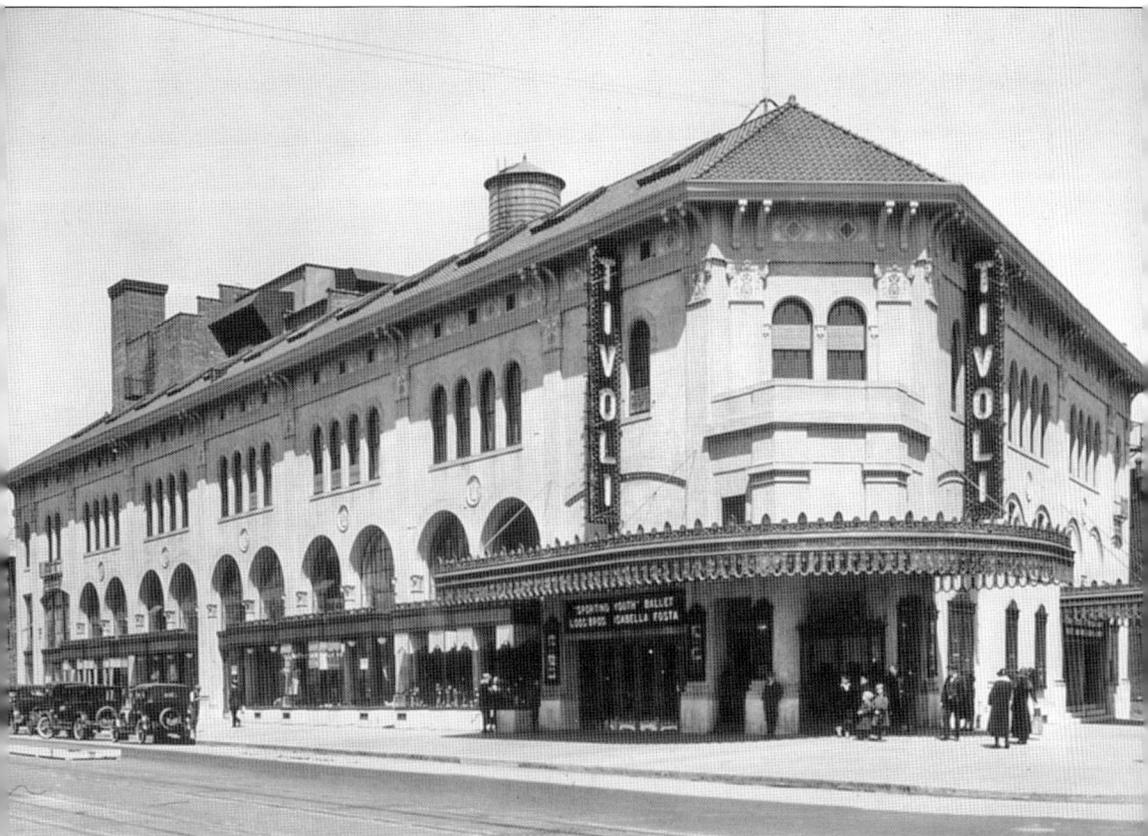

Harry Crandall's Tivoli Theater (3215 Fourteenth Street NW, 1924–1976) was a movie palace that compared favorably with the big first-run theaters on F Street. It was originally to be built according to plans by Reginald Geare, but Crandall brought in Thomas Lamb to plan the Tivoli after the disaster at Geare's Knickerbocker.

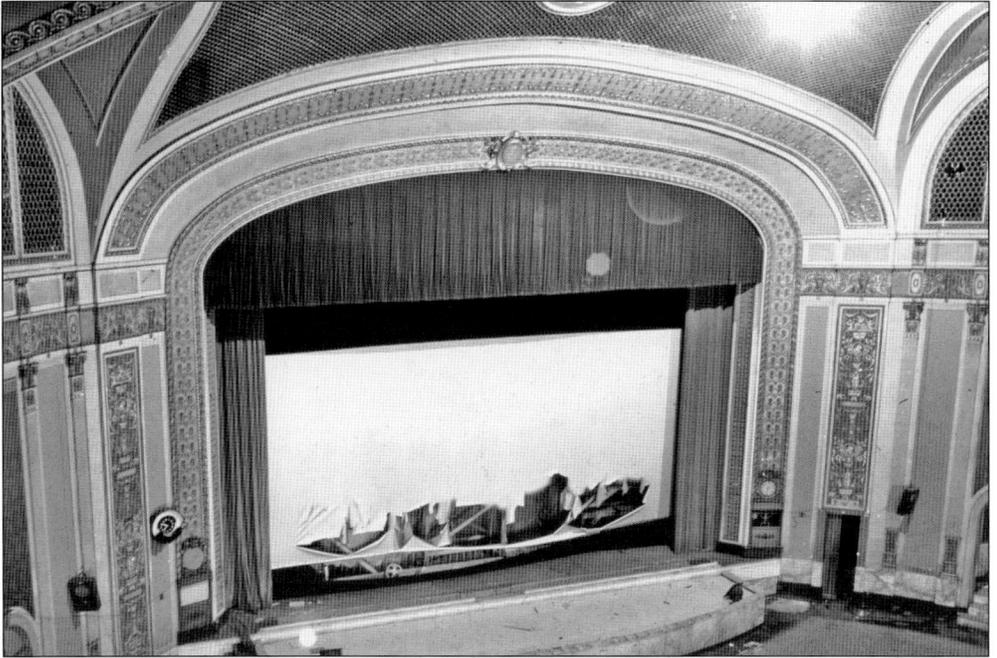

The Tivoli auditorium was one of the finest in Washington. The plaster decoration of the ceiling and proscenium dripped with gold leaf, making it probably the most ornate auditorium of any neighborhood theater in Washington.

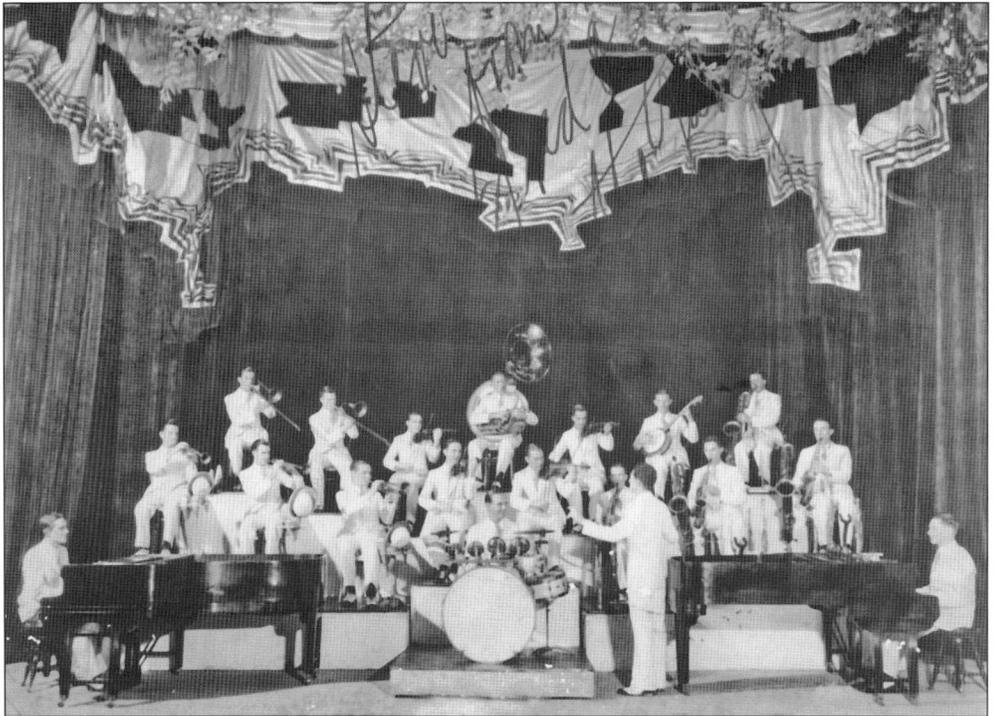

Fred Waring's orchestra played for the opening of the Tivoli, and the bandleader autographed this photograph to commemorate the occasion.

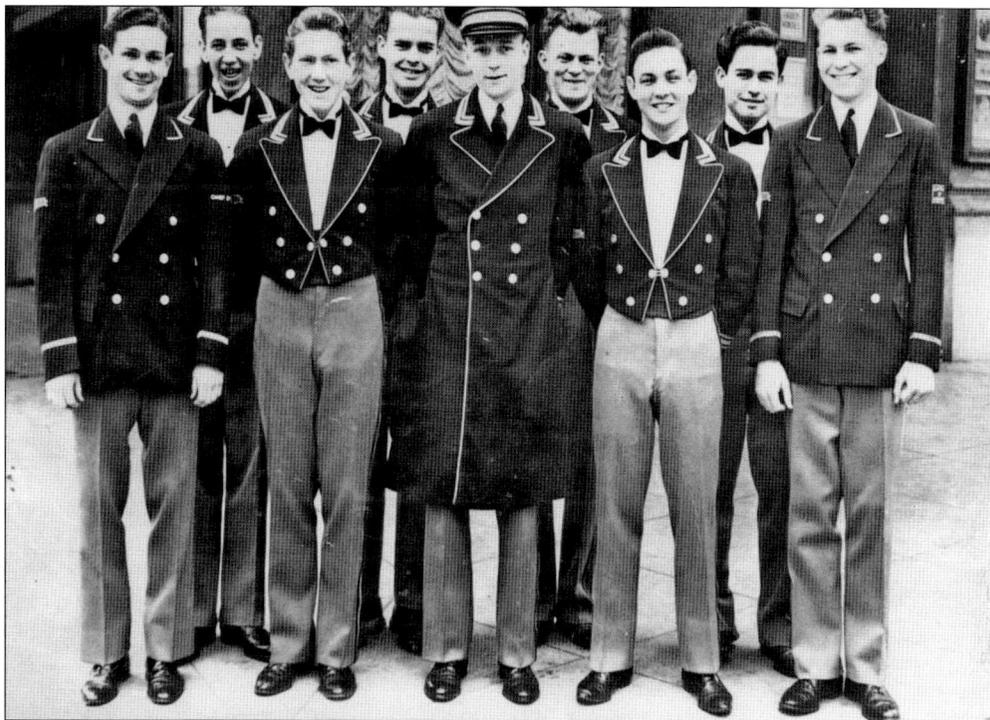

The Tivoli maintained a staff of ushers similar to and almost as large as a first-run theater. Here, they pose on the marble steps of the lobby.

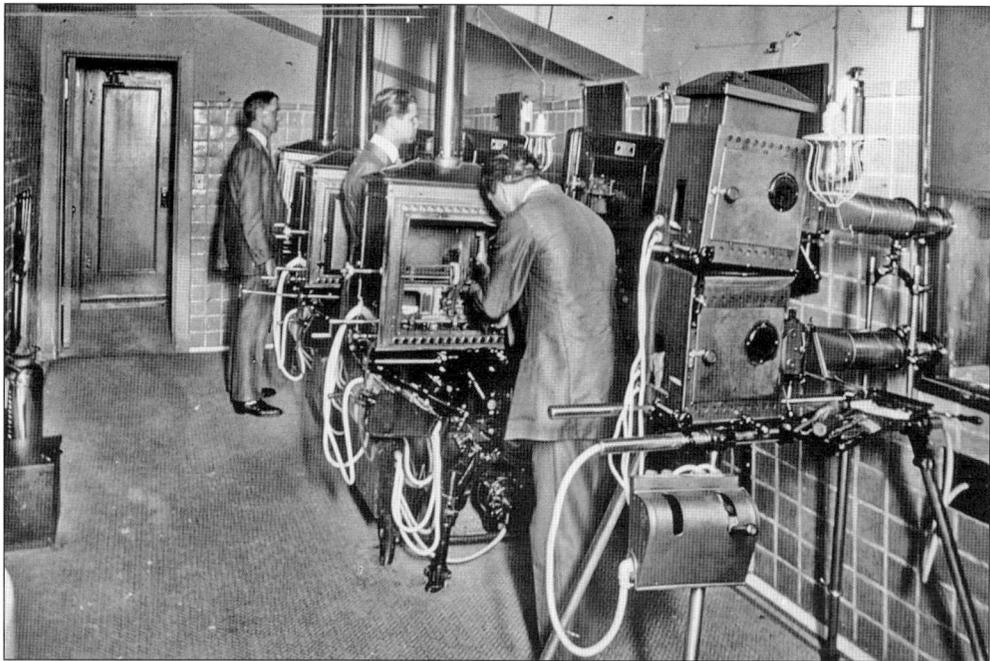

The Tivoli's projection booth had a window in the rear through which patrons in the mezzanine lounge could watch the projectionists at work. The lounge was lighted by cut-glass chandeliers and lined with panels of hardwood.

Designed for the Brylawski organization by C. Howard Crane and Kenneth Franzheim, the Earle Theater (501–515 Thirteenth Street NW, 1924–present) shows off its spectacular facade in 1944, a few years before Harry Warner changed its name to the Warner. Severe construction difficulties resulted in the theater being taken over by the Stanley Company before it opened in December 1924. The Earle seated just over 2,000 people and featured vaudeville and movies. After several years of generally forgettable films and stage shows, the theater was sold to the Kaempfer organization, which restored and reopened it for live theater in October 1992.

The beautiful, restrained Warner lobby is pictured at its opening in 1924. It has been restored to near original condition.

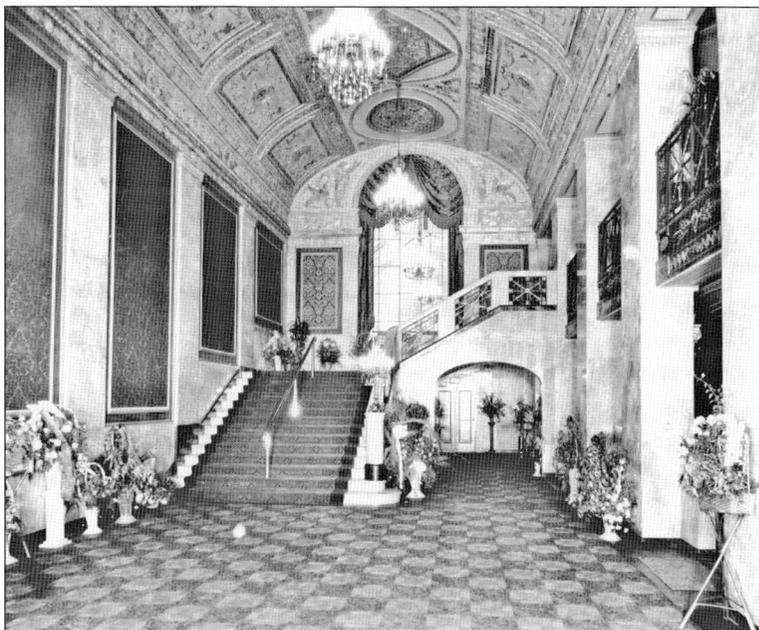

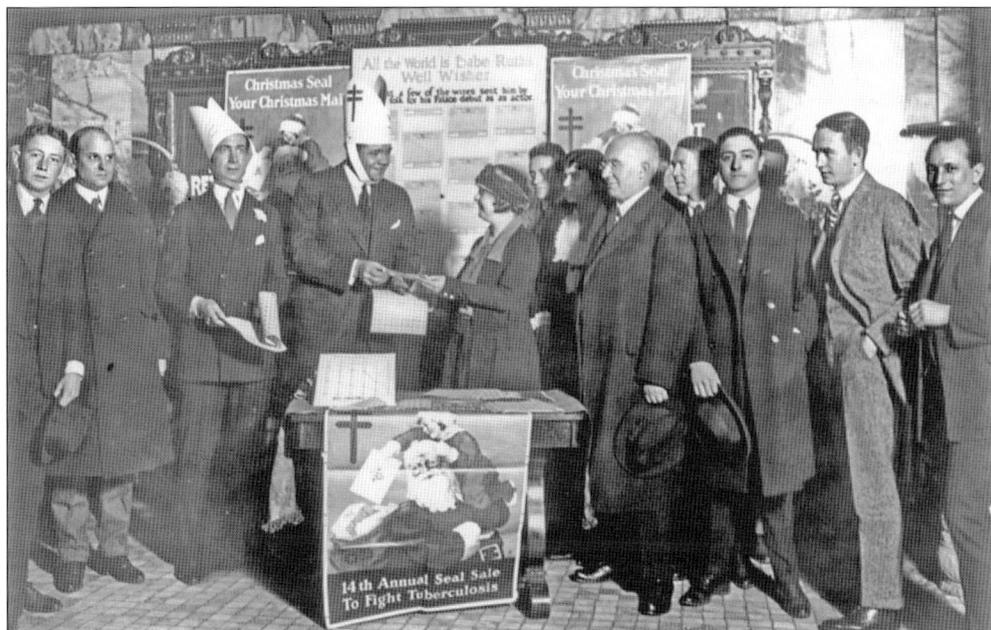

Babe Ruth showed what a good sport he was by wearing a silly hat and taking part in an event at Keith's Theatre in 1921 to raise money for the Tuberculosis Society. (Courtesy of the Library of Congress, Prints & Photographs Division, National Photo Company Collection, LOT 12293, v. 3, p. 14.)

The Washington Theatre Supply Company sold everything for the theater. It was one of the major suppliers for projectors, screens, and ticket machines for local theaters.

The interior of a theater supply store is pictured here. Rolls of tickets, exit signs, attraction boards, oils, and cleaning supplies were available at the store. (Courtesy of the Library of Congress, Prints & Photographs Division, National Photo Company Collection, LC-F82-6376.)

Designed by Chicago architects Rapp & Rapp, the 3,433-seat Fox (later and better known as the Capitol) opened in 1927 in the National Press Building (1328 F Street NW). It was the largest and arguably the most voluptuous movie theater in town. Its auditorium was described as being in the Louis XVI style, with draperies of gold and red velour copied from the French palaces at Versailles and Fontainebleau.

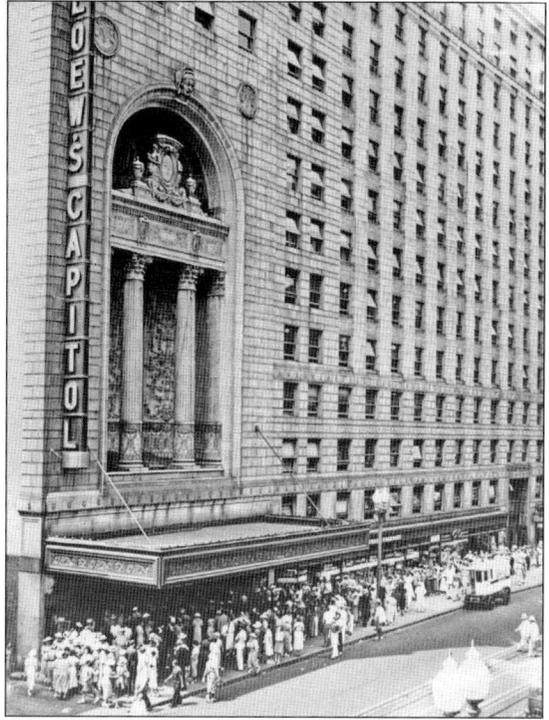

The only way to describe the Capitol lobby is grand. No expense was spared to make movie palaces into sumptuous, ornate venues. Lobbies dripped imported marble, crystal chandeliers, exotic woods, and brass trim that turned commonplace areas into places of extravagance.

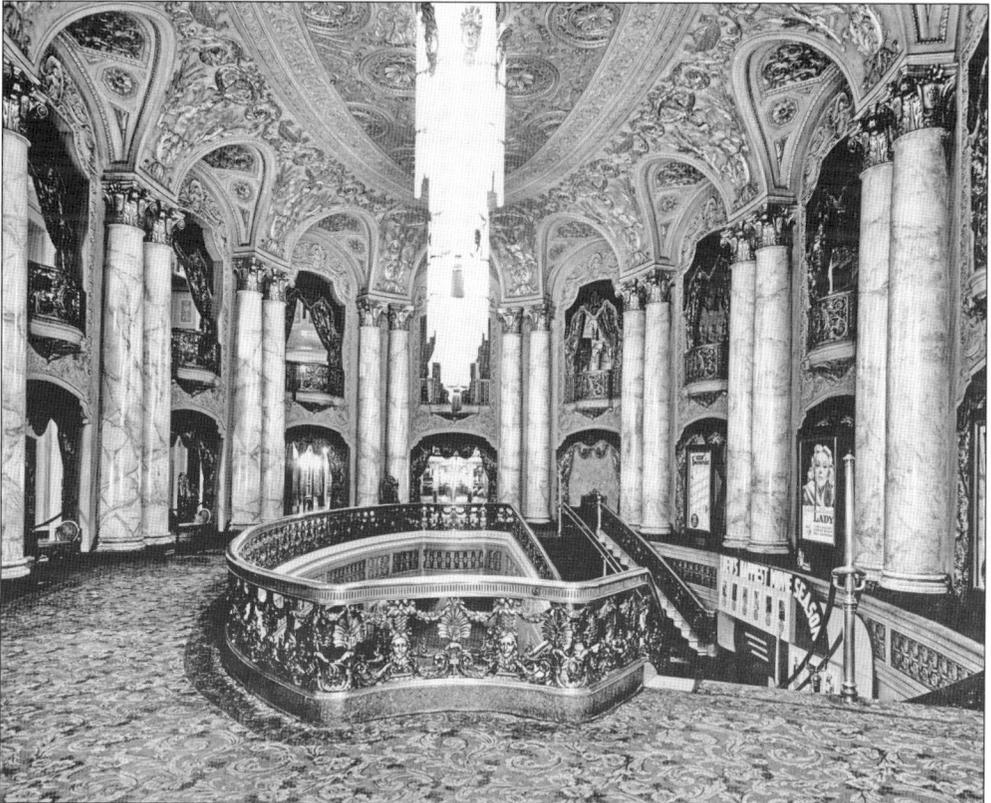

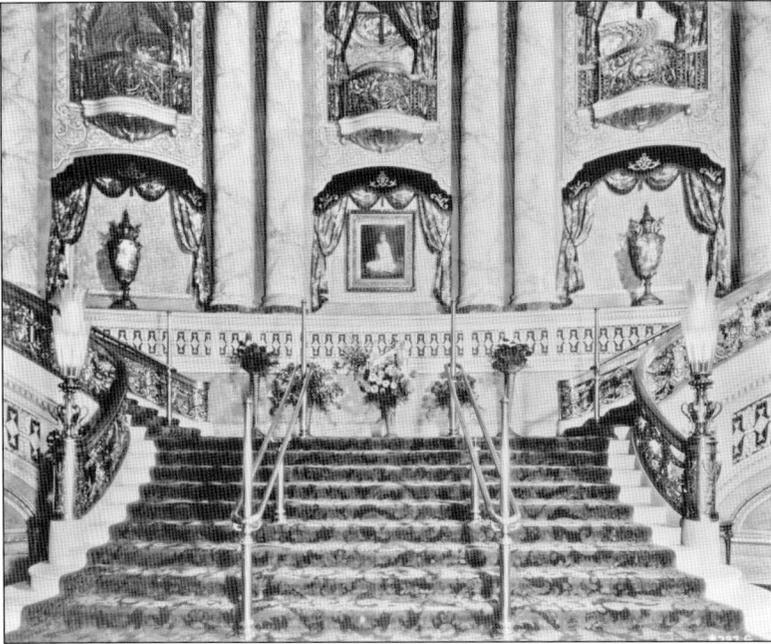

The main staircase at the Capitol, with real and fake antiques, was worthy of the great palaces of Europe. This great theater was gutted and the furnishings auctioned off in 1963.

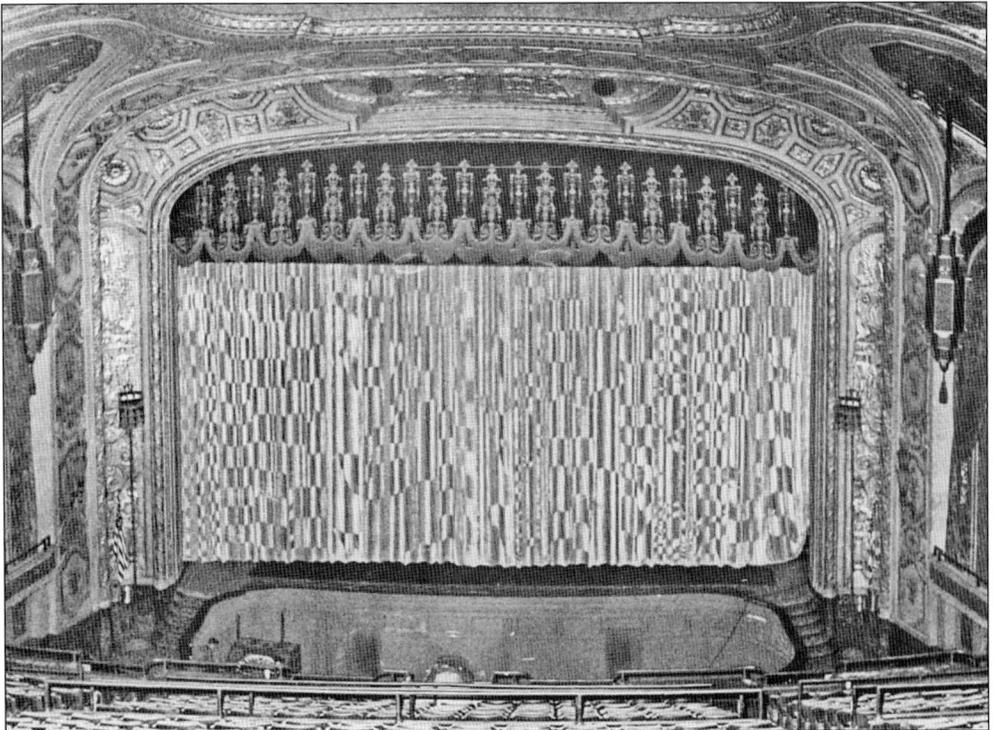

The huge stage of the Capitol hosted theatrical, vaudeville, ballet, and opera programs. Most of the major entertainers, like Red Skelton, Vaughn Monroe, Mickey Rooney, and Judy Garland, appeared here.

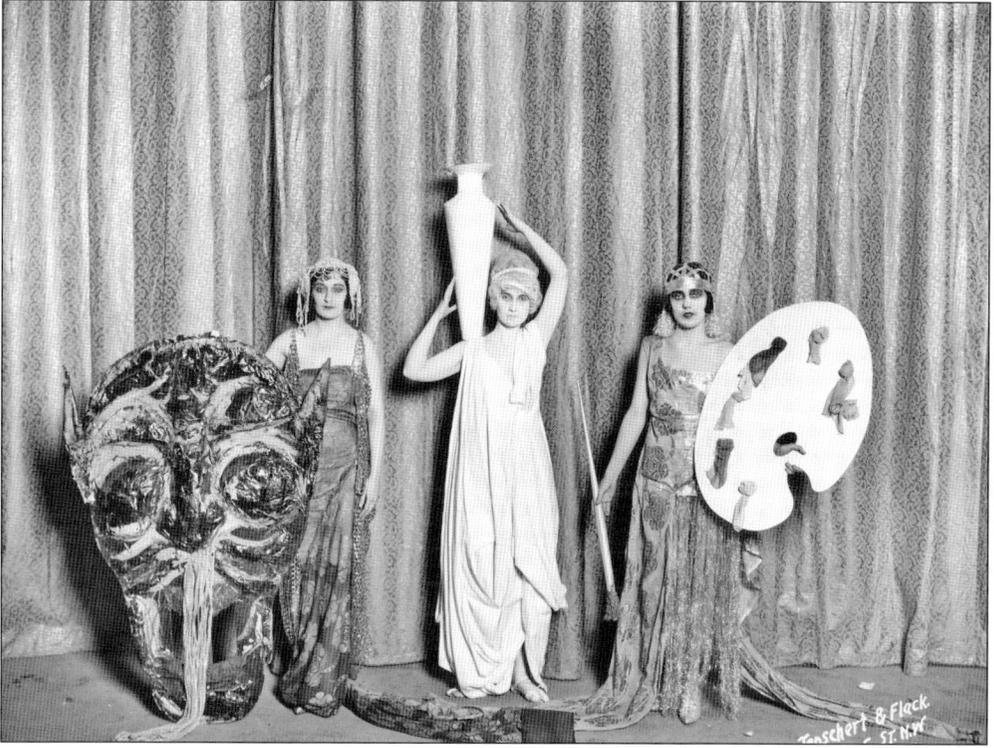

A stage show at the Tivoli often featured young women in rather unusual outfits.

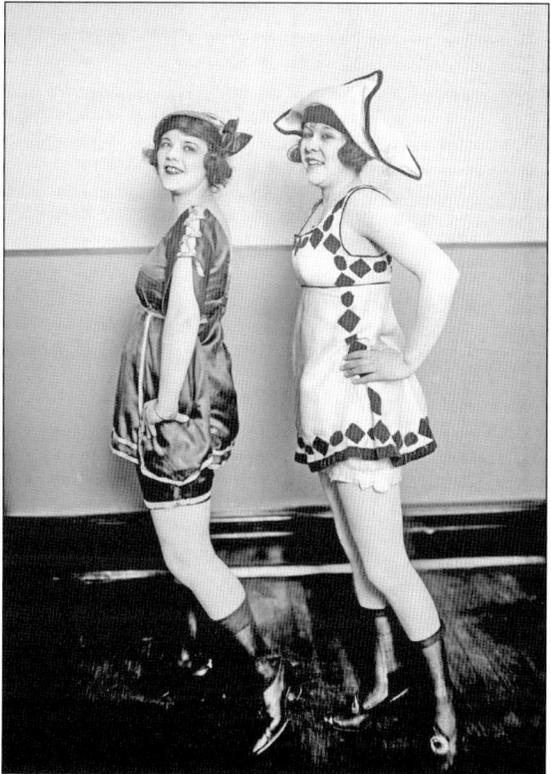

Local exhibitor Sidney Lust was a consummate showman who was constantly thinking up new ways to attract customers. Typical of his showmanship, he hired attractive young women—billed as the "Lust Girls"—to put on live shows at his theaters. These women probably graced the stage of his Leader Theater on Ninth Street NW. (Courtesy of the Library of Congress, Prints & Photographs Division, National Photo Company Collection, LC-F82-3780.)

The Metropolitan placed a huge ad in the *Washington Post* to announce the showing of its first sound movie. The sound was provided by the sound-on-disk Vitaphone system used by Warner Bros.

Five

A Theater Near You

After the stock market crash in 1929, there were few large downtown theaters built by the major studios, but local exhibitors took up the slack and built many modestly appealing theaters in suburban neighborhoods. In Washington, K-B Theaters, Sidney Lust, Lloyd Wineland, and Louis Bernheimer were active local exhibitors. The Warner organization opened the Penn, Calvert, Beverly, and Kennedy. K-B opened the Atlas and Apex. Wineland opened the Fairlawn and Congress; Lust opened the Milo, the Bethesda, and Marlboro; and Bernheimer opened the Newton and acquired several older theaters.

This was the great age of the neighborhood movie theater. Millions of children attended Saturday matinees that might feature an action film with Gene Autry, Roy Rogers, or Hopalong Cassidy, a serial, several cartoons, and maybe, if they were lucky, a comedy with the Three Stooges.

The building of movie theaters ceased entirely after 1941, although the War Department built hundreds of large wooden theaters on military bases throughout the country. Movie attendance increased, and some movie theaters stayed open to accommodate shift workers at defense plants.

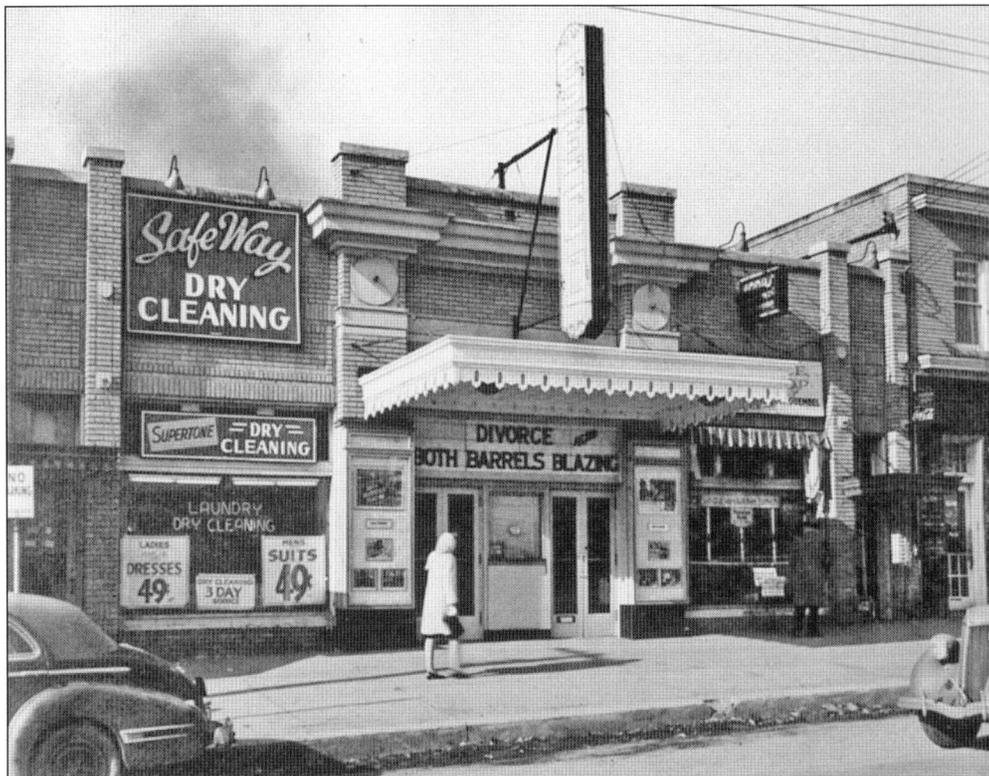

The Seco Theater (8242–8244 Georgia Avenue, Silver Spring, Maryland, 1927–1991) was one of the early theaters built in the growing suburbs of Washington. It was designed by Faulconer & Proctor. "Seco" stood for Southern Electric Company.

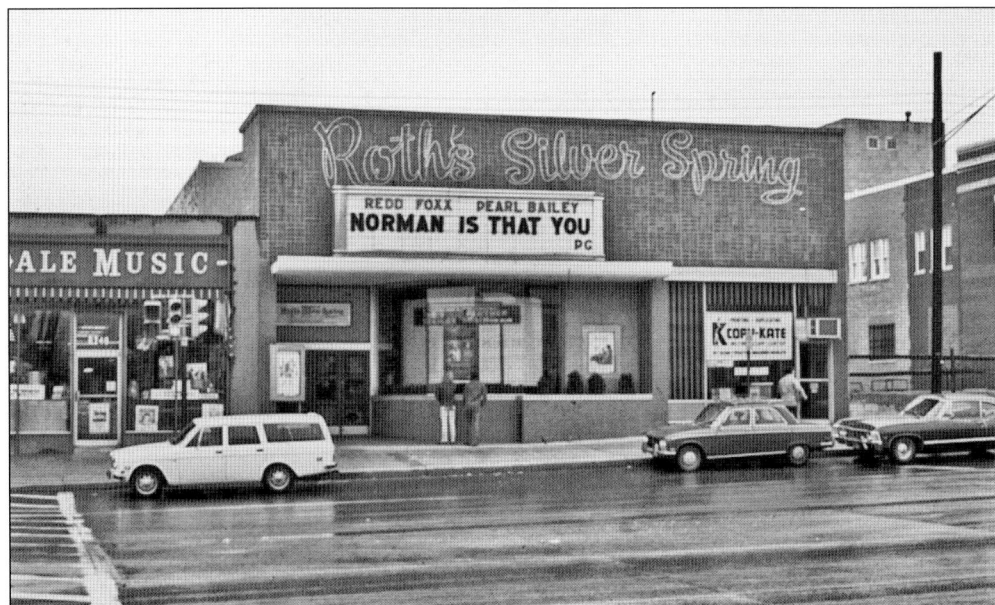

The Roth organization took over the Seco in 1953 and modernized it inside and out. It changed the name to Roth's Silver Spring and later the Silver Spring West.

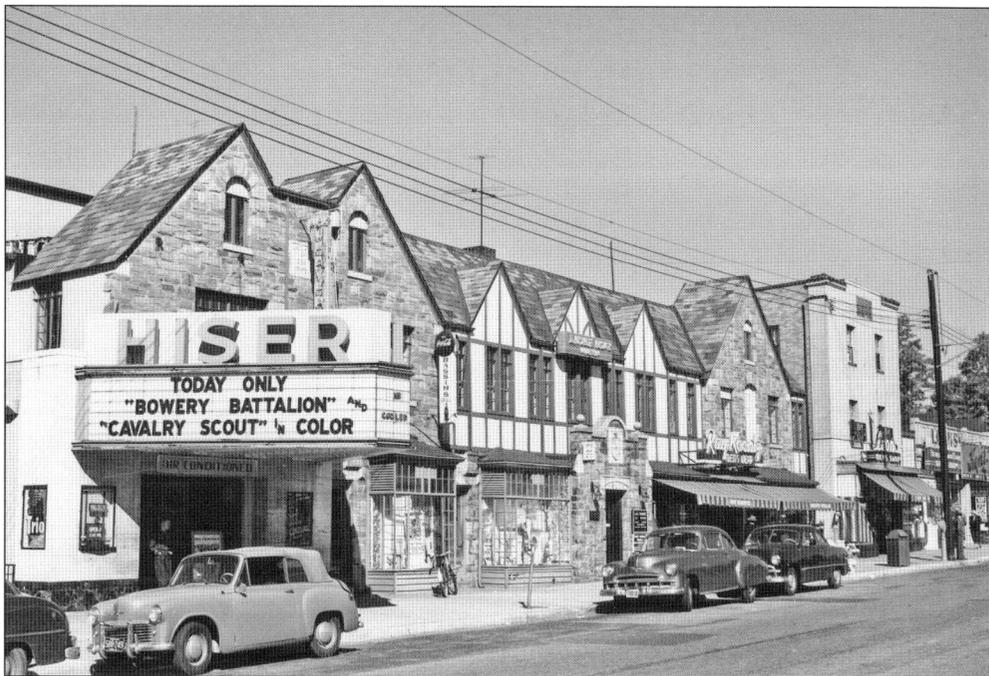

The Hiser Theater (6970/7414 Wisconsin Avenue, Bethesda, 1928–1977) opened as the Bethesda. It was the first movie theater in the Montgomery County suburb. J. Henry Hiser acquired it in 1939 and renamed it after himself. K-B changed the name again in 1960 and called it the Baronet. It was demolished to build the Bethesda Metro station. (Courtesy of the Library of Congress, Prints & Photographs Division, Joseph S. Allen Collection, LC-A7-3096.)

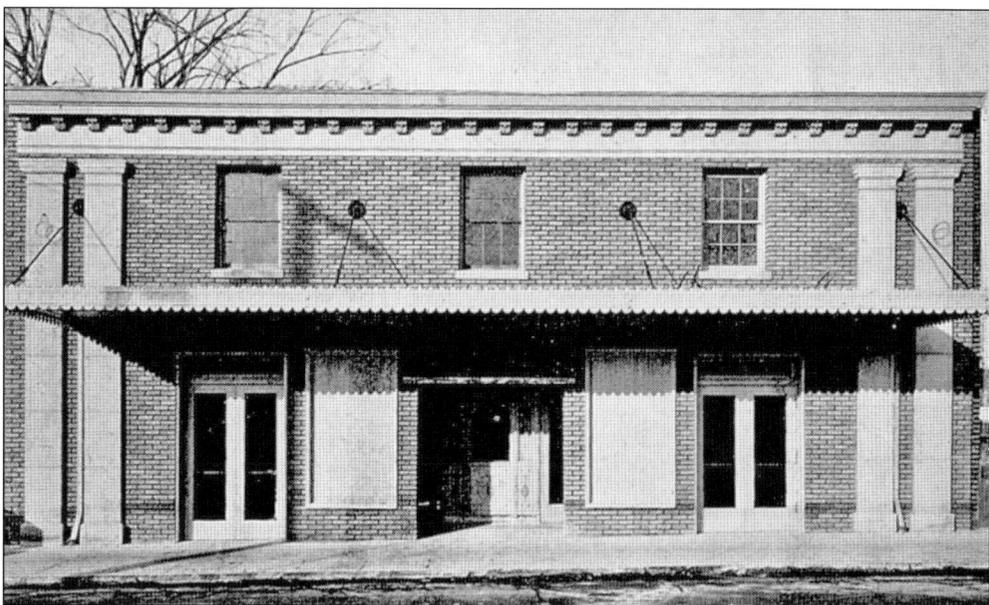

The Fairlawn (1342 Good Hope Road SE) was the first movie house built by Lloyd Wineland's Fairlawn Amusement Company. It was designed by Clarence L. Harding and seated 484 people. The Fairlawn opened in 1929 and lasted until 1951; it has since been demolished.

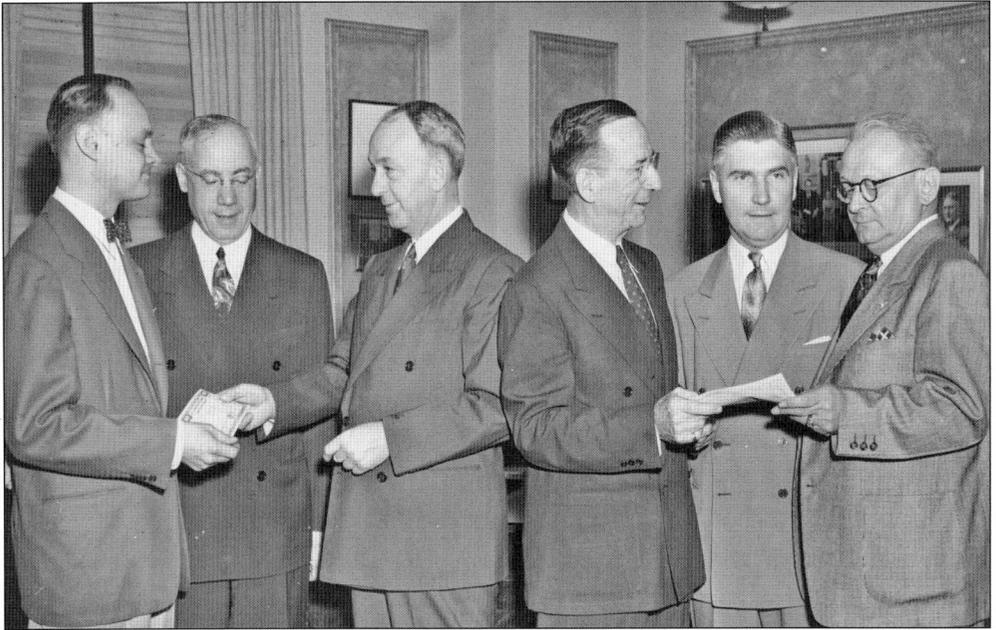

The Warner Bros. front office hands out savings bonds to managers. From left to right are Mark Keen (manager of Capitol Theater, Winchester), Nat Glasser, John Payette, Bob Smeltzer, Charles Grimes, and Charles McKinney (manager of Masonic Theater, Clifton Forge).

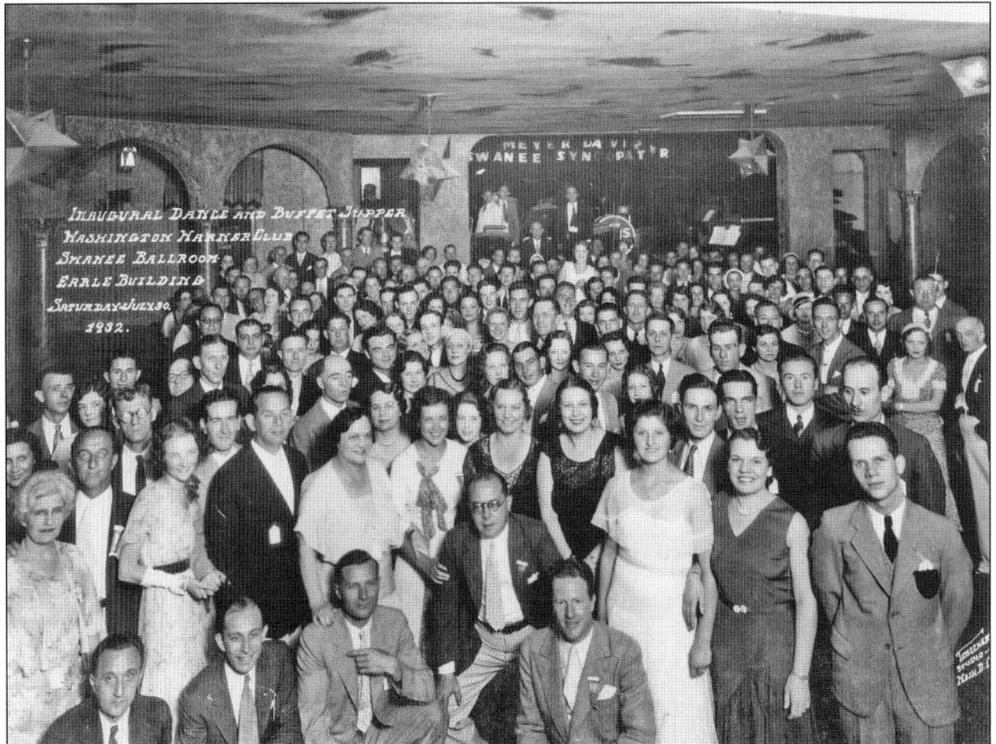

A dance and supper evening is held for Warner Bros. employees in July 1932. The first three men kneeling from left to right are Fulton Brylawski, Frank LaFalce, and George Crouch.

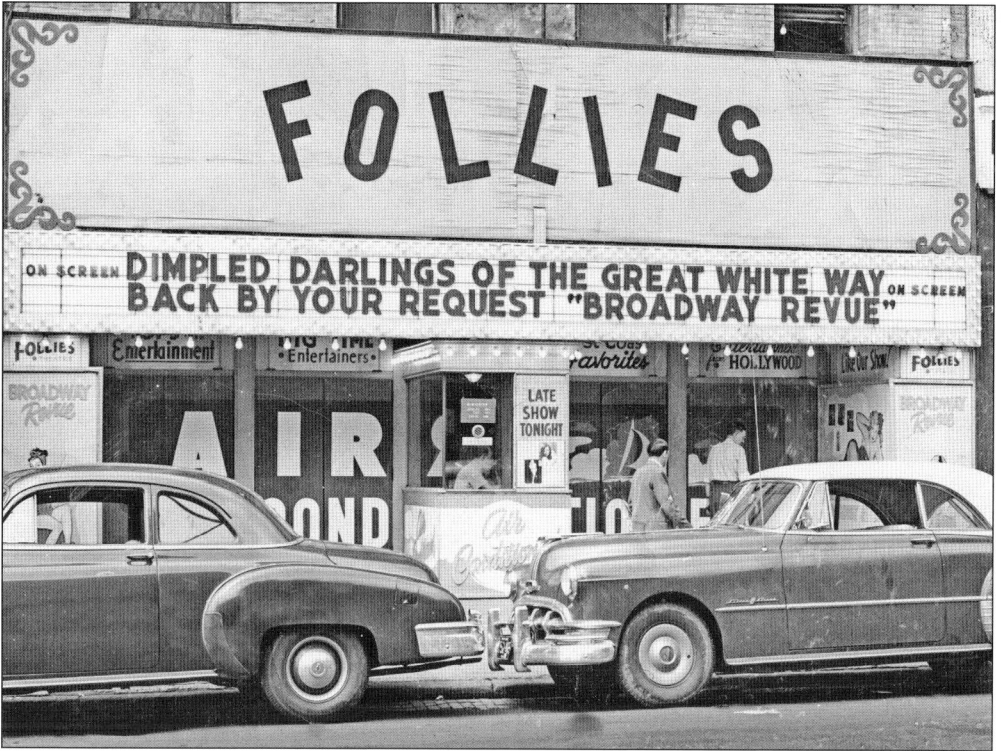

The Roosevelt (508 Ninth Street NW) opened in 1933, and in later years, it operated as the Follies, the Art, and the Gayety—the third Washington theater to use that name. In its final years in the 1980s, the Gayety hosted burlesque shows and X-rated films. The theater was torn down in 1987 to make way for office buildings. (Photograph by John Vachon, courtesy of the Library of Congress, Prints & Photographs Division, FSA/OWI Collection, LC-USF33-TO1-001065.)

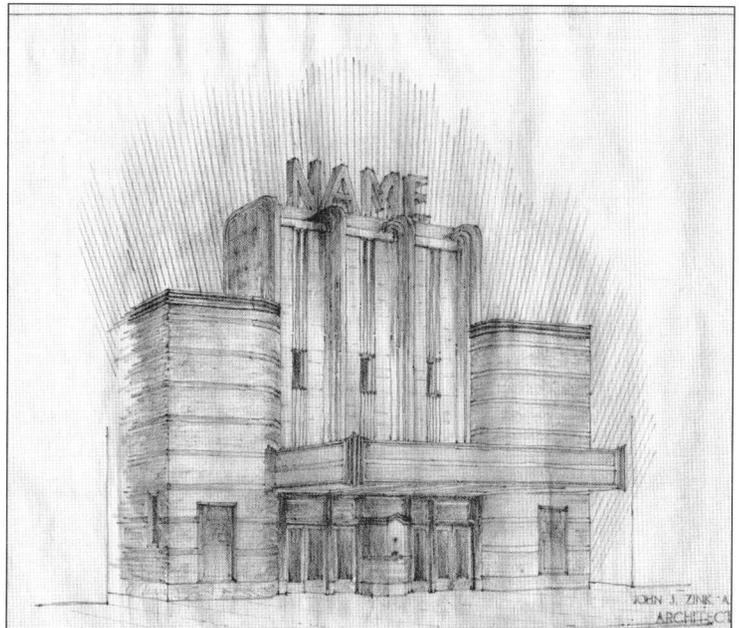

John J. Zink made this sketch for the front elevation of the Milo Theater (120 Commerce Lane, Rockville, Maryland, 1935–1969). The name was changed to the Villa in 1956.

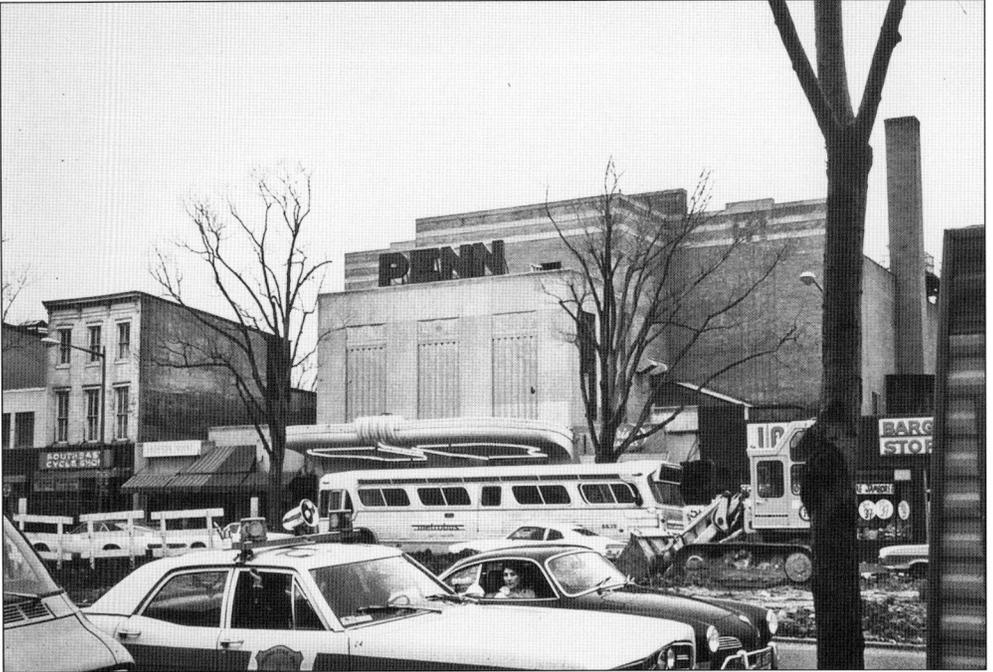

At 1,400 seats, the art deco Penn (644–650 Pennsylvania Avenue SE, 1935–1982) was the largest movie theater in Southeast Washington. It was probably John Eberson's finest design in the city. The auditorium has been demolished, but the front has been saved.

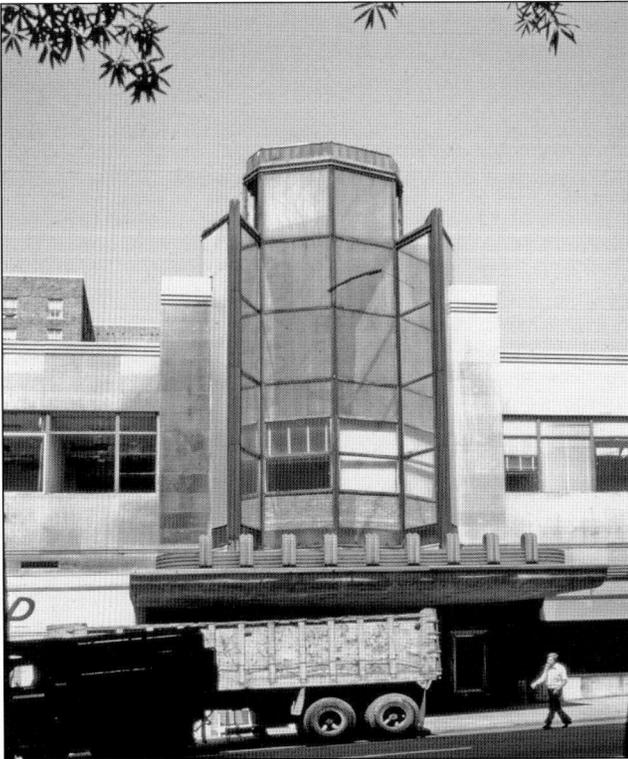

Washington's first and only newsreel theater, the Trans-Lux (738 Fourteenth Street NW, 1936–1974) was one of Thomas Lamb's art deco designs. It had unusual rear-screen projection and housed the Washington radio studios of the National Broadcasting Company. The Trans-Lux stopped featuring newsreels and became a first-run theater in 1948. It was torn down in 1974.

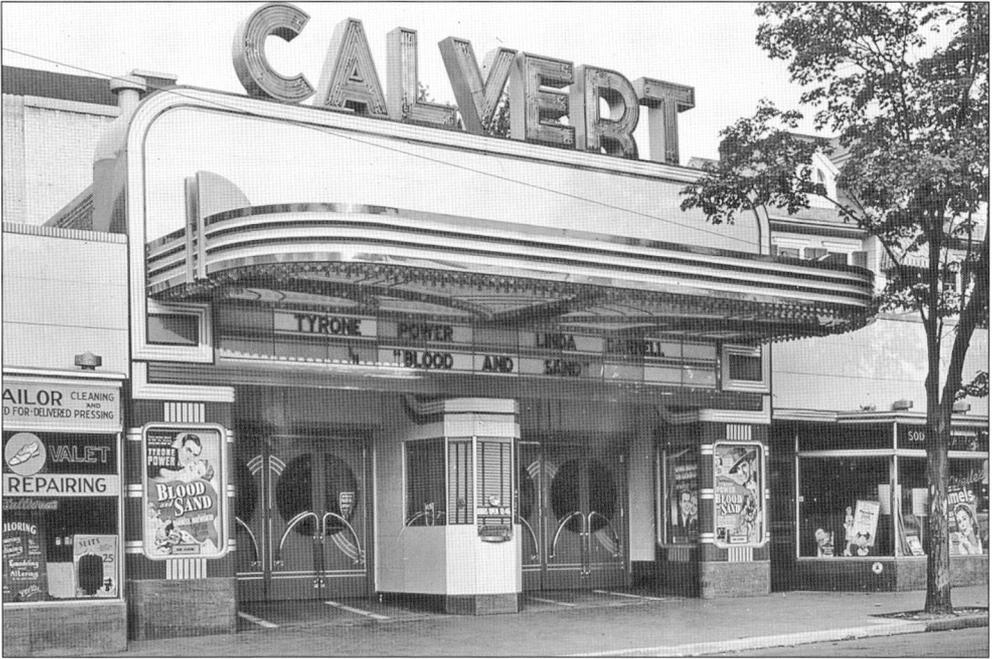

John Eberson designed the Calvert Theater (2324 Wisconsin Avenue NW) for Warner Bros. in 1937. Sadly, this art deco masterpiece lasted only 30 years. Festooned with yards of Vitrolite and polished aluminum, the Calvert started out as a neighborhood theater and later showed primarily foreign films. After the auditorium was demolished, part of the facade remained as the entrance to a parking lot, but today even that reminder is gone.

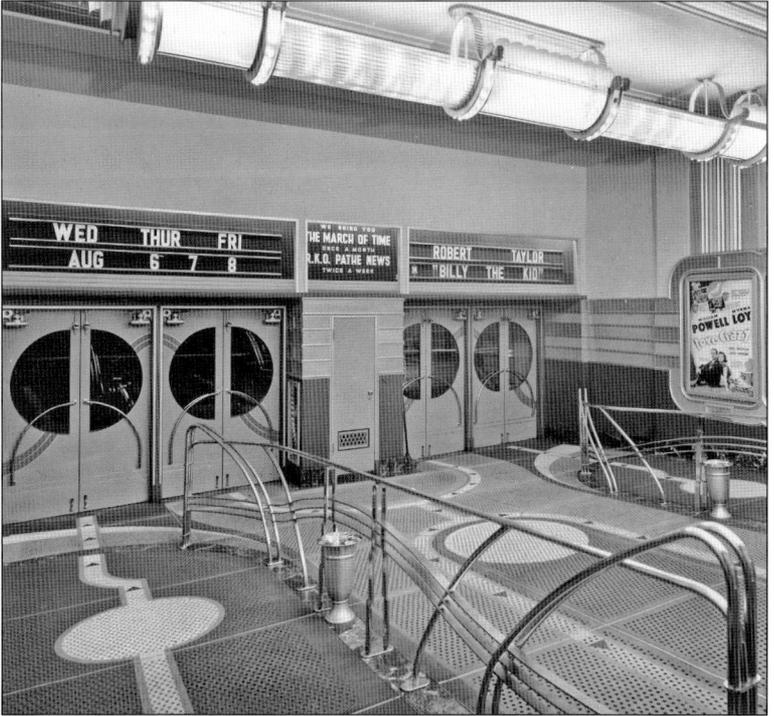

Entering the outer lobby of the Calvert Theater, patrons were met with a bright sea of polished metal, chrome, and aluminum.

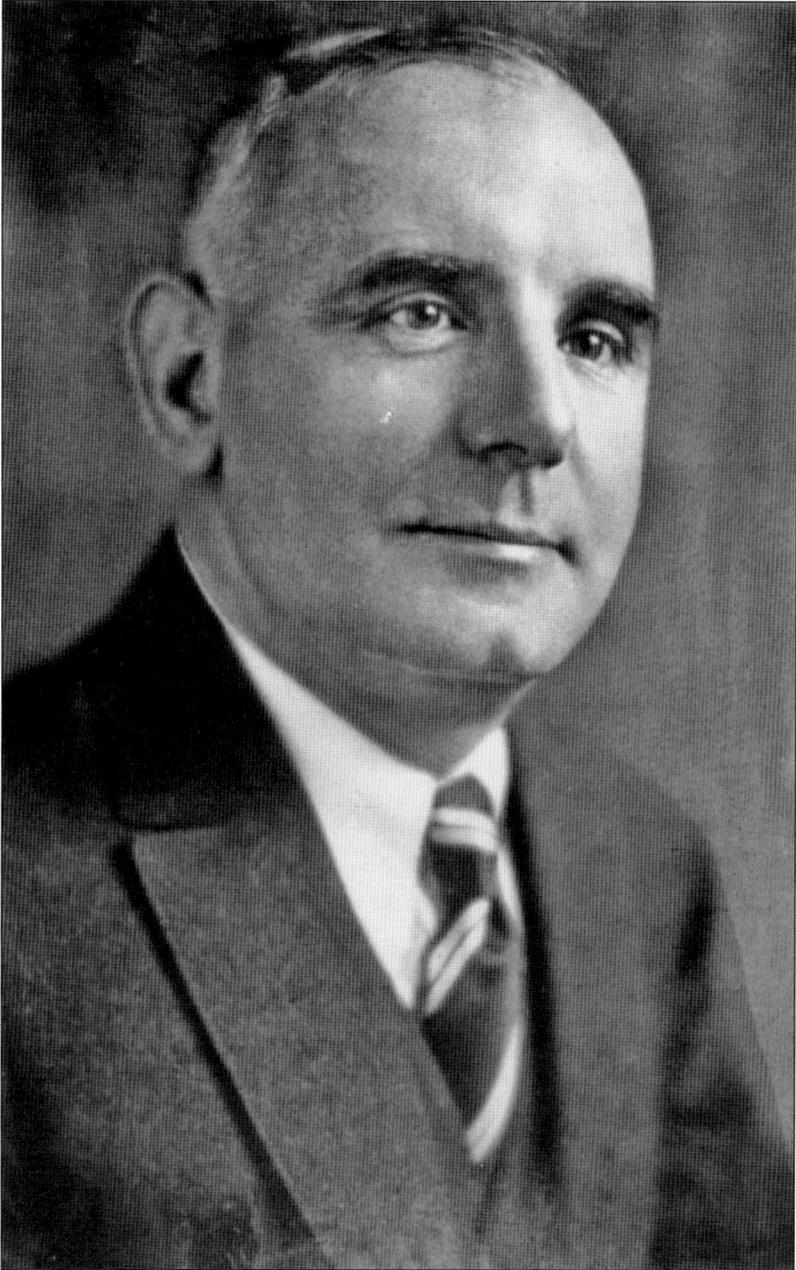

A lifelong area resident, Harry Crandall (1879–1937) became synonymous with movies in Washington. He was inspired to enter the movie business after attending a show at the Unique Theater and opened his first small theaters around 1910. By 1916, his theaters had a total of about 5,500 seats. Over the next 25 years, Crandall opened or acquired such theatres as the Joy, Avenue Grand, Metropolitan, Knickerbocker, Ambassador, and Tivoli. After the Knickerbocker disaster, he continued in the business but in 1926 merged with the Stanley organization to form the Stanley-Crandall circuit. He retired in 1929 after Warner Bros. acquired Stanley-Crandall. In 1937, unable to return to the movie business and beset with financial problems, Crandall committed suicide. He was only 57.

K-B Theaters had John Zink design the art deco Atlas Theater (1331 H Street NE), which seated just under 1,000 and opened in August 1938. In 1949, the Atlas was the first movie theater in Washington to put on a television show from its stage. After sitting abandoned for many years, it was gutted and converted into the Atlas Performing Arts Center, which opened in 2006 as one of the pioneers of a revitalized H Street corridor.

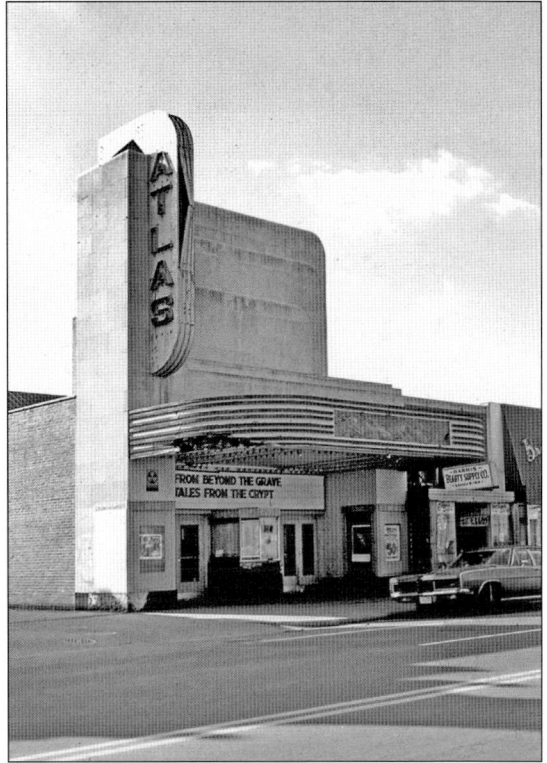

The second theater to open in Bethesda started its existence as the Boro in 1938. Built by Sidney Lust, the Bethesda (7719 Wisconsin Avenue, Bethesda, Maryland) had a long history as a neighborhood theater. K-B Theaters took it over in 1972, and it became the Bethesda Cinema and Drafthouse in 1983. The Bethesda was designated a historic landmark in 1986.

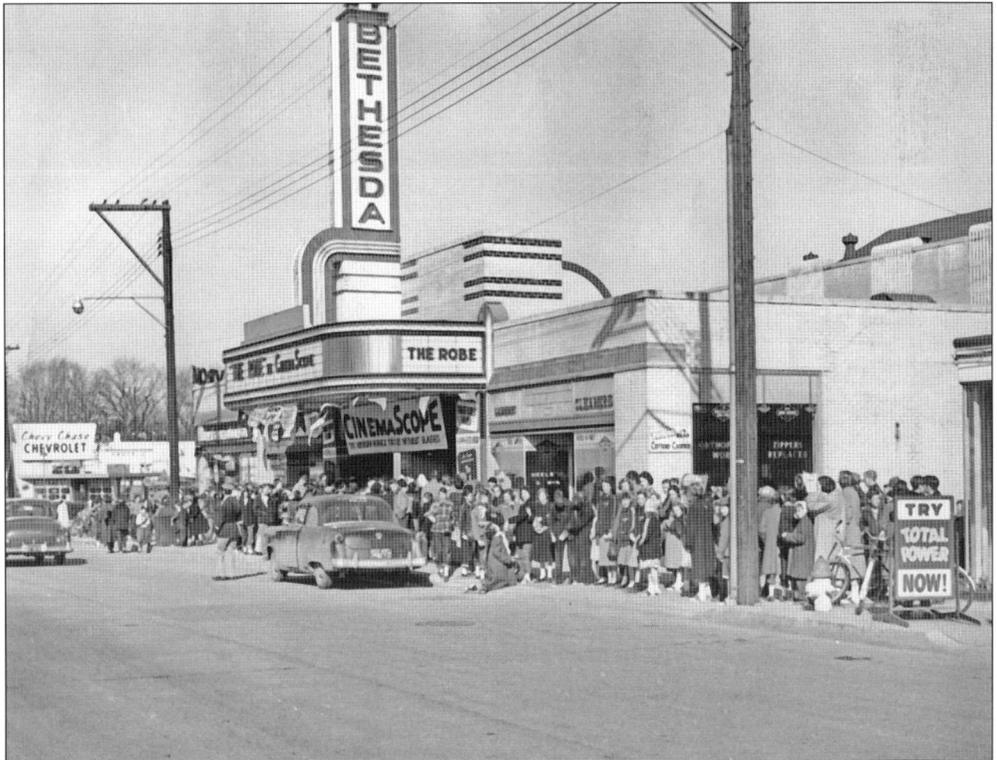

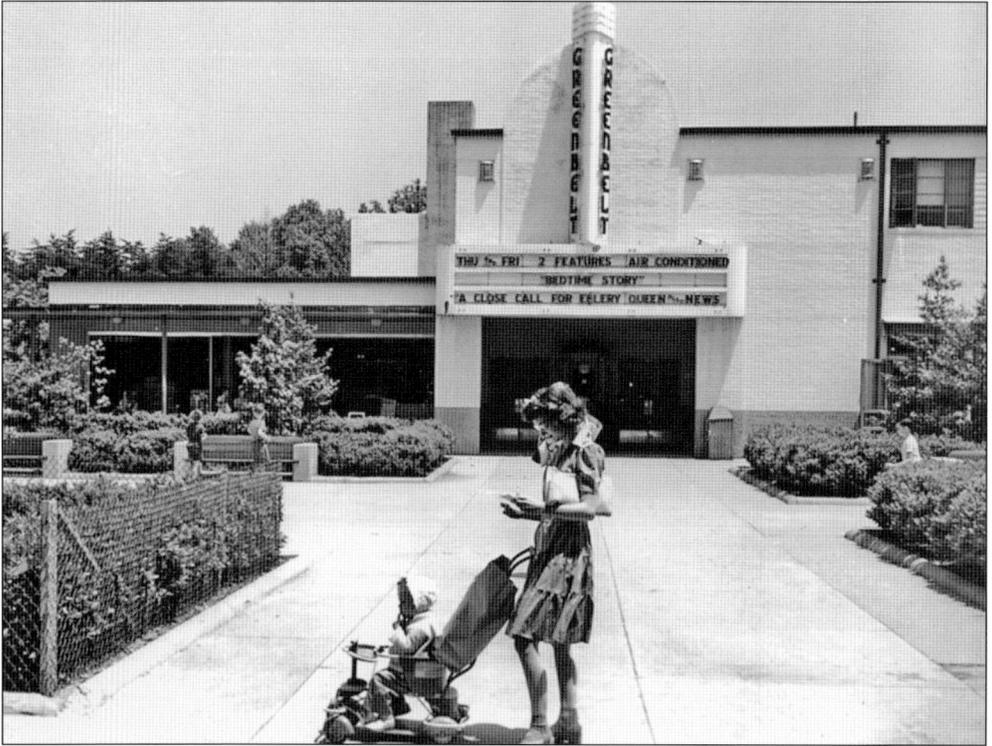

The Greenbelt Theater (129 Centerway) opened in the planned community of Greenbelt, Maryland, in 1938. For many years, it was just another neighborhood theater, but under former operator Paul Sanchez, it became well known as a venue for foreign and independent films. It continues to operate today. (Courtesy of the Library of Congress, Prints & Photographs Division, FSA/OWI Collection, LC-USW3-003454-C Lot 2)

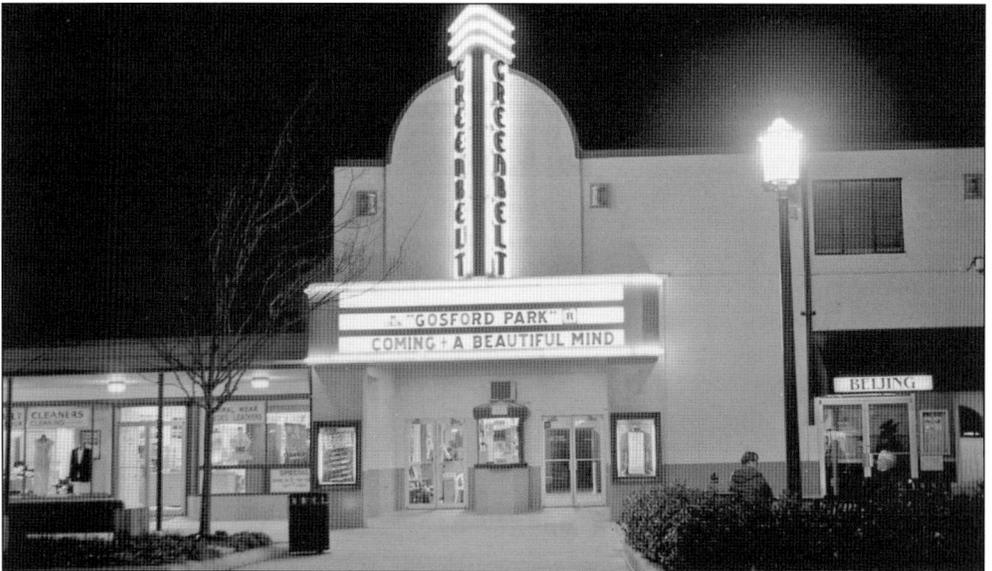

A night photograph of the Greenbelt Theater shows off the duplicate of the original vertical sign that Sanchez installed in the Greenbelt in February 2001.

74

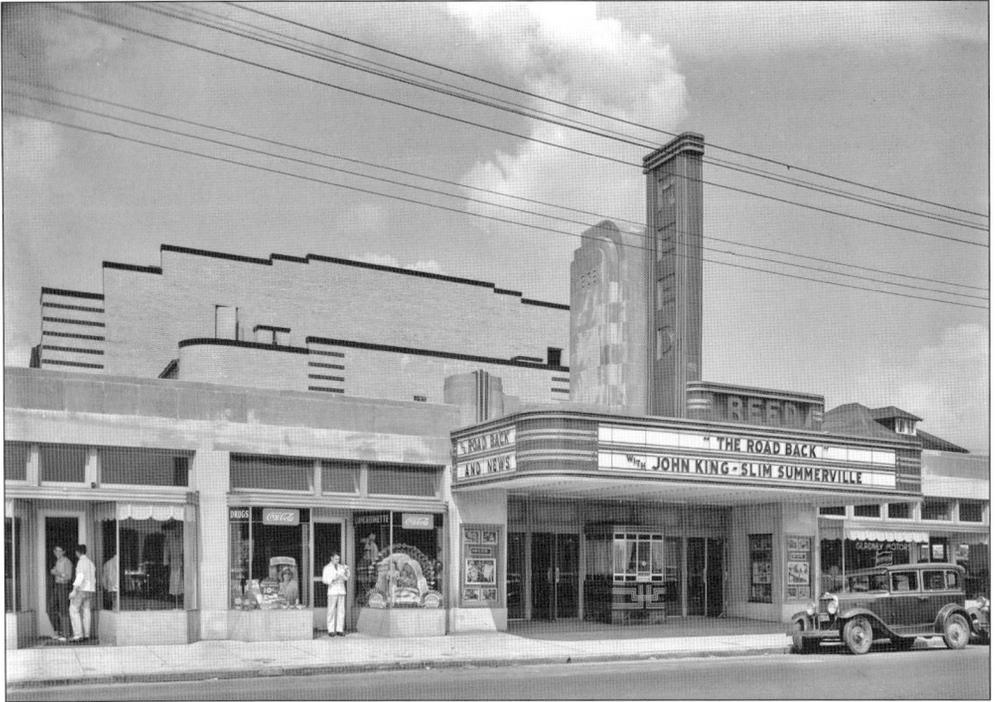

Alexandria's Reed Theater (1723 King Street, 1937–1976) was designed by John J. Zink, and its front is somewhat reminiscent of his Ambassador Theater in Baltimore. It was demolished in 1979.

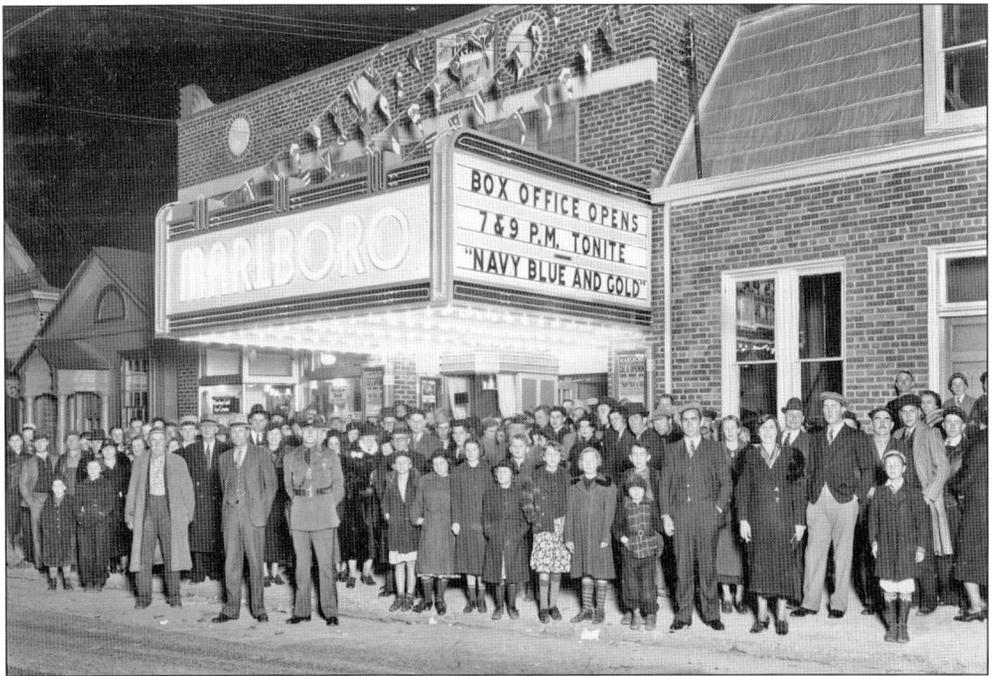

The Marlboro Theater (Upper Marlboro, Maryland, 1938–1952) was designed by John Eberson for Sidney Lust. For many years after it opened, it was segregated, with separate entrances and prices for blacks and whites. (Courtesy of Paul Sanchez.)

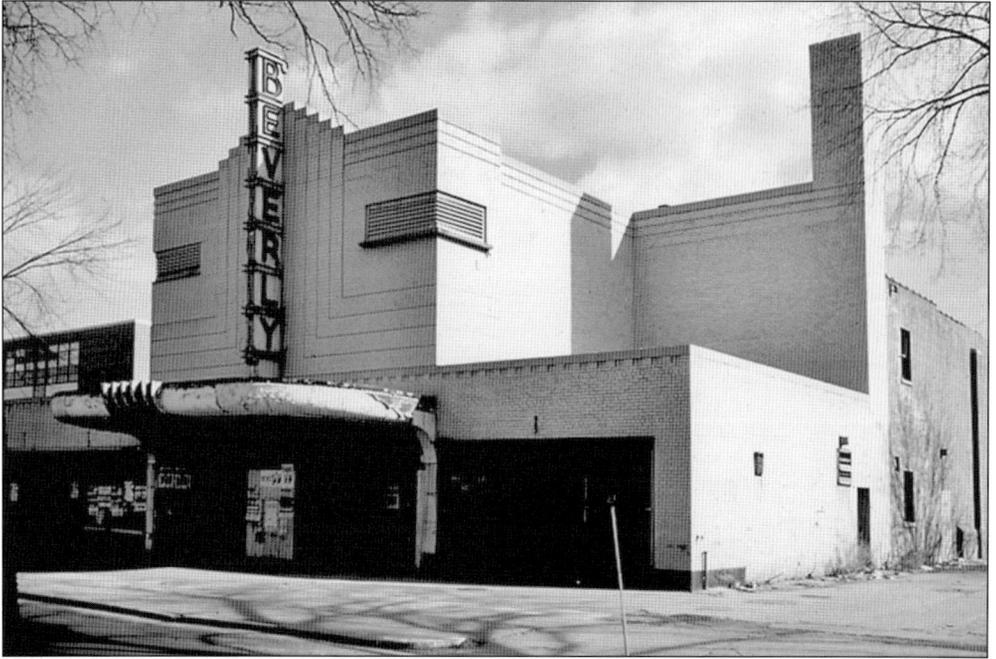

Warner Bros. tried to compete with K-B by opening the Beverly Theater (511–519 Fifteenth Street NE) in 1939 just a few blocks away from K-B's new Atlas Theater. The plan did not work, and although the Beverly was a handsome theater with a spectacular art deco curtain designed by John Eberson, it never did good business. It closed in 1963 and has since been torn down.

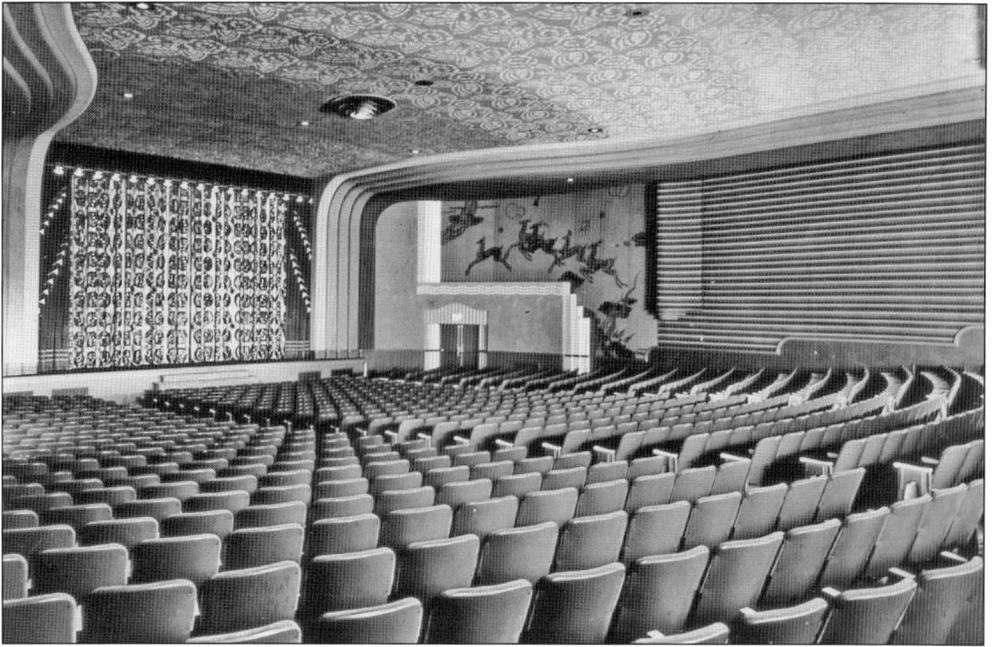

People who attended the Beverly Theater remember its beautiful curtain. Sadly, today's audiences cannot enjoy the thrill of seeing the houselights dim and the curtains part at the beginning of the show.

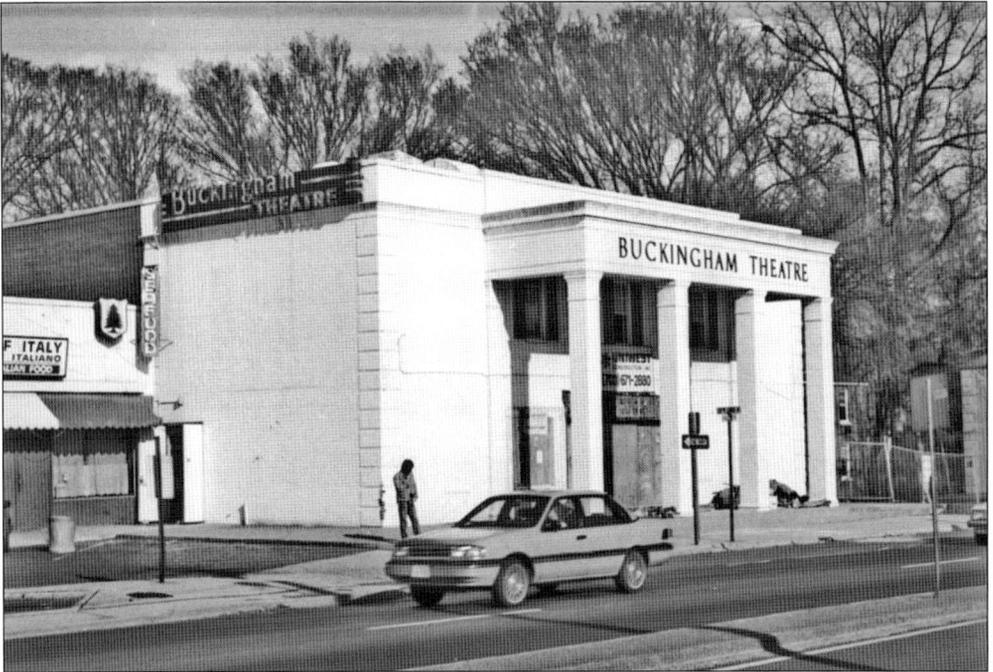

The Buckingham Theatre (321 North Glebe Road, Arlington, Virginia, 1939–c. 1986) was constructed for the Buckingham community in a style that echoed other buildings in the area. After it closed, the building became a post office.

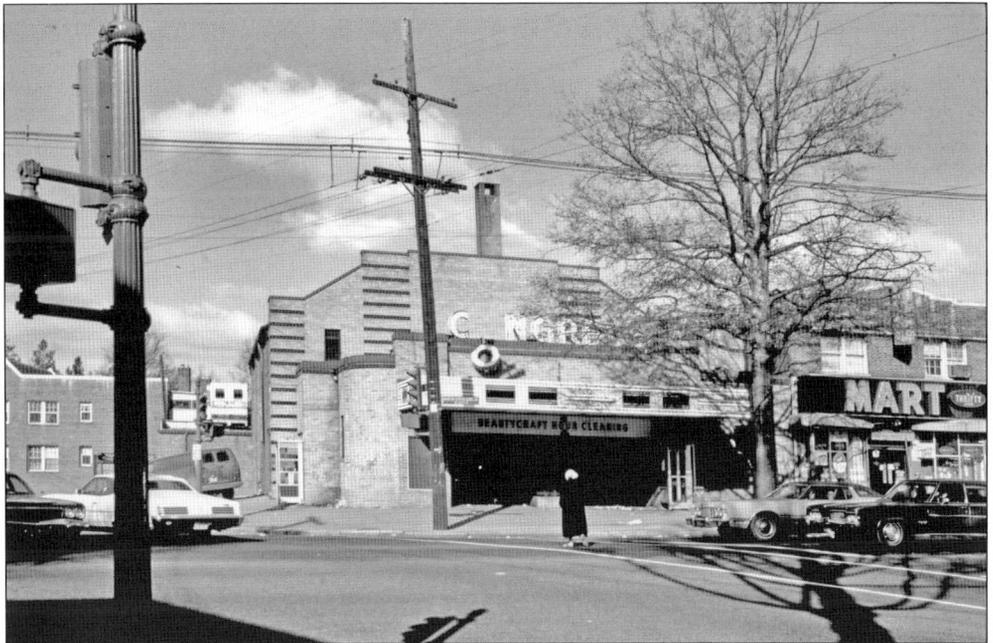

A sad sight, the Congress Theater (2931 Nichols Avenue, later Martin Luther King Jr. Avenue SW, 1939–c. 1971) sits closed and dilapidated in the 1970s. Built by the Wineland organization and designed by John J. Zink, it seated around 600 people.

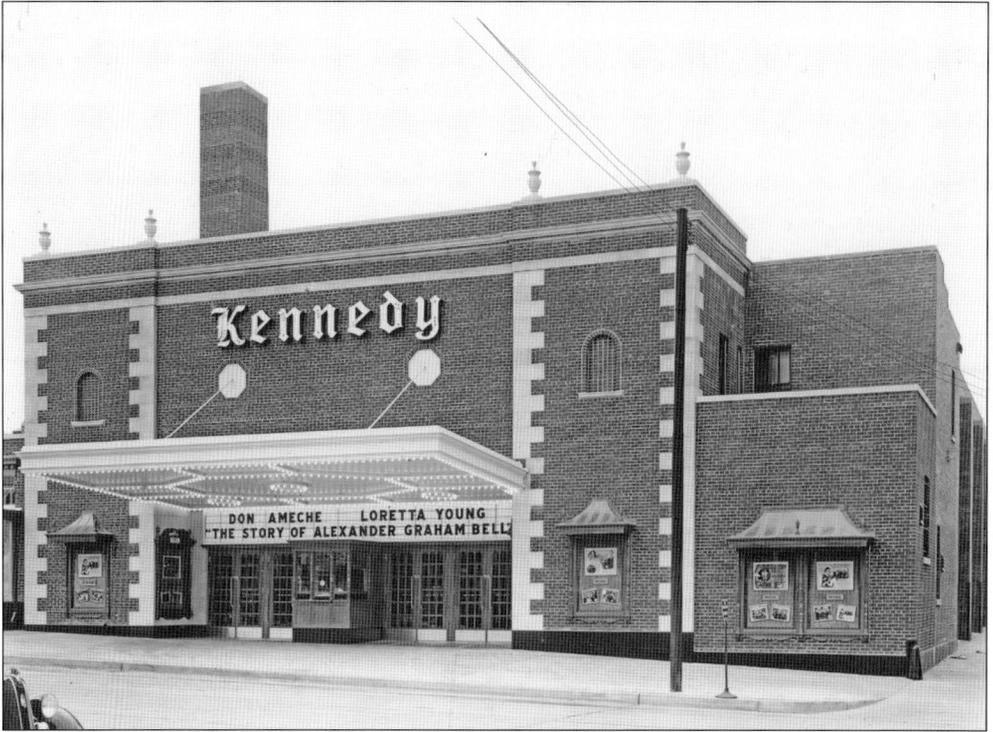

Warner Bros. opened the Kennedy Theater (326 Kennedy Street NW) in 1939. Architect John Eberson designed it in a Neocolonial Georgian style with the name spelled out in Old English letters. The Kennedy closed in 1974. After many years as a church, the auditorium was demolished, but the facade was retained.

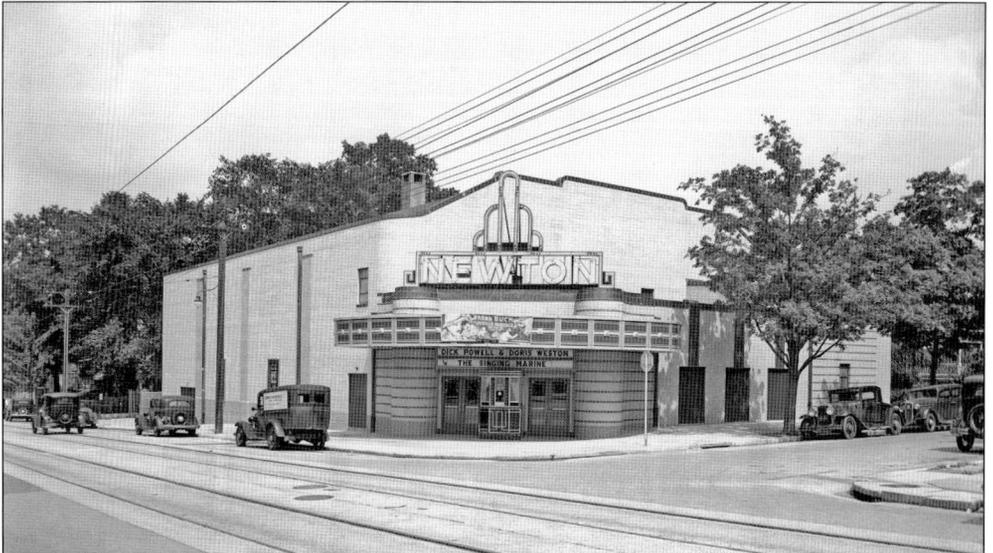

Louis Bernheimer's Newton Theater (3601 Twelfth Street NE, 1937–c. 1965) was the neighborhood theater for Brookland. After it closed, it was bought by nearby Catholic University and used by the music department. It later became a live music venue, a bookstore, and a nursery school, and it is currently a drugstore.

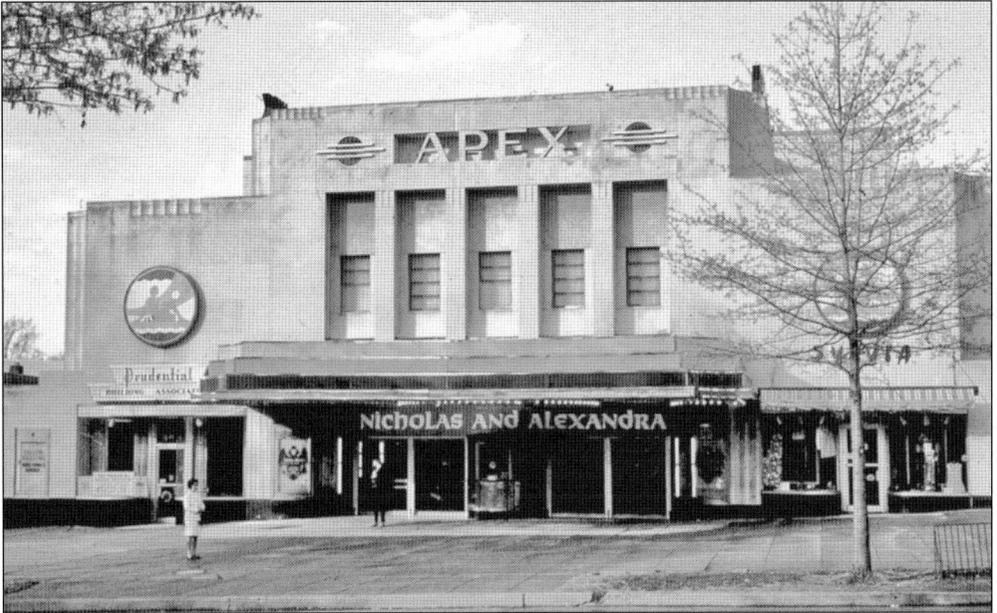

One of the finest movie theaters in Washington, the Apex (4813 Massachusetts Avenue NW) was opened by the K-B organization in 1940. It was designed by John J. Zink and seated just over 1,000. The Apex served the upscale Washington Circle area near American University for only 36 years—too short a life for this beautiful theater. It was demolished in 1977.

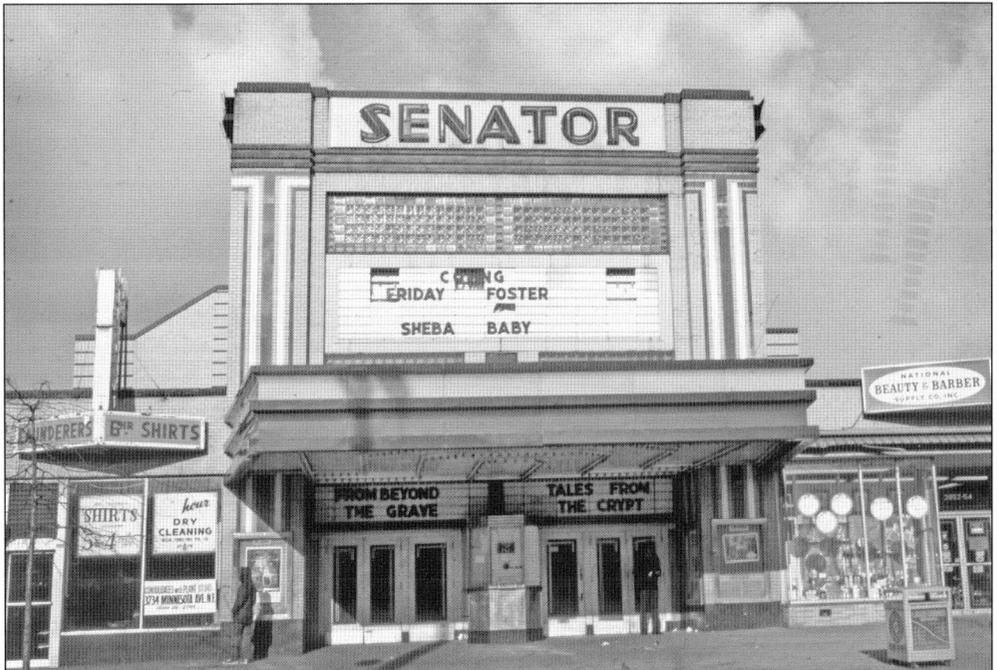

The Senator Theater (3946–3956 Minnesota Avenue NE, 1941–1989) was built on the site of an abattoir. It had several owners, including District Theaters, Bernheimer, and K-B Theaters. In a misguided attempt to preserve the theater, the DC government saved the facade but demolished the auditorium. It is no longer a theater.

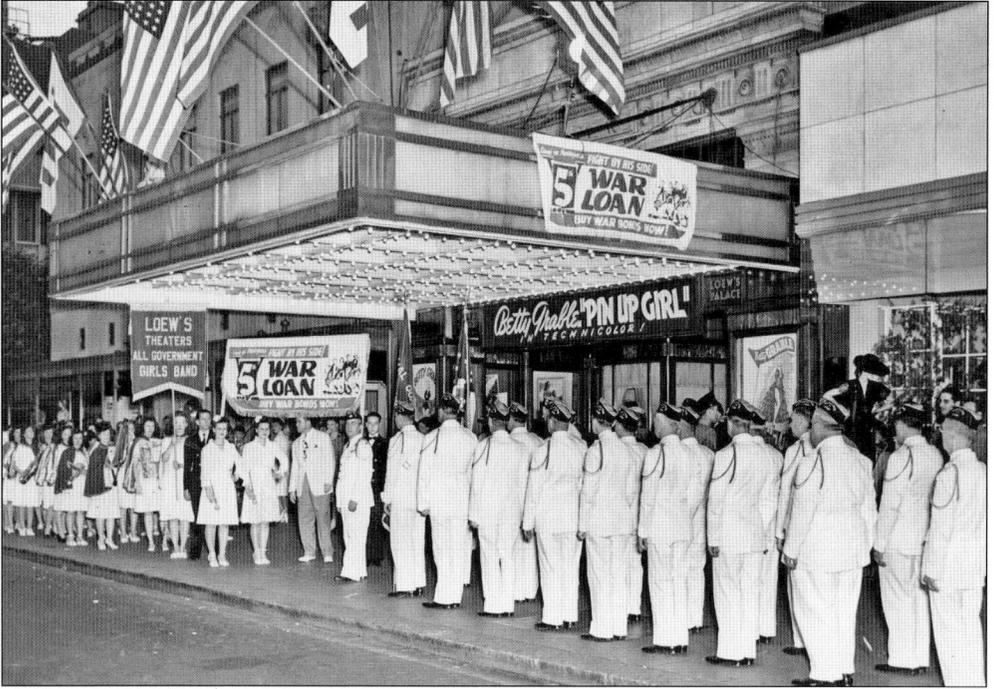

Exhibition hoopla fills Loew's Palace as Loew's Theaters All Government Girls Band entertain guests at a showing of *Pin Up Girl* in 1944.

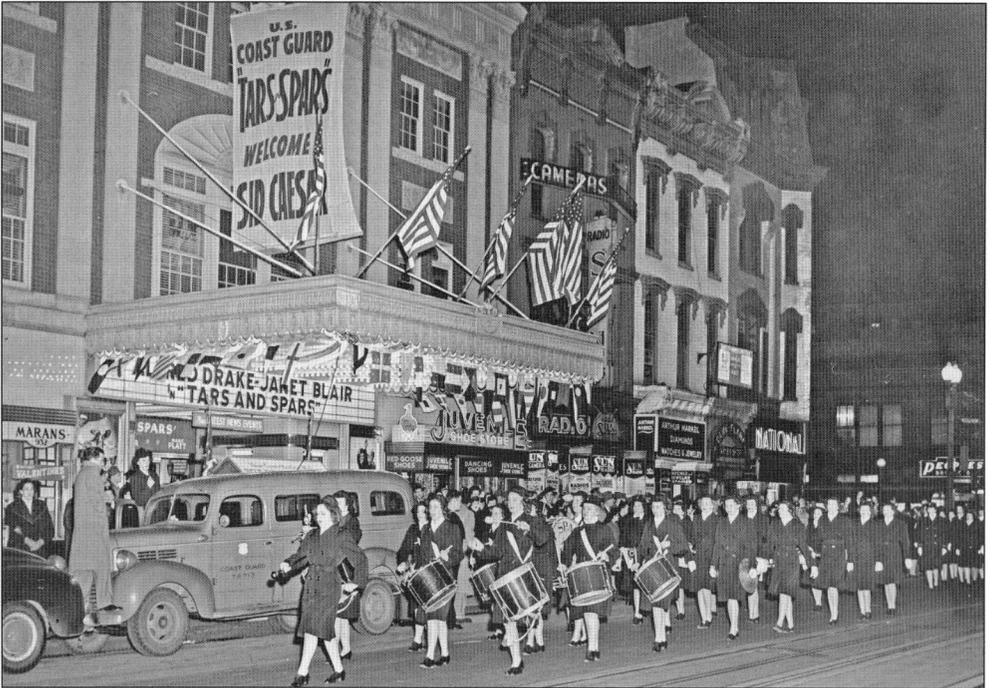

Another girl band provides more hoopla as *Tars & Spars* plays at the Metropolitan in 1946. During the Second World War, these demonstrations by bands brought crowds downtown, even at night.

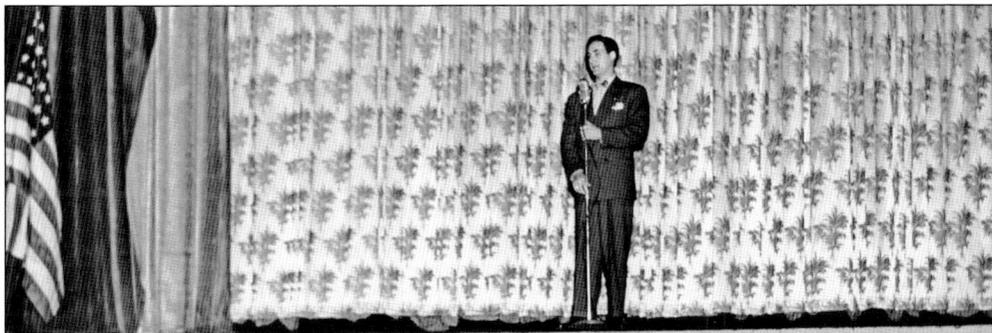

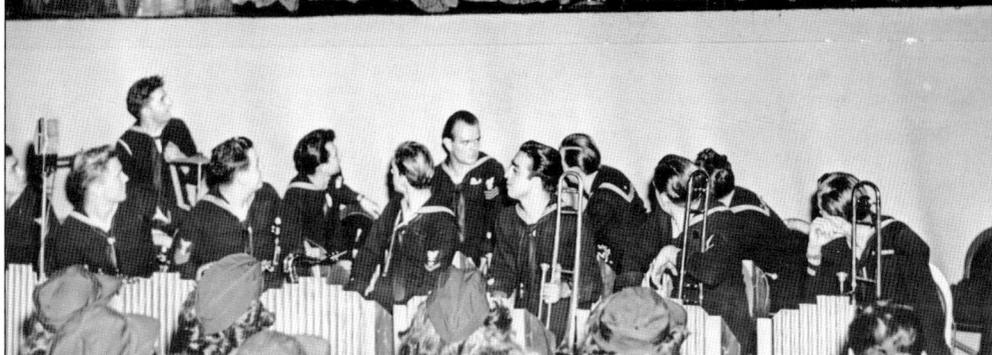

Young comedian Sid Caesar appeared in person at the Metropolitan showing of *Tars & Spars*.

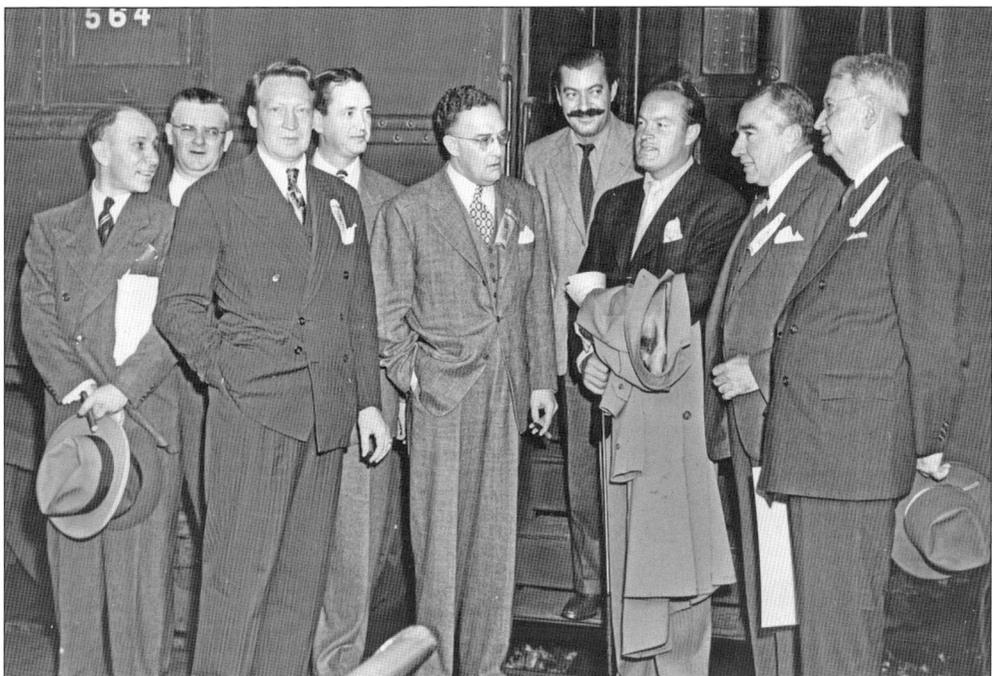

Local exhibitors were delighted when film stars came to town and they could show them off at their theaters. In this June 1945 photograph, Bob Hope, third from right, and his sidekick Jerry Colonna (with the magnificent mustache) are met at Union Station by a delegation of theater people including, at far left, Frank LaFalce, the local head of publicity for Warner Bros., and second from left, Carter Baron, the local head of Loew's Theaters.

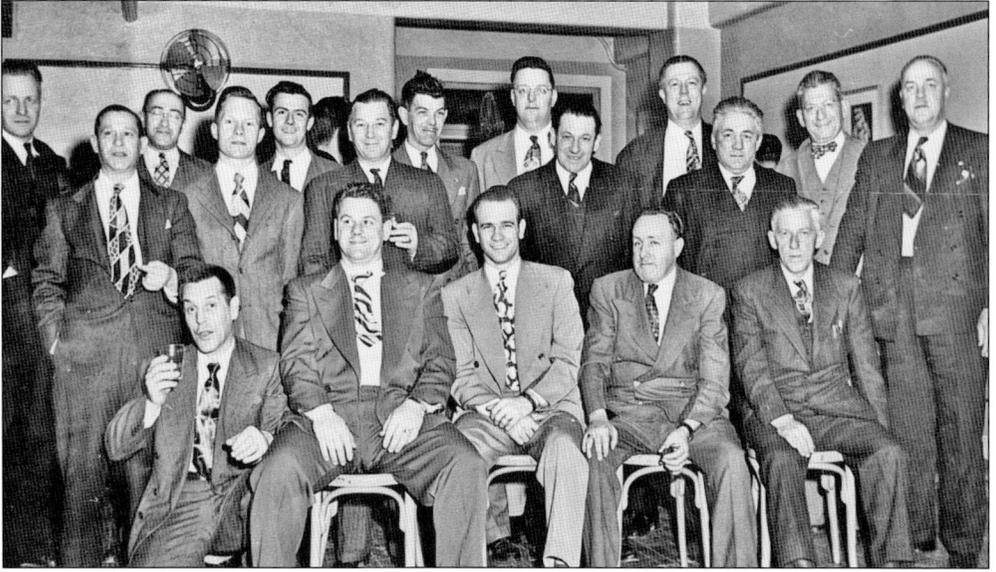

The Northern Virginia projectionists of Local 619 gather for a group photograph. Sadly, with the advent of the platter system and digital projection, the local projectionists' unions have withered and all but disappeared.

A typical projection booth is pictured with two modern Peerless projectors and an amazingly clean booth. This is probably the booth of Sidney Lust's Hippodrome Theater.

Sidney Lust (1885–1955) was the consummate showman, starting out in the circus before moving to movie exhibition. Lust opened numerous theaters in the city and surrounding suburbs, including the Leader, Bethesda, Hyattsville, Cheverly, Beltsville Drive-In, and Milo. He was also active in civic events, and many area residents fondly remember his annual Easter egg hunts in Hyattsville's Magruder Park.

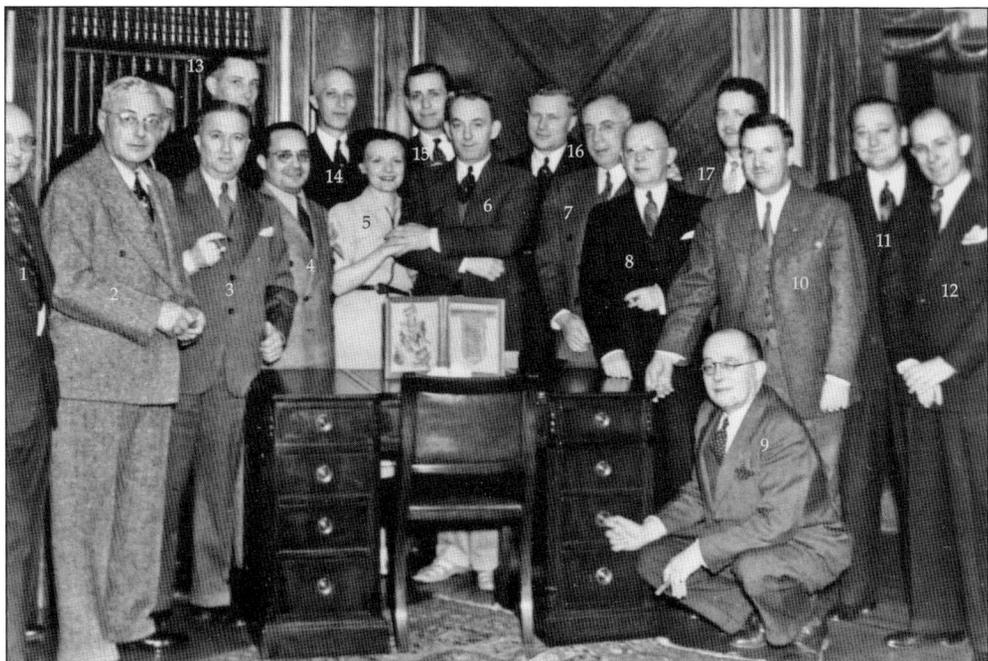

The Warner Bros. management gets together for a picture. The following people have been identified: Julian Brylawski (2), Bob Folliard (3), John Payette (6), Nat Glasser (7), Guy Wonder (9), and George Crouch (16).

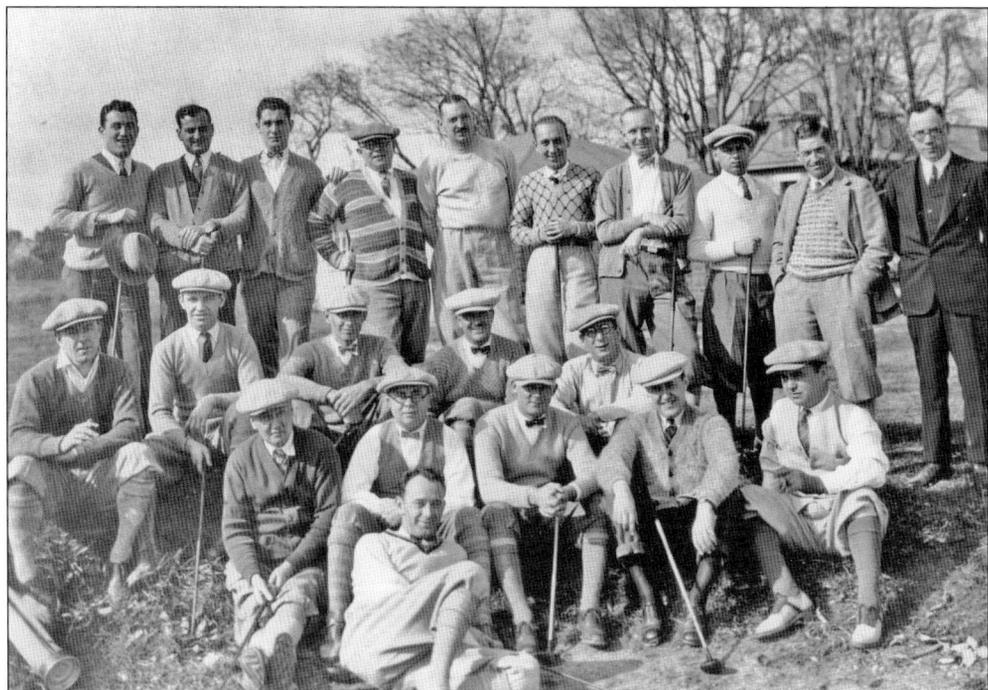

Warner Bros. management gathers at a golf course. The sport was one of the bonding methods used by the upper management of the local Warner Bros. zone headquarters. John Payette, head of the Washington Zone, is reclining in front.

Washington's premier neighborhood theater, the Uptown (3426 Connecticut Avenue NW) was a last attempt by Harry Crandall to get back into the theater business. It was designed by John J. Zink and seated about 1,300 before it was remodeled for Cinerama in 1962. It is shown here on opening night in 1936. The theater is still in operation today.

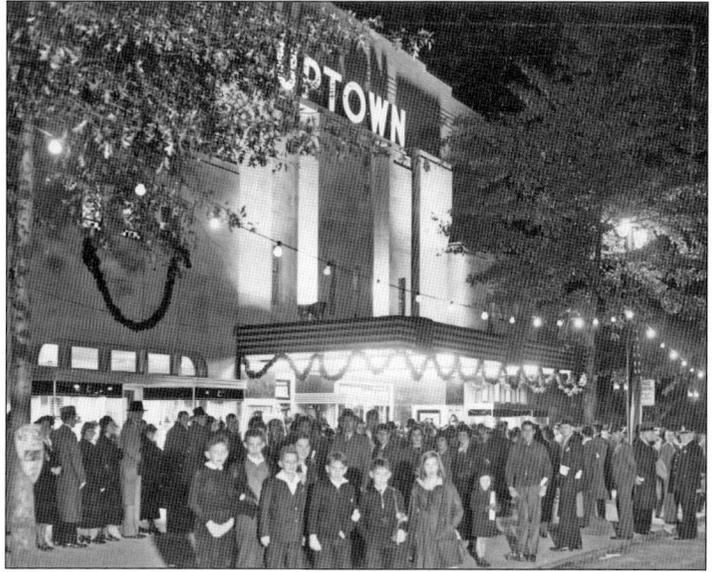

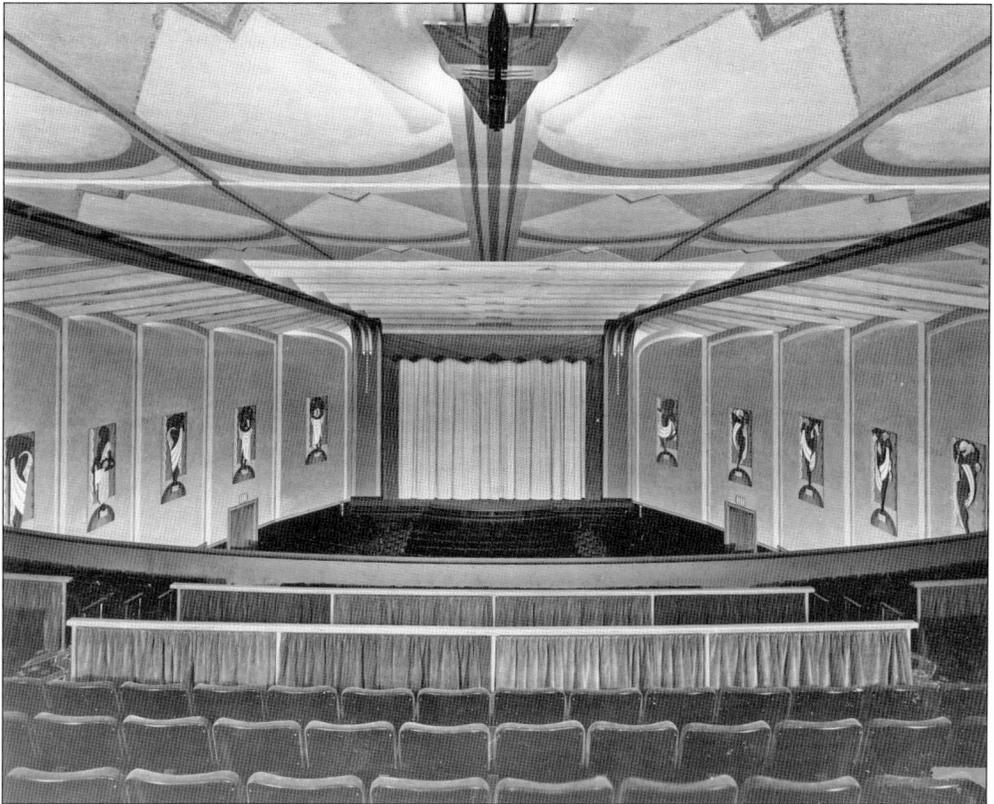

The handsome auditorium of the Uptown is pictured before an unpleasant 1940 remodeling. The front rows in the balcony remain some of the best spots in Washington to watch a movie.

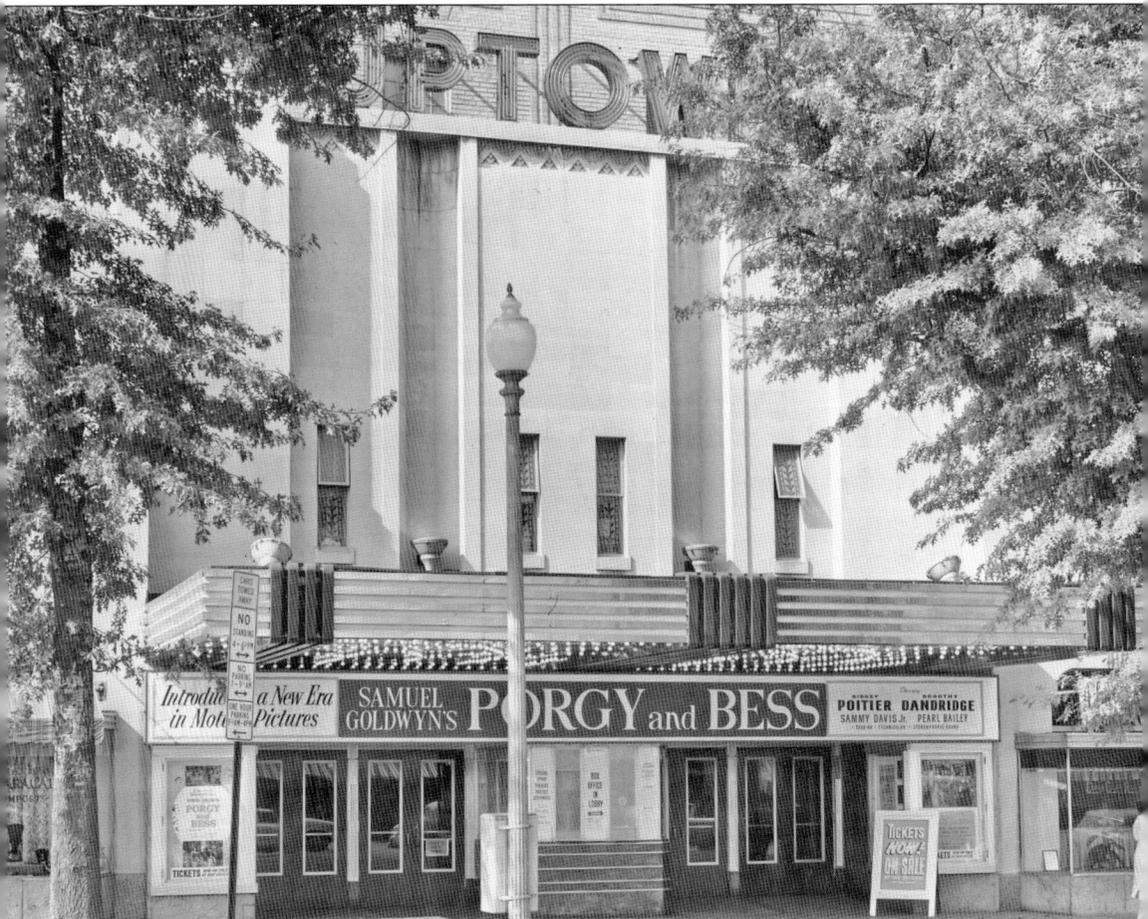

A close-up of the Uptown entrance is given here. The Uptown has been the site of countless premieres over the years, and its imposing facade dominates the 3400 block of Connecticut Avenue NW.

Six

THE MOVE TO
THE SUBURUBS

With the end of the building restrictions of World War II, the late 1940s saw a boom in movie theater construction: 31 theaters were built in the Washington area from 1945 to 1952. But with the rise of television and the commercial decline of downtown, the next decade would be devastating to the grand old movie palaces.

The building boom already showed signs of this change, not just in the way people watched movies but also in the way—and where—they lived. In this mid-century construction boom, only three theaters opened in downtown Washington: the Playhouse, Dupont, and Plaza. Most of the new theater construction took place in suburban Maryland and Virginia.

The very material of movies changed, as in 1950, dangerous, flammable nitrate stock was replaced by safety film. The 21st-century debate between digital images versus celluloid has its parallel in this technological shift. Change was in fact prevalent not just behind the camera but also in the fabric of society, as theaters began to take sides on desegregation. Rather than desegregate, the National Theatre, a venue that in its present form is one of Washington's premier venues for such musical theater productions as *Mean Girls*, held fast to segregation, preferring to change from a live stage venue to a movie theater rather than change its policies.

The Hollywood studio system took a hit from the Supreme Court when the case of the *United States v. Paramount Pictures*, also known as the Hollywood Antitrust Case of 1948, was decided 7-1 in the government's favor. The result, known as the Paramount Consent Decree, had a profound effect on the way people see movies. Studios were no longer allowed to own their own theaters and could not force a theater to book its entire slate of product, sight unseen. This led to the rise of independent theaters and caused venues to look beyond ticket sales for revenue sources—hence the rise of concession stands, ever more elaborate and expensive.

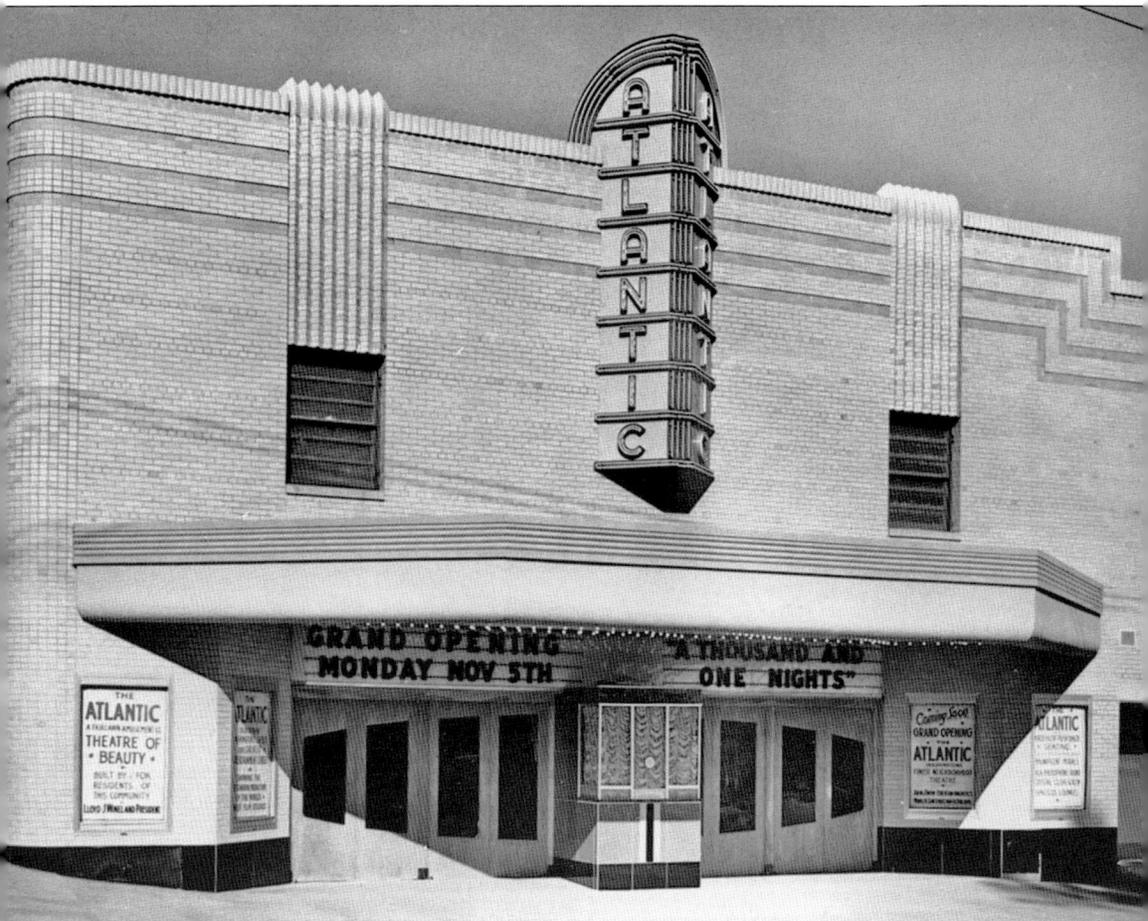

Opening on November 5, 1945, with the Cornell Wilde feature *A Thousand and One Nights*, the Atlantic (21 Atlantic Street SW) was designed by John and Drew Eberson. The theater was operated by the Wineland organization until it closed in 1968. It was converted into a disco in the 1970s.

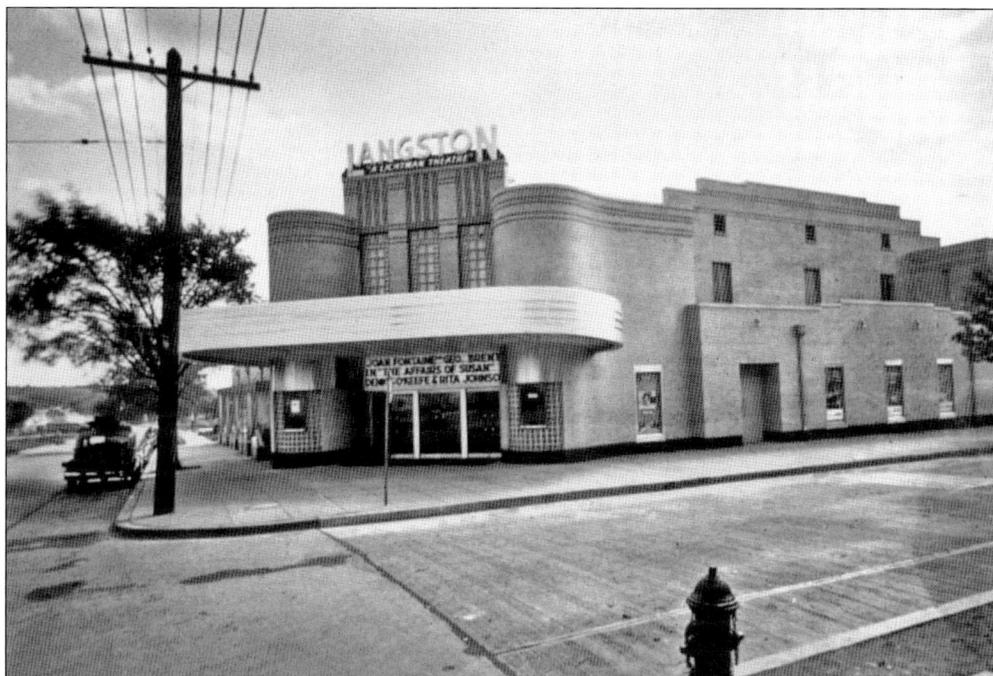

The art deco Langston (2501–2507 Benning Road NE) was designed by John J. Zink and opened in 1945 with a press screening of the Irene Dunne comedy *Over 21*.

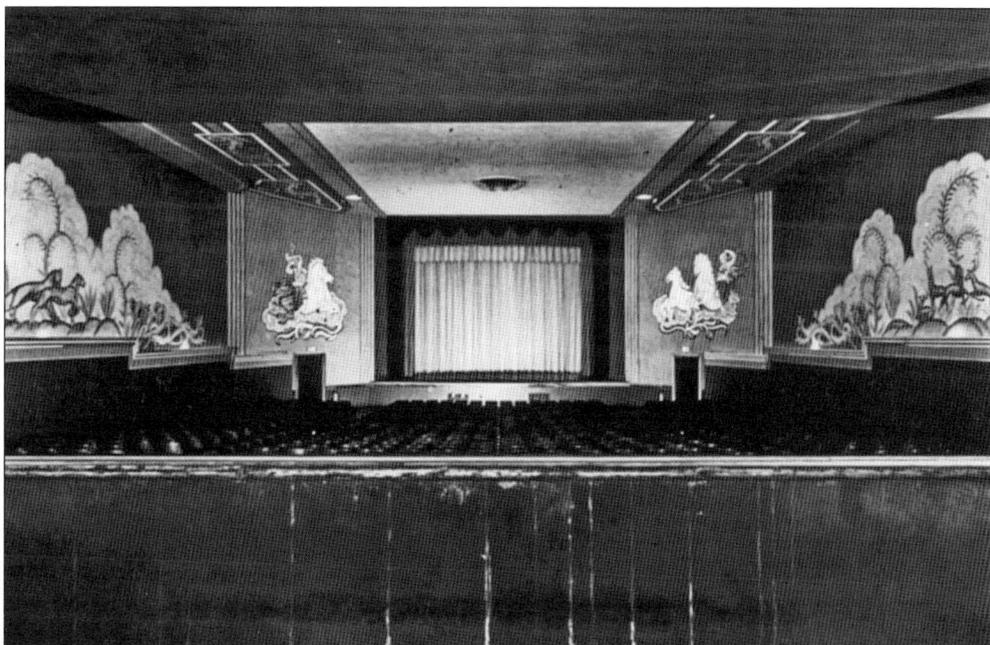

The Langston had a seating capacity of nearly 700. Its interior walls were decorated with modernistic forest scenes, and its screen was flanked by images of Greek gods riding horseback. The Langston closed in 1977 and was converted to a church before it was demolished to make way for a fast-food restaurant.

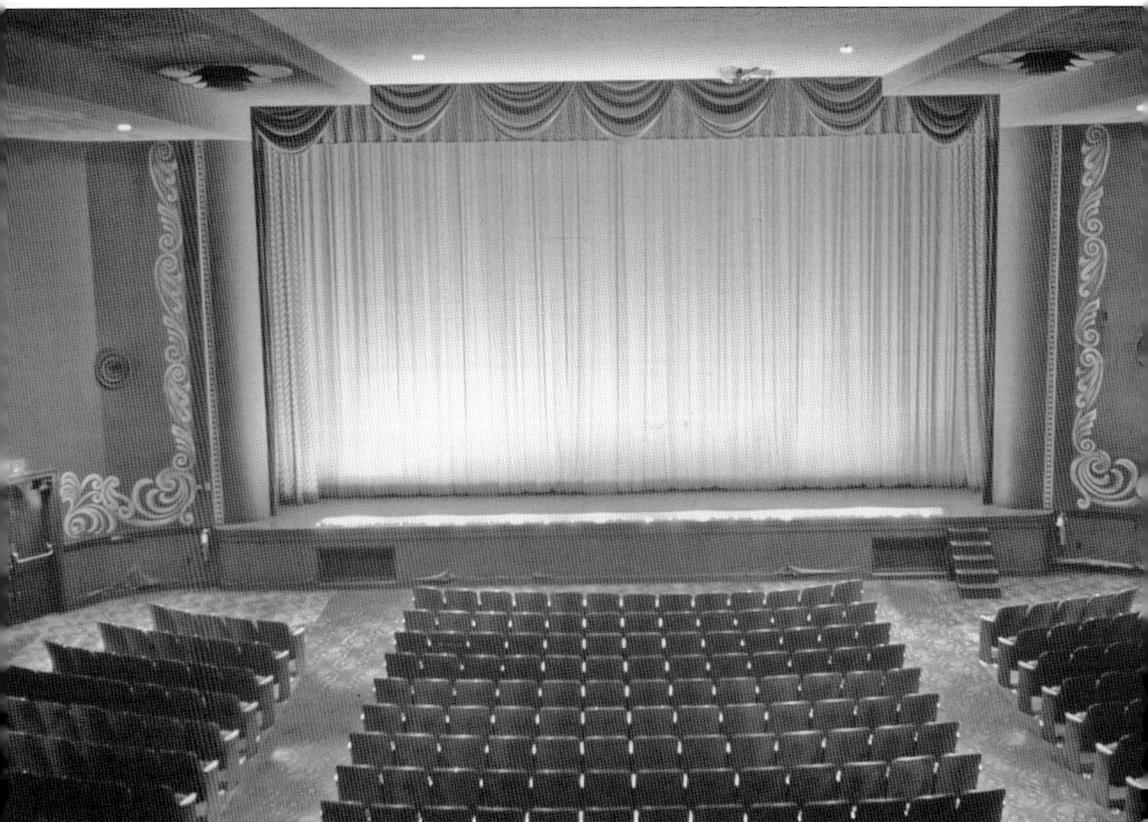

John J. Zink's 1,000-seat MacArthur (4859 MacArthur Boulevard NW) opened on Christmas Day 1946. Facilities included a private party room and a "cry room." Threatened with closure in 1981, the theater was purchased by the Pedas brothers, who converted it to a triplex; the last film shown in the original single-screen configuration was an homage to old-fashioned serialized adventures: *Raiders of the Lost Ark*. As a triplex, the theater showed such art house films as Robert Altman's *Short Cuts* and a repertory program of three films from director Jacques Tati. The theater closed in 1997 and is now a drugstore.

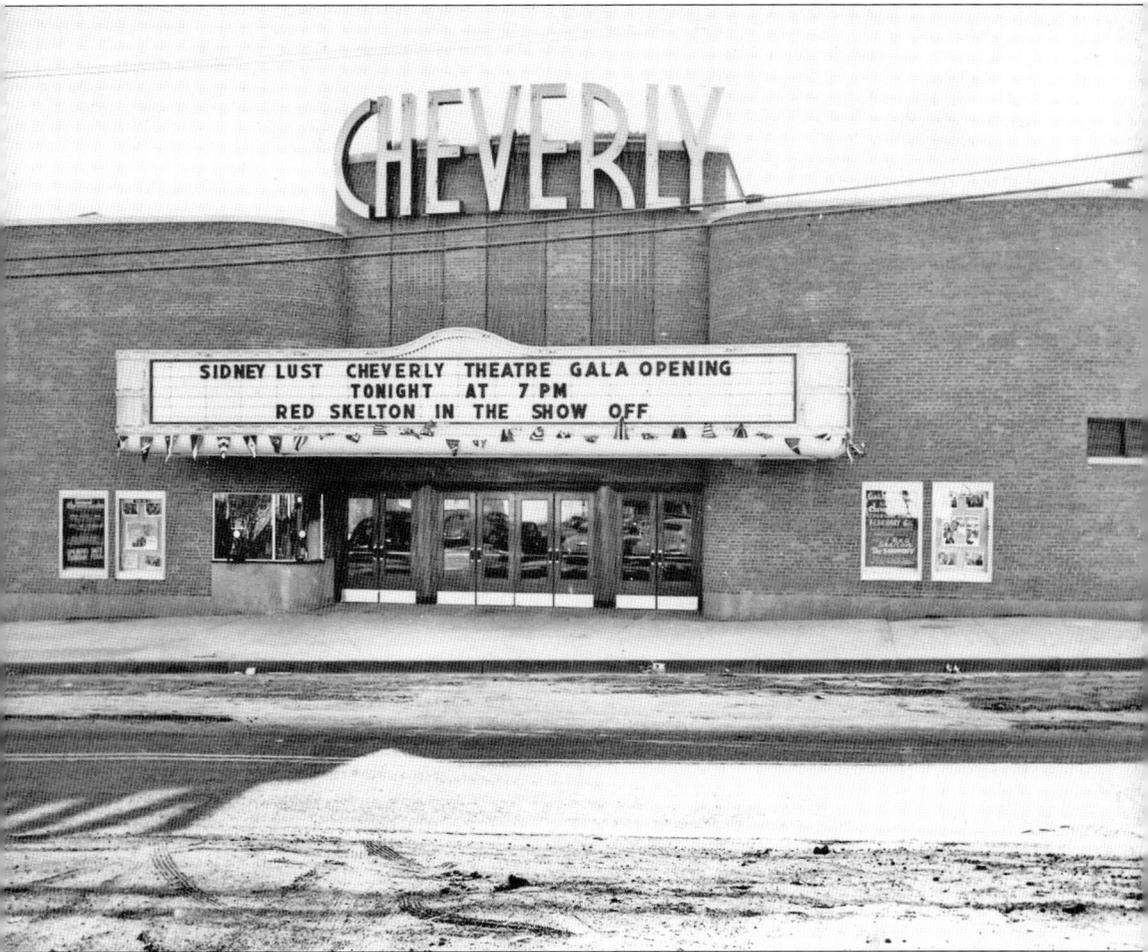

The Ebersons-designed Cheverly (5445 Landover Road, Cheverly, Maryland) opened in 1947 as part of the Sidney Lust chain. The opening feature was *The Show-Off*, starring Red Skelton as a man of false bravado. By the late 1960s, such family-friendly fare was a distant memory, with the theater showing X-rated movies. Closing after a 1971 fire, the theater reopened in 1977 as the performing arts venue the Publick Playhouse, which still operates today. (Courtesy of Paul Sanchez.)

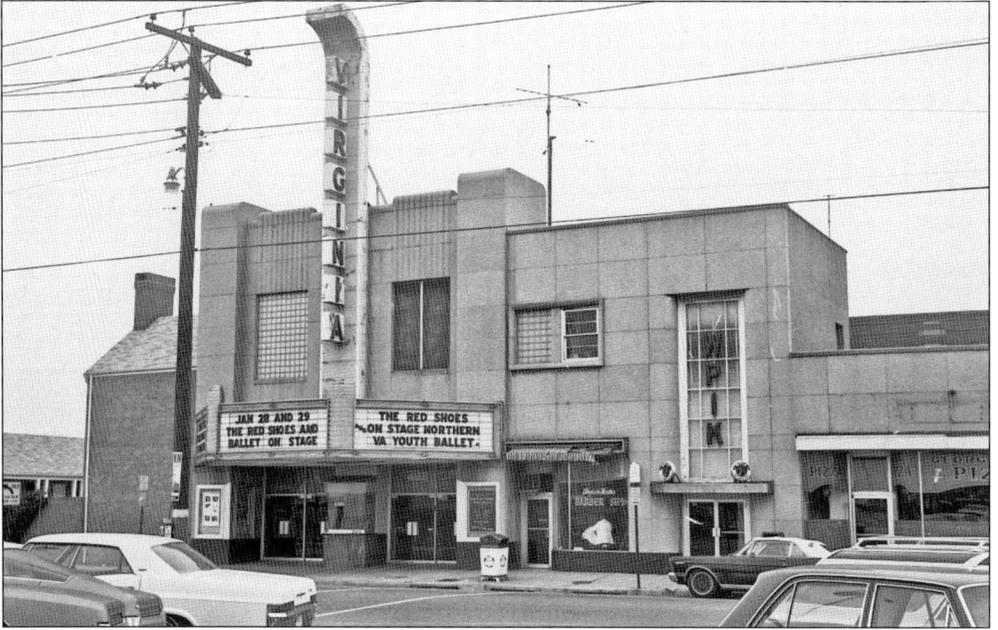

Designed by John Eberson, the Virginia (601 First Street, Alexandria, Virginia) opened on May 22, 1947, with the Dick Haymes and Vera-Ellen musical *Carnival in Costa Rica*. The gala ceremonies were attended by such luminaries as Virginia representative Howard W. Smith, Alexandria mayor William Wilkins, vice president of Paramount Pictures J.W. Sweigart, Miss Virginia Betty Cannon, and other young women who represented Alexandria's six movie theaters.

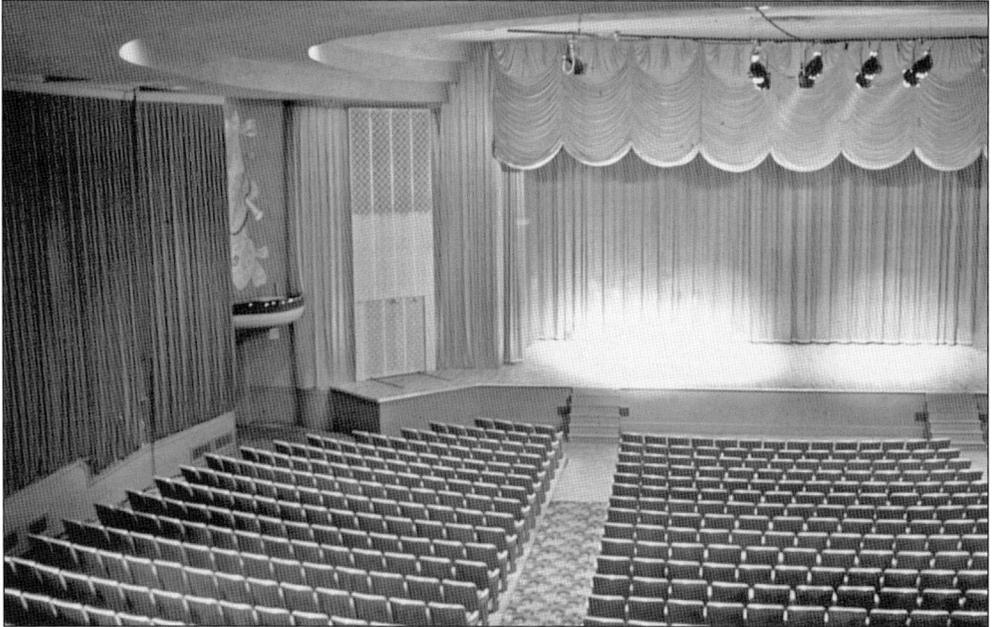

At the time of its 1947 opening, the Virginia boasted the largest screen and stage in the area, with a capacity of nearly 1,200. As theater attendance declined, the venue was completely refurbished in 1966, and in the 1970s hosted live music, such as the early rock musical *The Me Nobody Knows*. The theater closed in 1976 and was subsequently demolished.

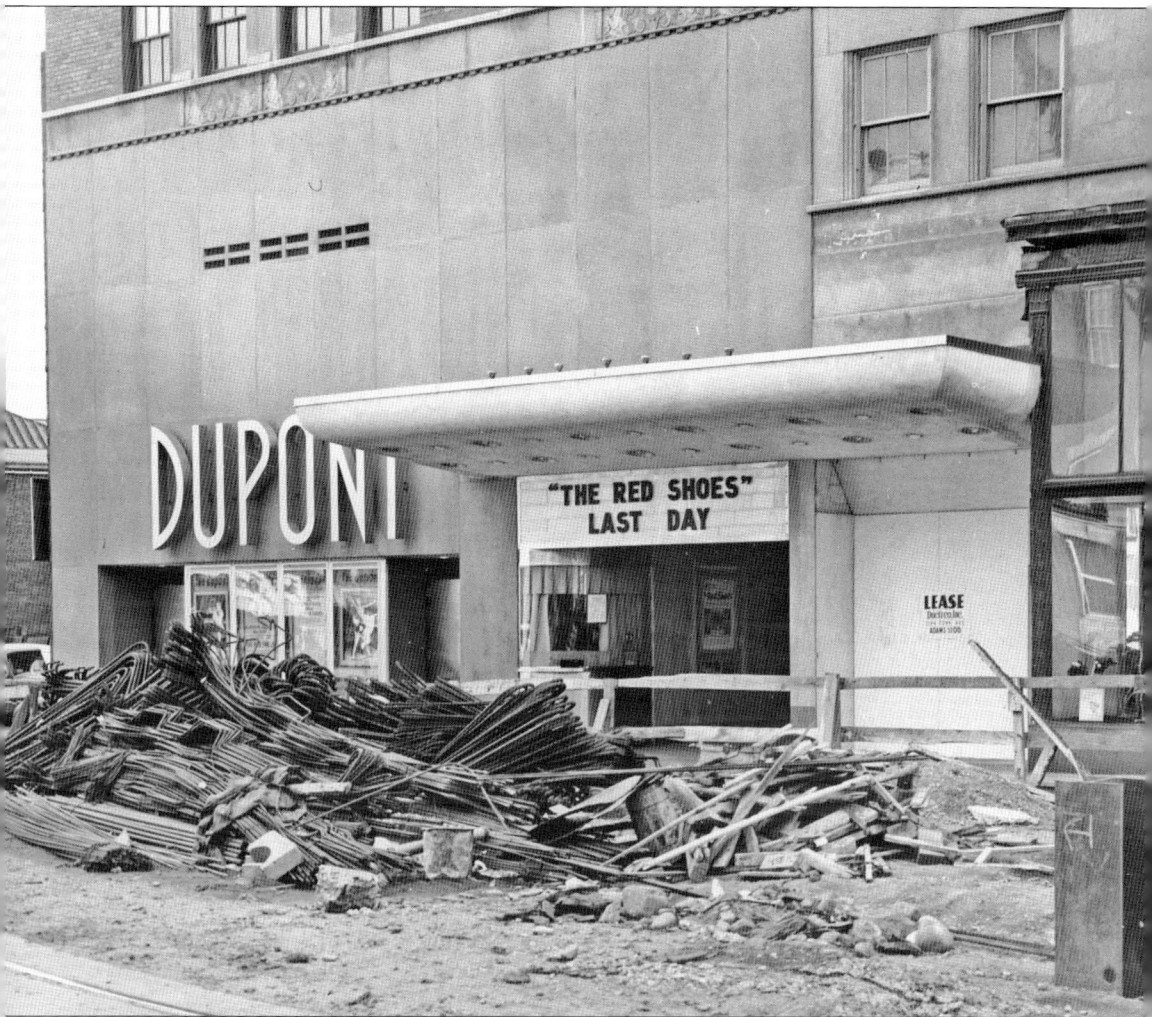

Designed by Leon Julius and Max Barth, the 400-seat Dupont (1332 Connecticut Avenue NW) opened in 1948 as one of the few desegregated theaters of the era. The theater remained profitable through the 1980s, hosting contemporary art house fare as well as a revival of *The Seven Samurai* and an Alfred Hitchcock retrospective. Developers gutted it in 1986 to make way for an undistinguished five-screen multiplex that opened on Christmas Day 1987, with a lineup that included *Dirty Dancing* and *Matewan*. This postage-stamp multiplex closed in 2008, leaving the once-cinema-saturated neighborhood without a movie theater. The space is now a drugstore.

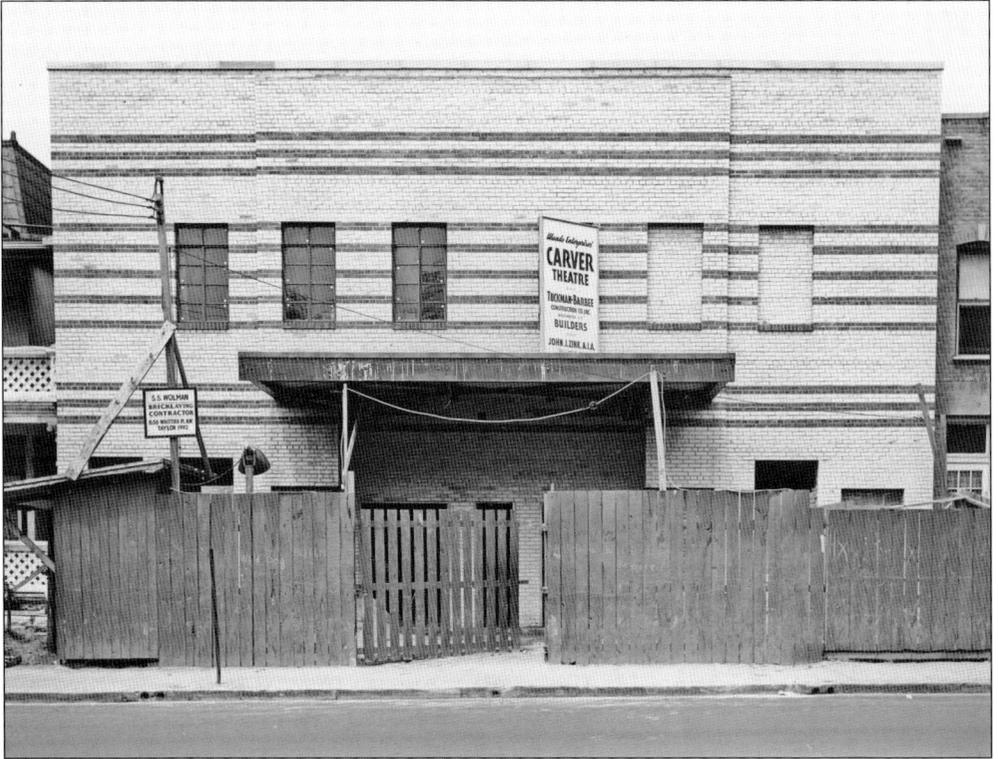

One of two John Zink-designed theaters named the Carver to be built in 1948, this 508-seat venue at 2405 Nichols Avenue (now Martin Luther King Jr. Avenue) opened as the only non-segregated theater in Southeast.

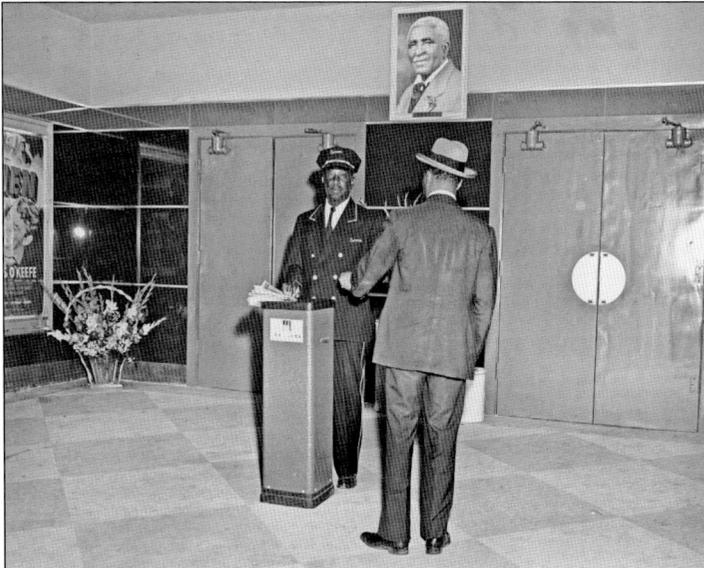

Even modest neighborhood theaters had uniformed ticket-takers. Unfortunately, the Carver was not successful and closed after just six years. The space has continued to serve the community as a roller-skating rink, a neighborhood museum, and as of 2018, a community college.

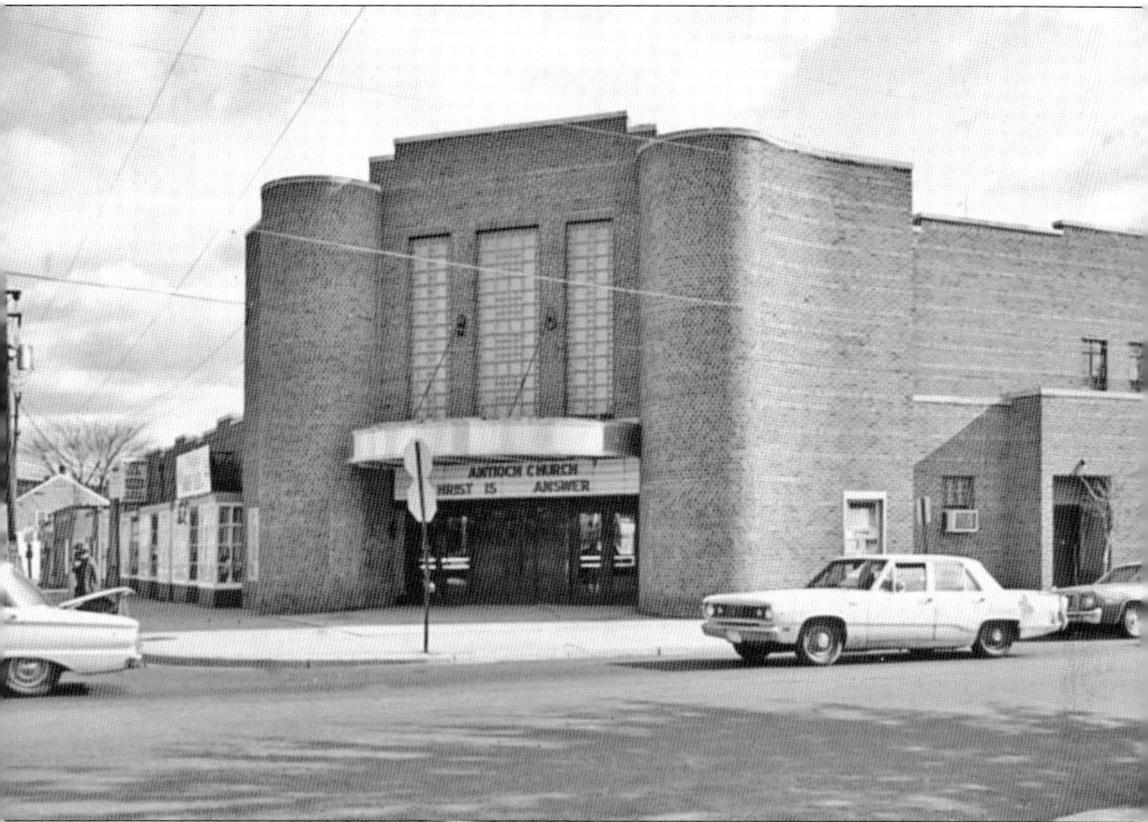

Attendees of the 1948 opening of the Carver in Alexandria, Virginia, heard staff read congratulatory telegrams from Lena Horne, Humphrey Bogart, Hattie McDaniel, and George Raft, whose 1947 crime drama *Intrigue* christened the screen. Located at 1120 Queen Street, the venue, which featured hand-painted murals depicting the life of George Washington Carver, was planned as Alexandria's first-run African American theater. The movie theater operated for 18 years and is now a church.

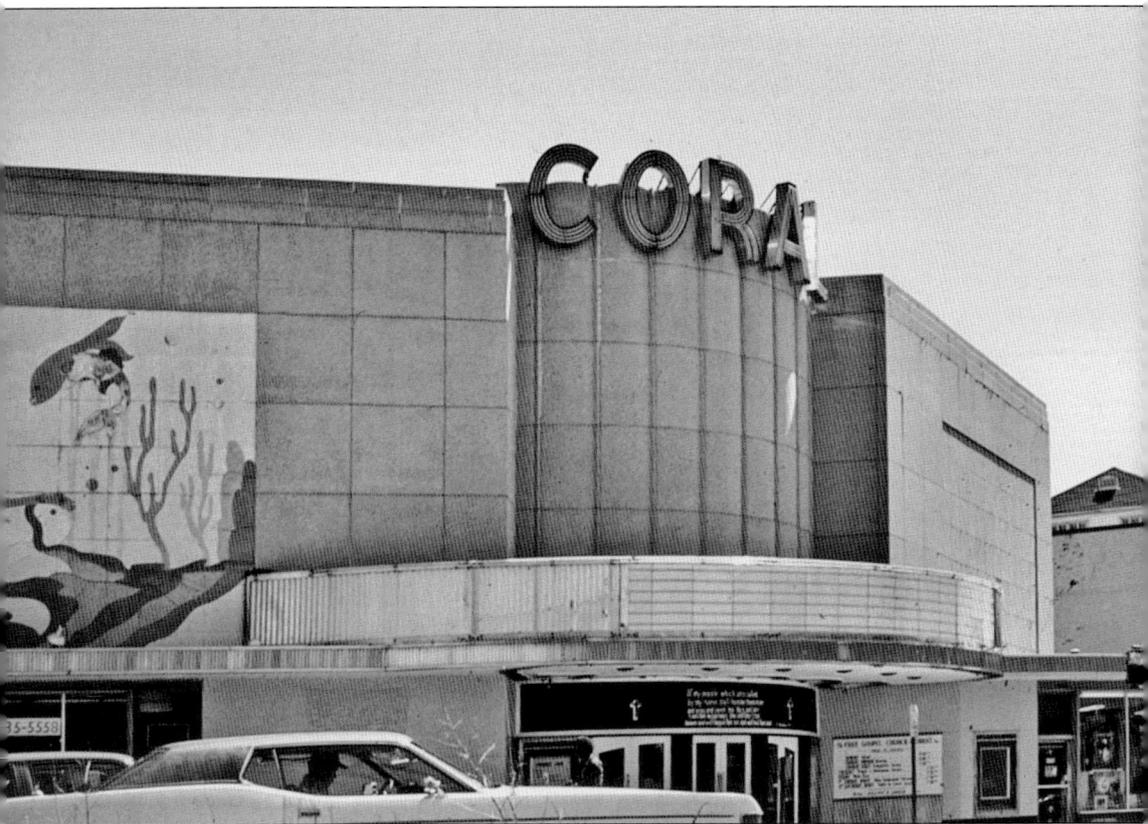

The Ebersons embraced a watery theme with the Coral (4703 Marlboro Pike, Capitol Heights, Maryland). A huge panel of multicolored terrazzo was decorated with an underwater motif that faced Marlboro Pike, and interior walls were festooned with a lyre-shaped damask of coral and eggshell. Wineland opened the theater in 1948 and operated it for 20 years. It closed in 1974.

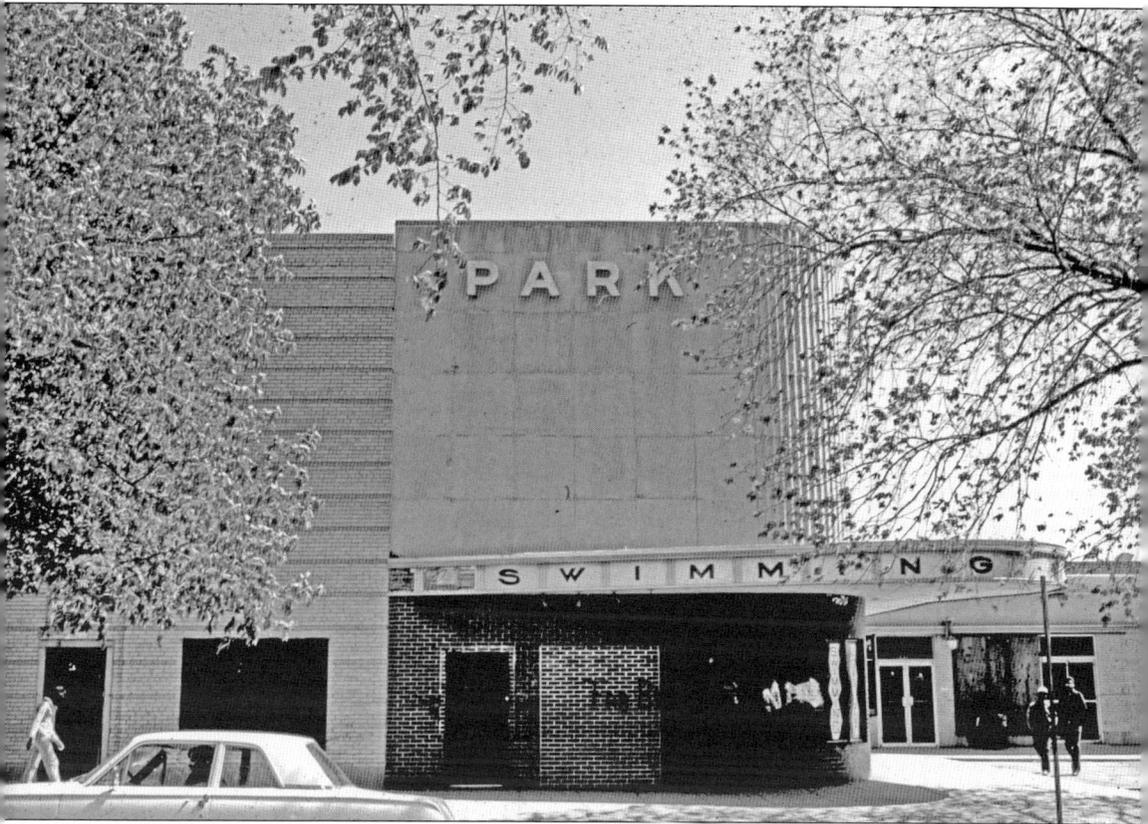

Designed by Hal A. Miller, the short-lived Park Theatre (1361 Savannah Street SE) was operated by the Roth organization. The 1,000-seat theater opened on April 20, 1951, with the Susan Hayward drama *I'd Climb the Highest Mountain*, a biopic about Methodist minister Lundy Howard Harris. The Park was unable to obtain good films and closed after only 11 years. It was turned into an indoor pool.

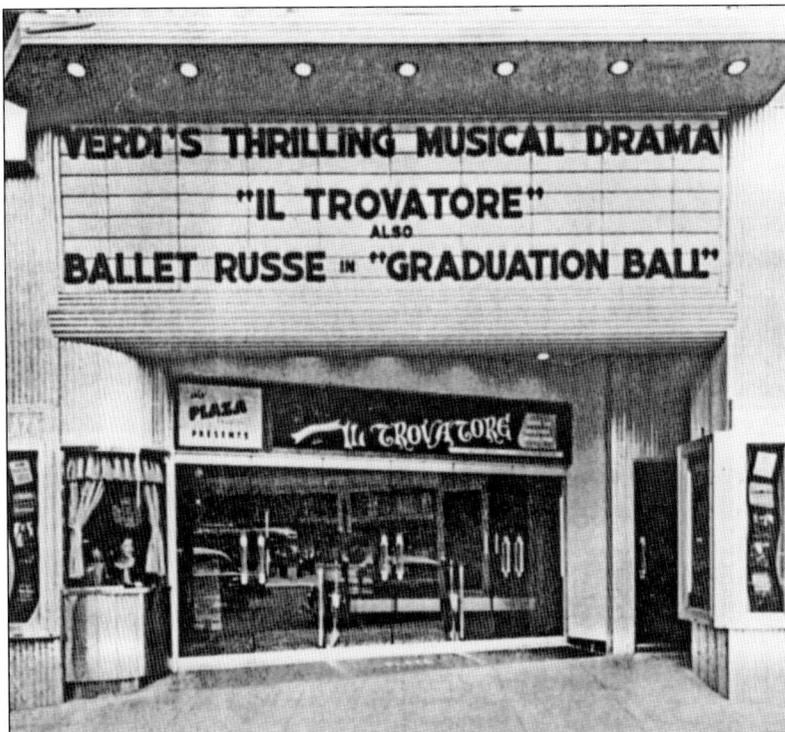

Pictured are two very different sides of the Plaza (1336 New York Avenue NW). The long, narrow art house theater opened in 1950 with director Edward Dmytryk's *Salt to the Devil*. The Plaza piped in Muzak between shows, a service it also provided for the office building that housed the theater.

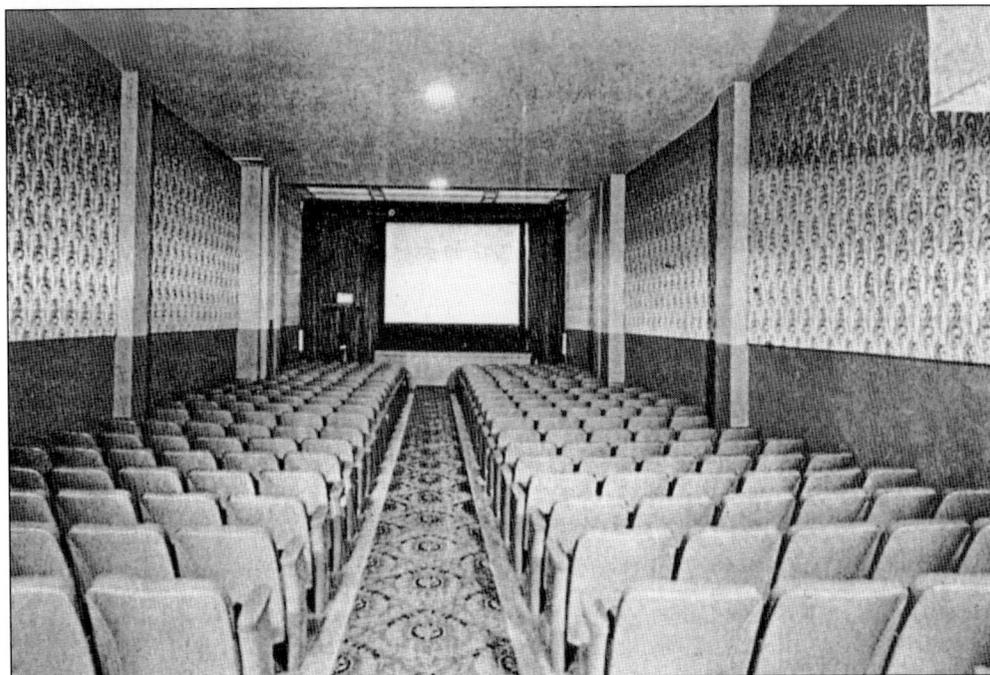

The tiny auditorium of the Plaza was reminiscent of the early nickelodeons. As the downtown commercial district declined in the 1970s, theaters such as the Plaza, which once ran highbrow fare like the 1949 adaptation of Verdi's classic opera *Il Trovatore*, resorted to X-rated movies and live burlesque shows.

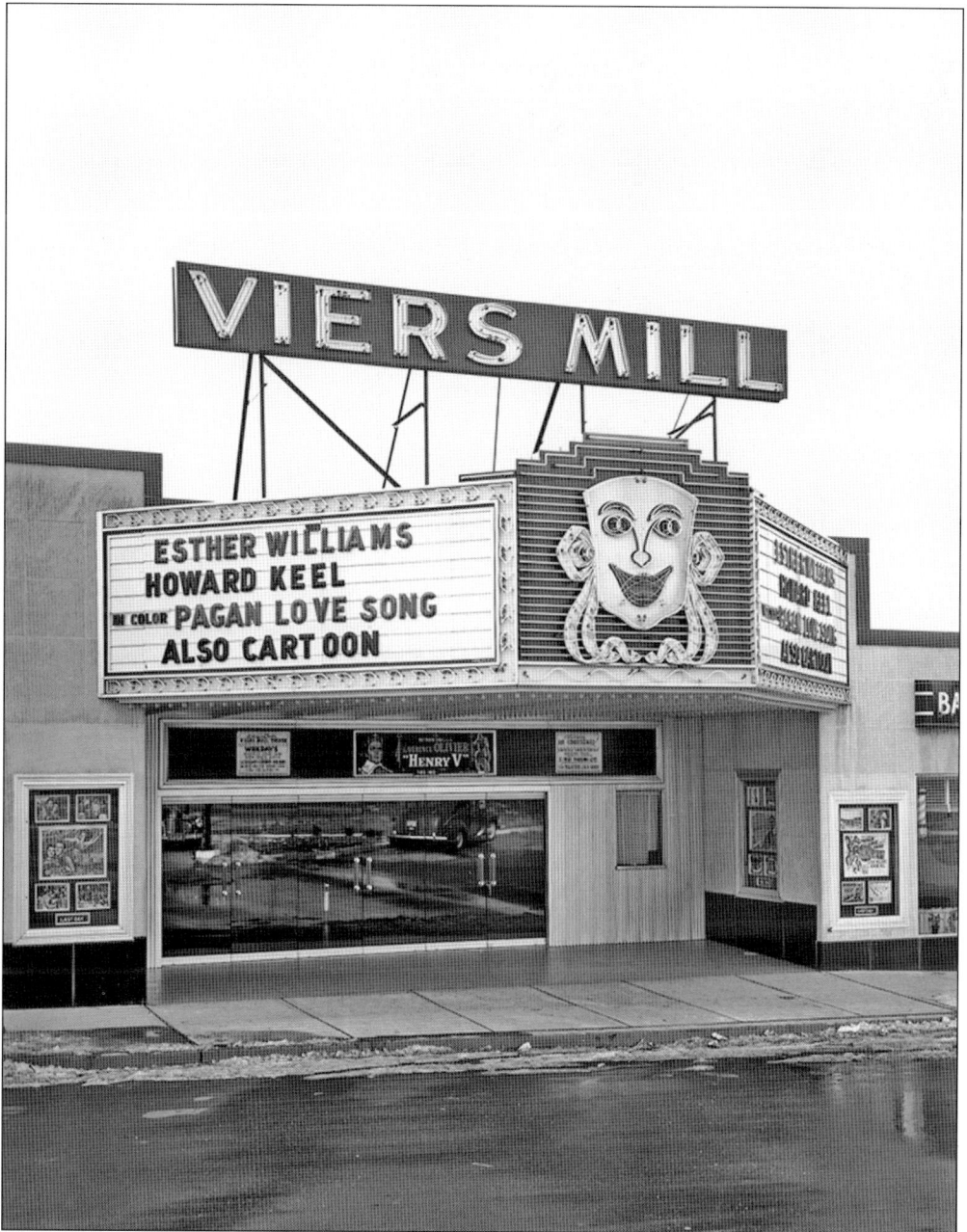

The 900-seat Viers Mill (12202 Viers Mill Road, Silver Spring, Maryland) was designed by Richard Parli and opened in 1950 with *The Good Humor Man*, a comedy starring Jack Carson as an ice-cream salesman. The theater boasted an RCA sound system and, perhaps more importantly to the moviegoer, American Bodiform Retractor Chairs. The Viers Mill was operated by the Sidney Lust organization, which loaned the space to a Catholic church for Sunday masses. The worshipers often faced a popcorn-strewn carpet from the previous night's show. The theater closed in 1975. (Courtesy of the Library of Congress, Prints & Photographs Division, Horydczak Collection, LGH-814-2631-001.)

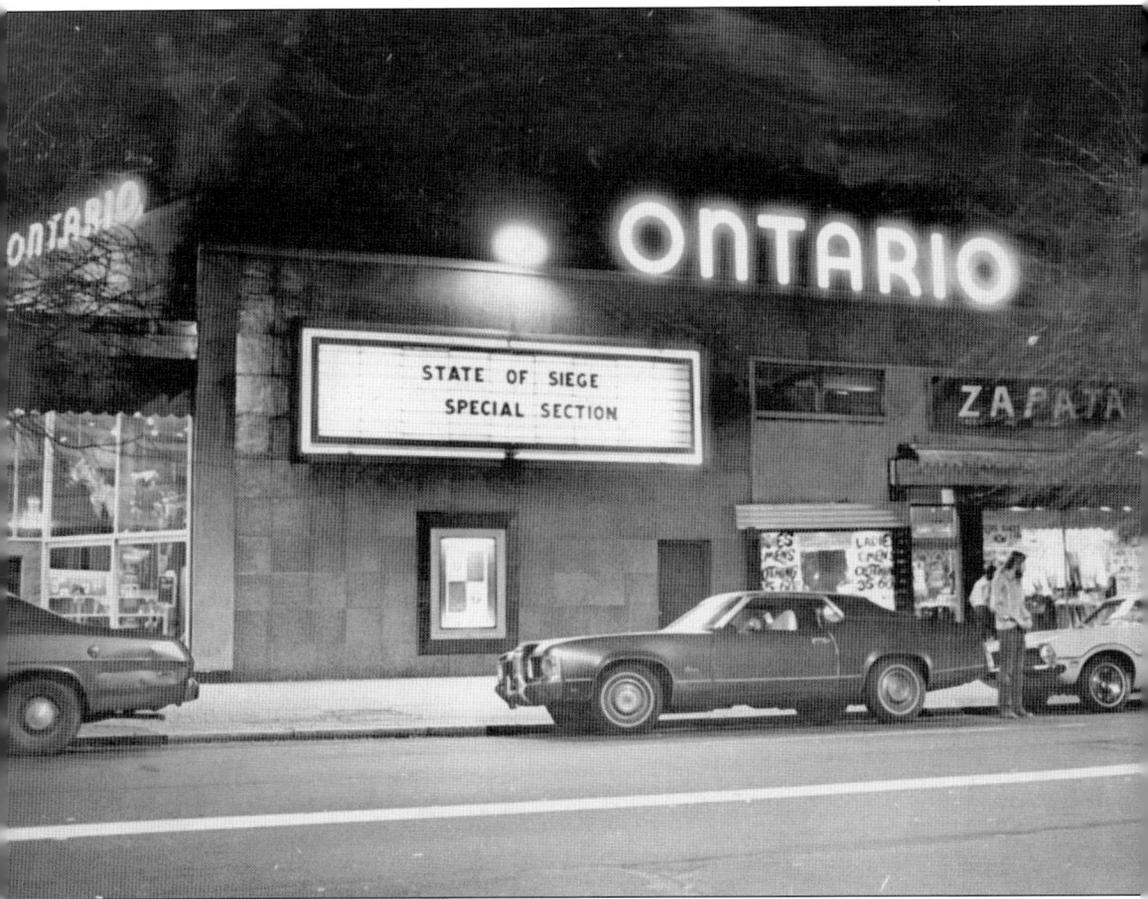

The Ontario Theater (1700 Columbia Road NW) was designed by John J. Zink and Frederick Moehle and opened in 1951 as part of the K-B chain. One of the first neighborhood theaters to offer first-run movies, the thriving venue hosted *The Sound of Music* for two years starting in 1966. As area demographics changed, the Ontario began to offer Spanish-language films in 1969. When the movie business struggled in the 1970s and 1980s, the venue hosted musical acts such as Todd Rundgren and Gang of Four. The Circle chain bought the Ontario in 1983, but it never reversed course. Its last show was *American Ninja 2*, which played to a crowd of 60 people in a space that held 800. The Ontario closed in 1987 and was converted into a drugstore. It has since been redeveloped as condominiums. (Reprinted with permission of the DC Public Library, Star Collection © *Washington Post*.)

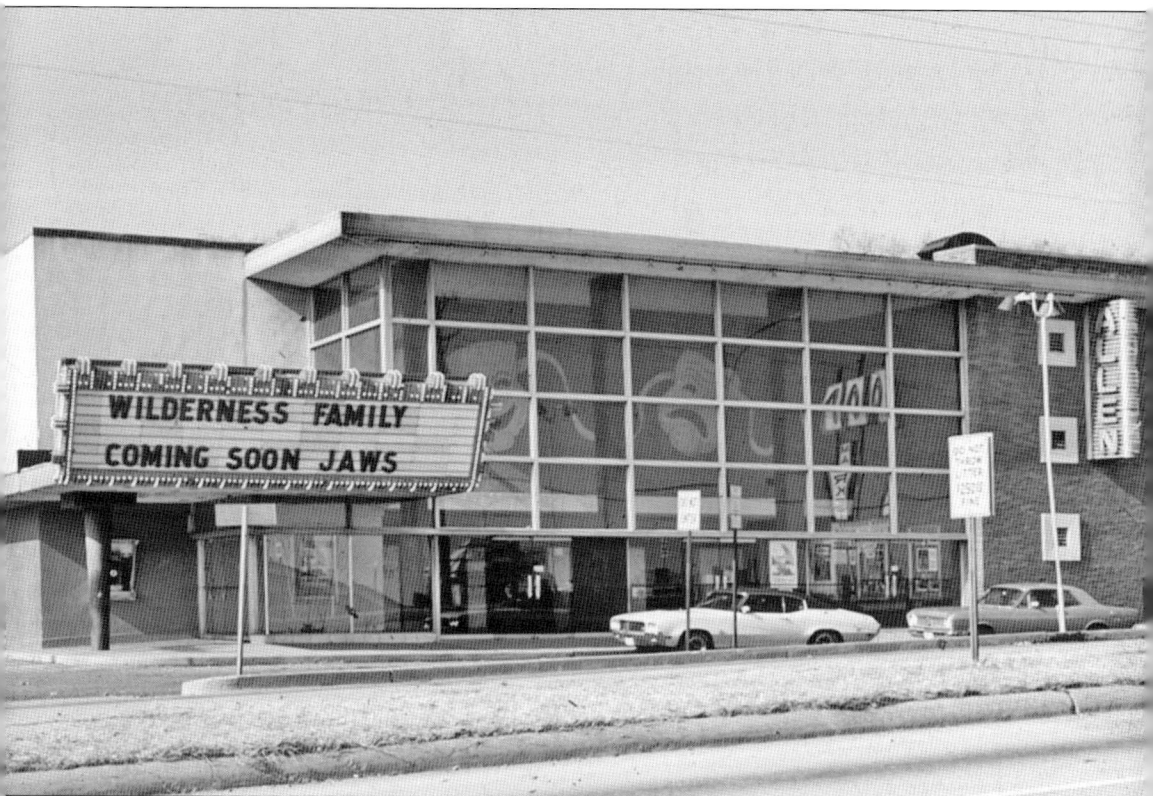

Designed by James Hogan and Francis Groff, the 946-seat Allen (6822 New Hampshire Avenue, Takoma Park, Maryland) anchored a 14-store strip mall. It opened on March 24, 1951, with the Jerry Lewis and Dean Martin comedy *At War with the Army*, as well as a stage show and an orchestra led by Leon Brusiloff, onetime conductor of the Fox Theatre Orchestra. Six floodlights operated by the Takoma Park Fire Department lit the way for the crowds that attended the opening night gala. Operated by Sidney Lust for many years, the theater was acquired by independent exhibitor Paul Sanchez in 1975. The Allen was twinned in 1985 and closed in 1990. The structure was converted into a shoe and clothing store that sustained massive damage in a 2009 fire.

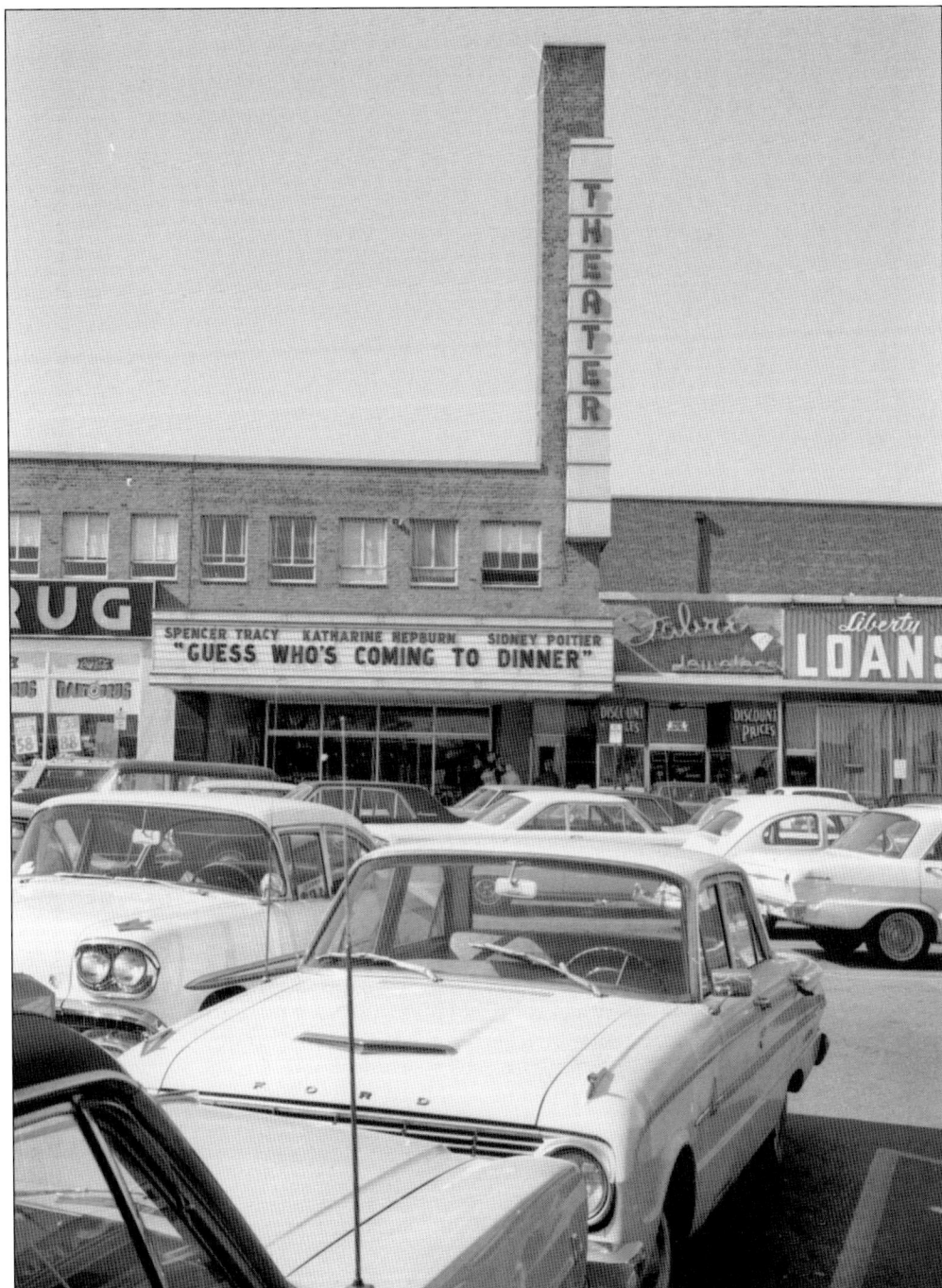

The John Zink and T.V. Craycroft–designed Langley opened in 1952 at 8014 New Hampshire Avenue in what was then the new suburb of Langley Park, Maryland. With 1,000 seats, the Langley featured amenities including a nursery, a private party room, and a coat check with refrigerated facilities that allowed patrons to check frozen foods and meat while they watched such movies as the Korean War drama *Retreat, Hell*, its premier offering. The Langley was twinned in 1982 and closed in 1989.

Seven

WIDESCREENS, SHOEBOXES, AND MULTIPLEXES, OH MY!

Built to hold 3,433 patrons, the movie palace once known as the Fox hosted its last vaudeville show on September 30, 1953, for an audience of just 150 people. The next day, Cinemascope premiered at the theater with *The Robe*, and the house set a daily record of 11,142.

This glorious return to spectacle for downtown theaters was short-lived. The Capitol closed in 1963 and was demolished in 1964; remaining downtown theaters that were once home to first-run studio pictures were often relegated to grindhouses as the downtown shopping district continued its decline and glorious buildings such as the Willard Hotel fell into disrepair.

In the 1950s, drive-in theaters continued to grow in popularity, with seven outdoor screens opening in Prince George's County alone. Yet Hollywood still felt the impact of television and developed ever-new ways of competing, offering big-screen spectacle that tiny home screens could not hope to match. More and more films abandoned the academy ratio for such widescreen formats as Cinemascope and Vistavision. Aromarama premiered in 1959 with *Behind the Great Wall*, a travelogue that had the scents of China piped in through a theater's air-conditioning vents. It was not a great success. Movies in 3-D lured viewers with promises of thrilling action in their laps, although the technology behind such films as *Creature from the Black Lagoon* did not quite live up to that promise.

Still, a renaissance was on the way. From 1962 to 1966, as baby boomers came of age, the demand for movies and movie theaters increased, although the public clamored for a different type of product and a different way to consume it. As shopping mall construction boomed in the suburbs, so did mall theaters.

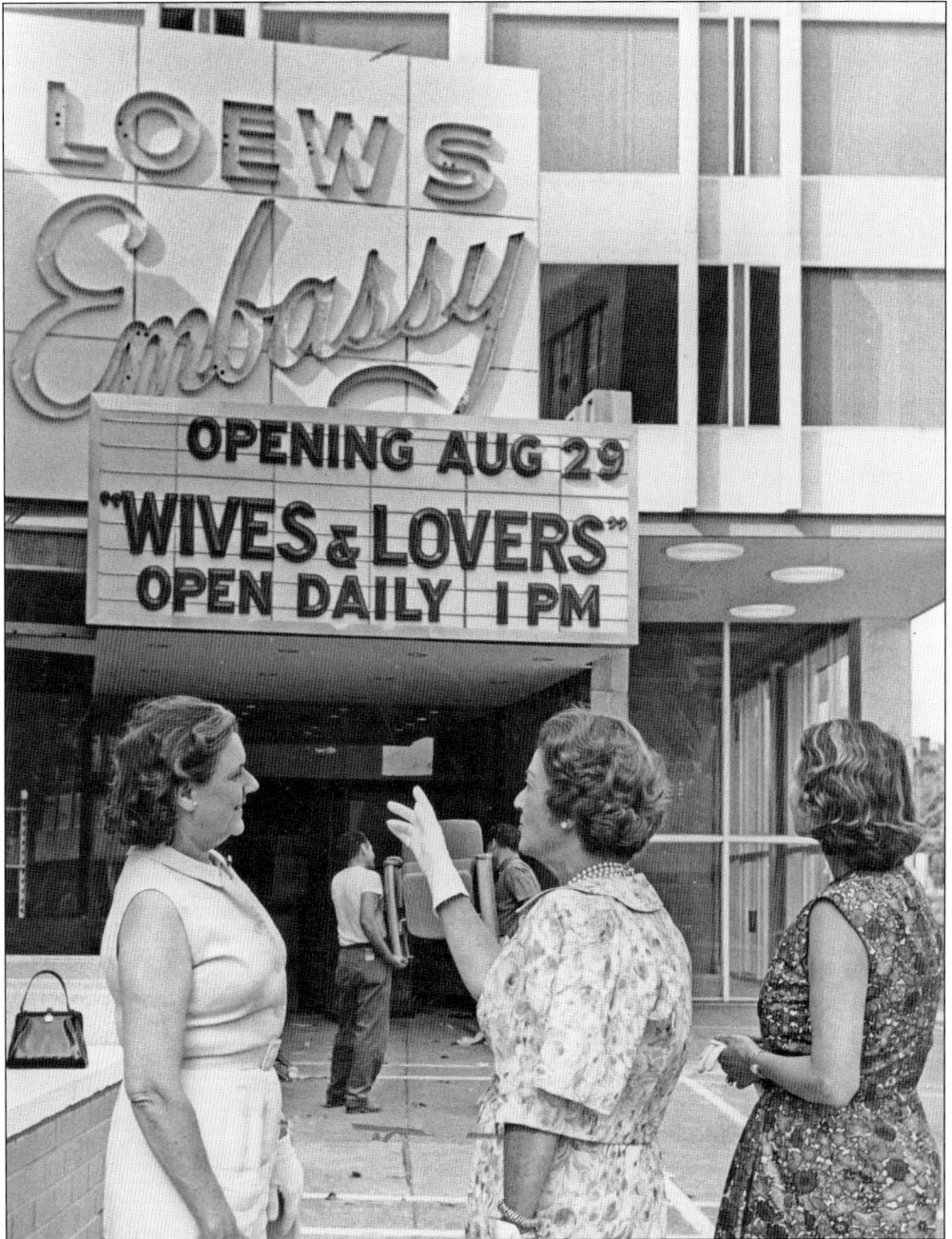

The Embassy (1907 Florida Avenue NW) is seen on its opening day in 1963. Just north of Dupont Circle, it was the first new downtown theater in 13 years, and its opening gala featured the star power of Janet Leigh, who appeared in person for the premiere of *Wives and Lovers*. But it would be the last big downtown movie theater opening for decades. In 1978, the Pedas brothers took over the theater, and they operated it until it closed in 1998. In 2000, the Embassy reopened as the independent art house theater Visions, but its once-impressive single screen was awkwardly twinned, and this theater closed in 2004. The theater is now the site of a gym. (Reprinted with permission of the DC Public Library, Star Collection © *Washington Post*.)

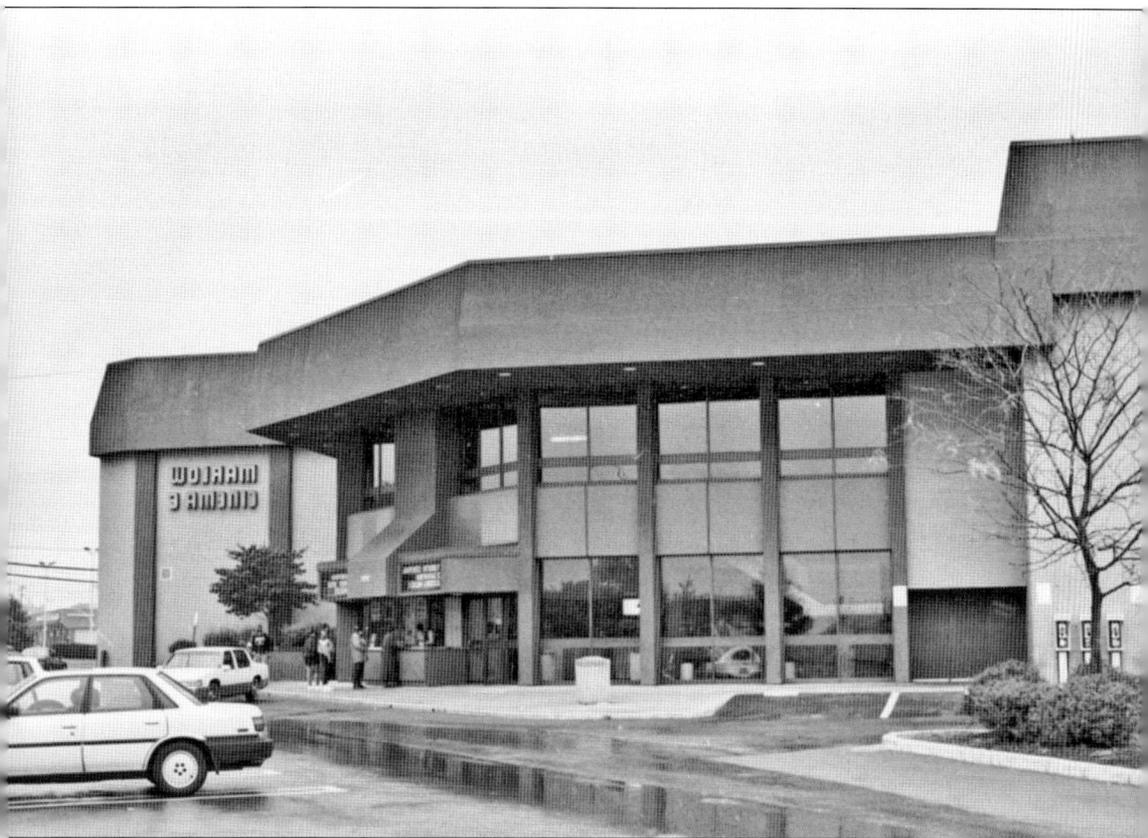

Designed by Loewer Sargent & Associates, the concrete geometry of the Marlow Cinema 6 (3899 Branch Avenue, Temple Hills, Maryland), which opened in 1963, suggested a shopping-mall variety of brutalism. Its stark design was in marked contrast to the Doris Day–James Garner confection *The Thrill of It All* that opened it. The first new indoor movie theater in Prince George's County in 15 years, the theater was later twinned in 1977, and in 1985, it closed for conversion to a six-screen multiplex that still operates today.

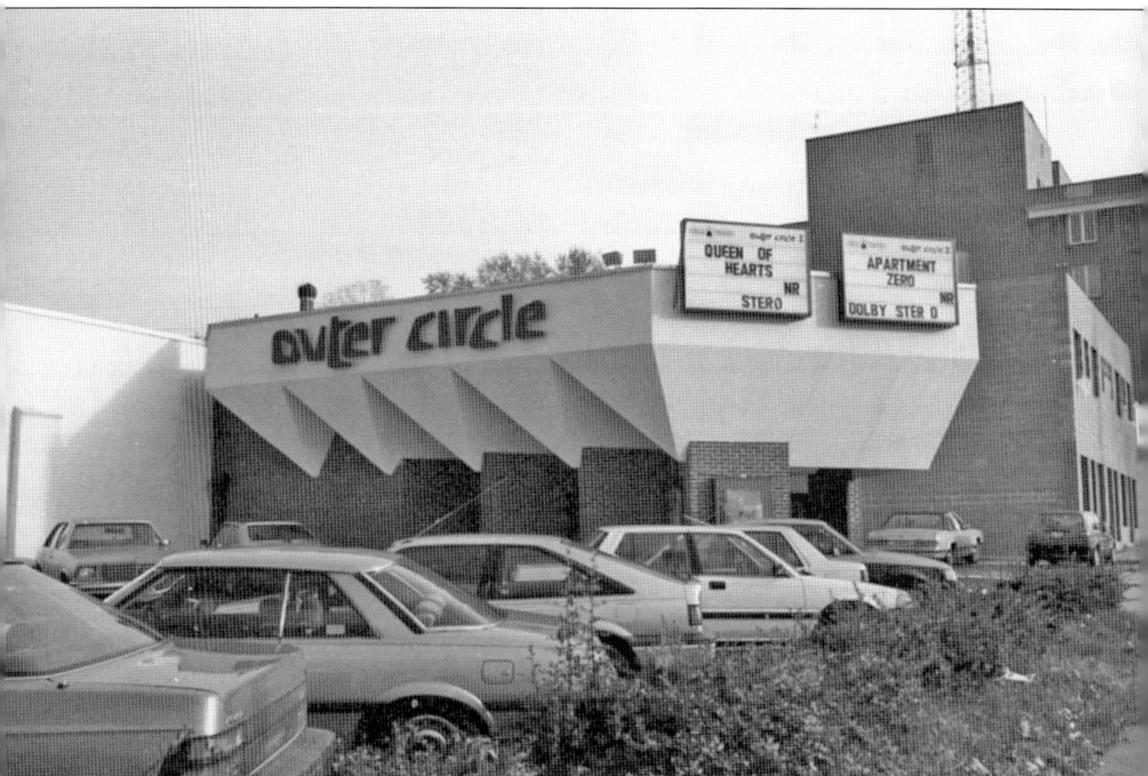

One of the smaller neighborhood theaters, the Outer Circle (4849 Wisconsin Avenue NW) was designed by Catholic University alumnus Walter Woodhouse of Goenner and Woodhouse, a firm that also designed the Tenley Circle farther up Wisconsin Avenue. The theater opened in 1970 with two small auditoriums that seated only 284 and 154 people. Long lines were the norm for such popular art house fare as *The Crying Game*. The Outer Circle closed in 2004 and was demolished in 2008, and even though its architecture was by then badly dated, its distinct example of commercial design of the era is missed. This stretch of Wisconsin Avenue was once a thriving movie hub, with the Cinema, Jennifer, Studio, Tenley, and Wisconsin Avenue Cinemas; the only theater remaining on the busy commercial corridor is the AMC Mazza Gallerie.

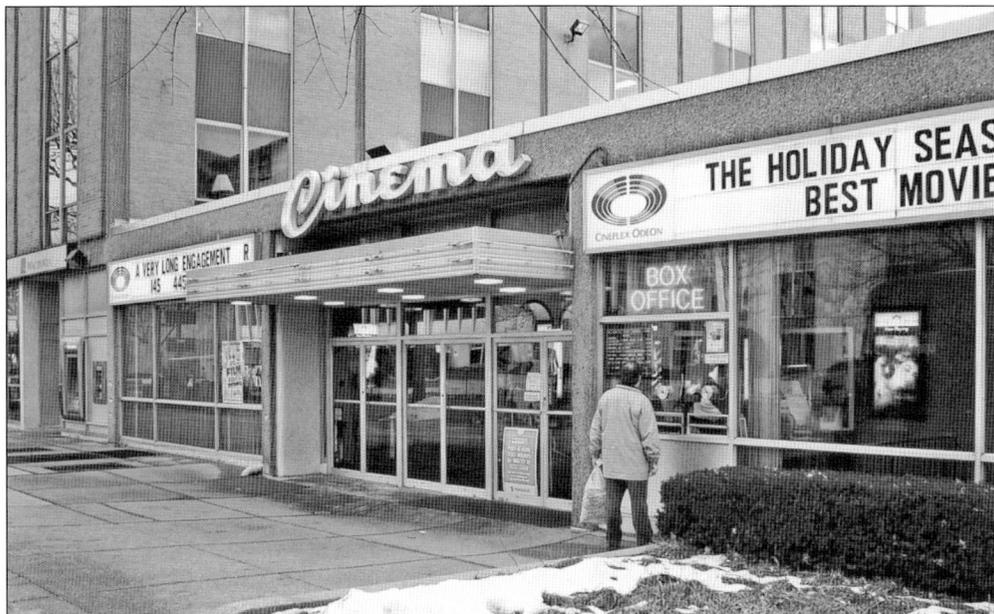

On April 2, 1965, writing about the "sparkling new" Cinema (5100 Wisconsin Avenue NW), the *Washington Post*'s Richard L. Coe excitedly described sound "that floats DOWN from speakers in the ceiling," and concluded, "Tomorrow's World is here." Yet he panned the theater's opening night film, the Italian comedy *White Voices*. The theater closed in January 2005 and has since been converted into a gym.

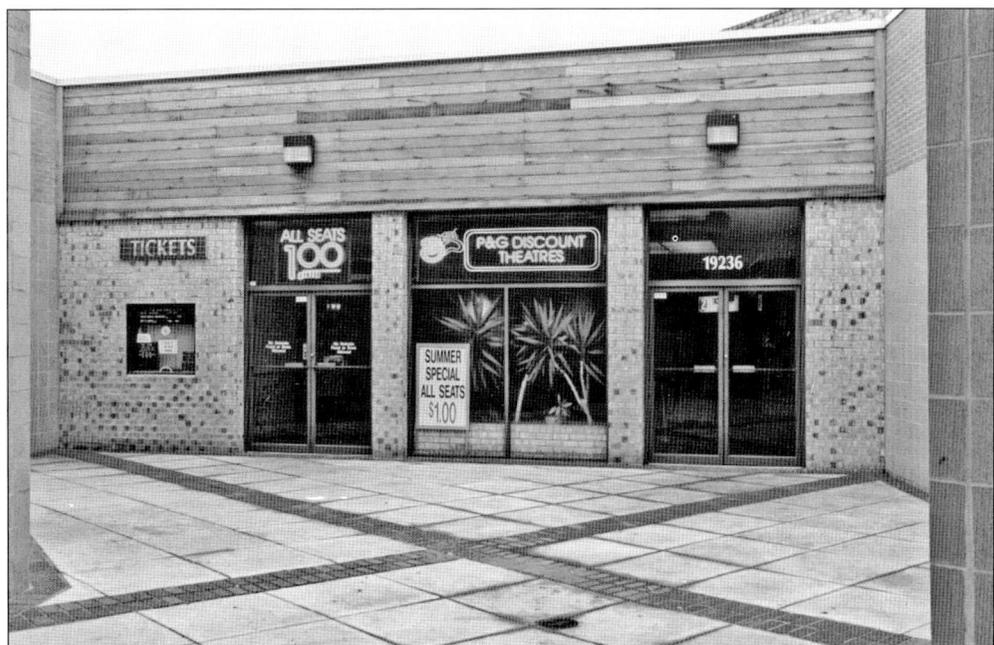

The Montgomery (558 North Frederick Avenue, Gaithersburg, Maryland) was built in 1966 in the Gaithersburg Square Shopping Center in an area of Montgomery County that was then predicted to become the second-highest population center in Maryland. The theater originally had a single 700-seat screen; a second 500-seat theater was added in 1970. It closed in 1993.

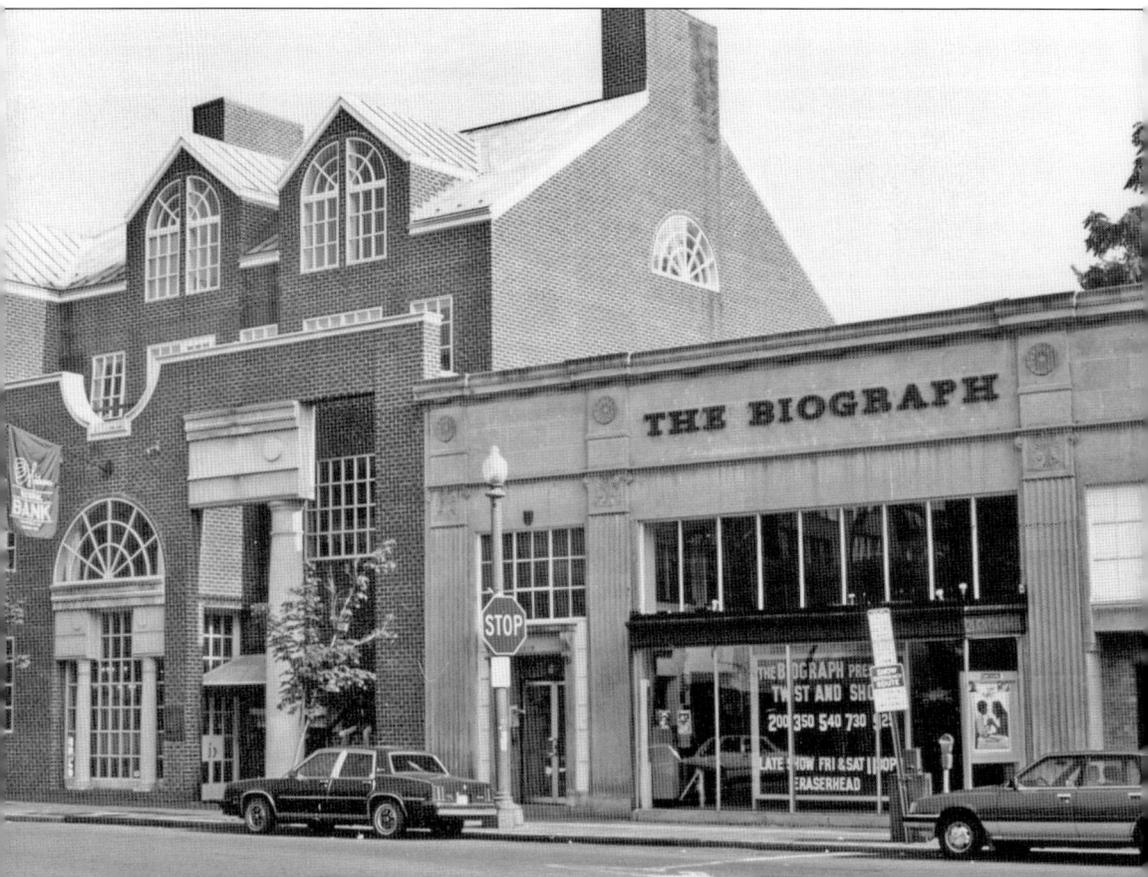

Alan Rubin, David Levy, Leonard Poryles, Paul Tauber, and Neil Cohen converted the Manhattan Auto Showroom into the Biograph (2819 M Street NW). Instead of tickets, the theater issued tokens that were placed in a turnstile leading to a 280-seat auditorium. As suited the venue's former life, it was like watching a movie in a garage, but despite its flaws as a theater, the Biograph is one of the most-missed institutions in Georgetown. The theater opened in 1967 with Jean-Luc Godard's *Masculin Féminin* and became a haven for art house and repertory programs. To help make ends meet, the theater began showing X-rated matinees in 1989. When the theater's lease expired in 1996, the Biograph closed its doors. It was replaced by a drugstore. (Courtesy of the Peabody Room, Georgetown Public Library.)

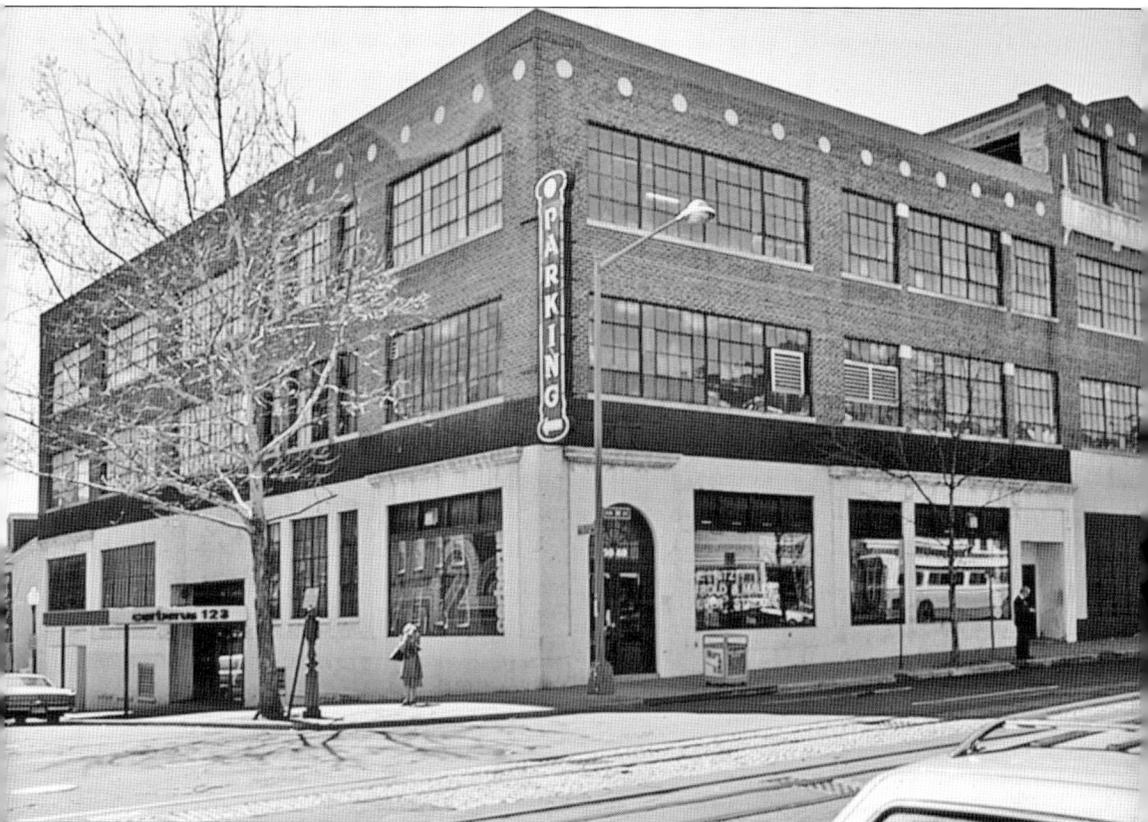

Named for the mythological three-headed dog, the Cerberus (3040 M Street NW), which opened in 1970, featured small auditoriums that were far from ferocious. Martin Field and Harold Slate forged the three-screen beast out of the former Parkway Dodge auto sales agency, reportedly with the profits made from showing the controversial *I Am Curious (Yellow)* at the Janus, the tiny Dupont Circle theater the team built in 1965. The Cerberus became a second-run $1 theater in 1991 and closed in 1993. The small auditoriums were dramatically reconfigured into a big-box bookstore, but that too closed, and the space sells sporting goods in 2018.

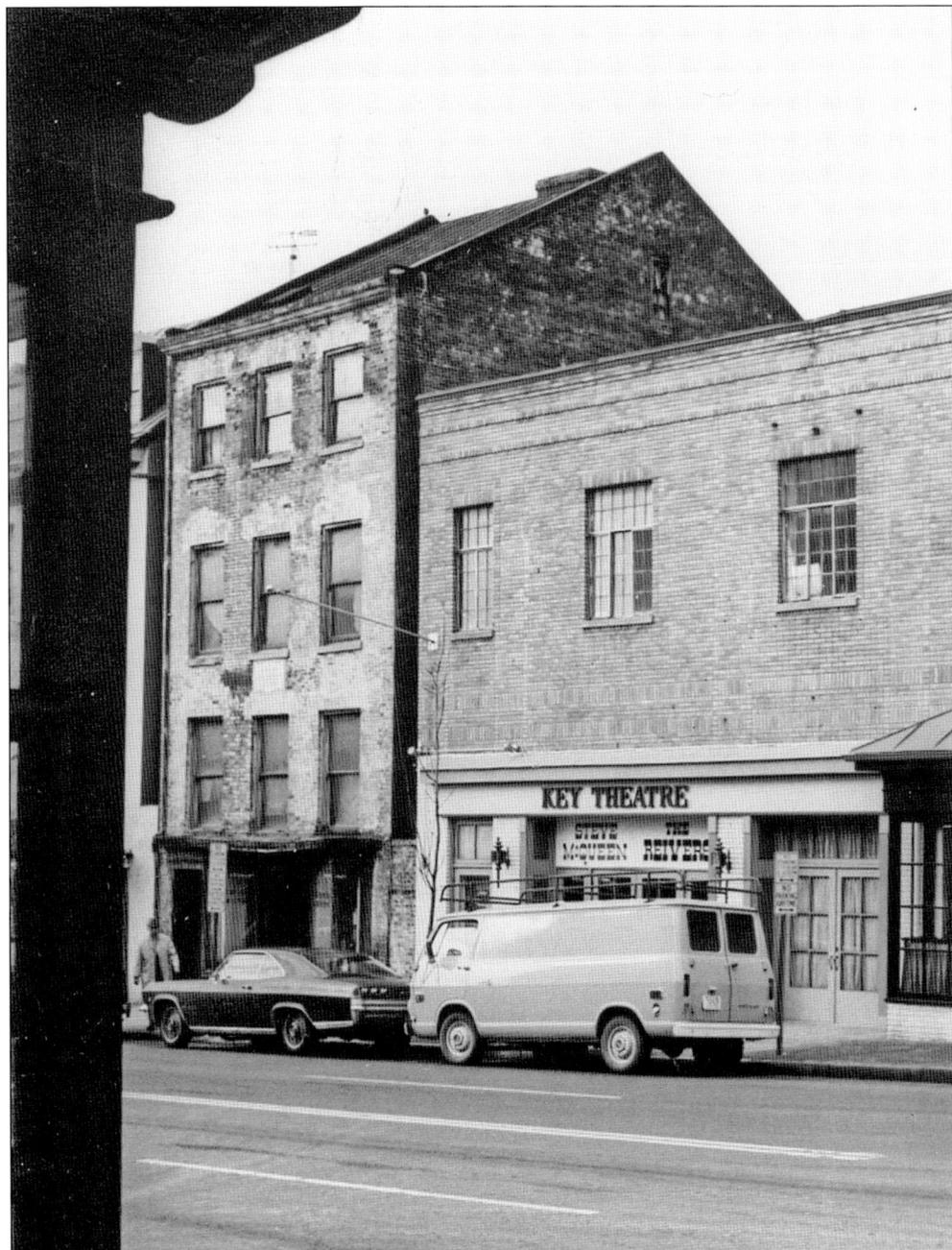

Don King opened the Key (1222 Wisconsin Avenue NW) in 1969 in a former bowling alley whose wide layout provided a surprisingly apt setting for an art house theater. Originally named after Francis Scott Key, author of "Defence of Fort M'Henry" and onetime Georgetown resident, the theater had a first-floor screen that held 360 people. Three smaller auditoriums were later built on the second and third floors. The Key's independent and repertory films and long-running midnight screenings of *The Rocky Horror Picture Show* were a mainstay of Georgetown life for nearly three decades. The theater closed in 1997 and is an upscale furniture store in 2018. (Courtesy of the Peabody Room, Georgetown Public Library.)

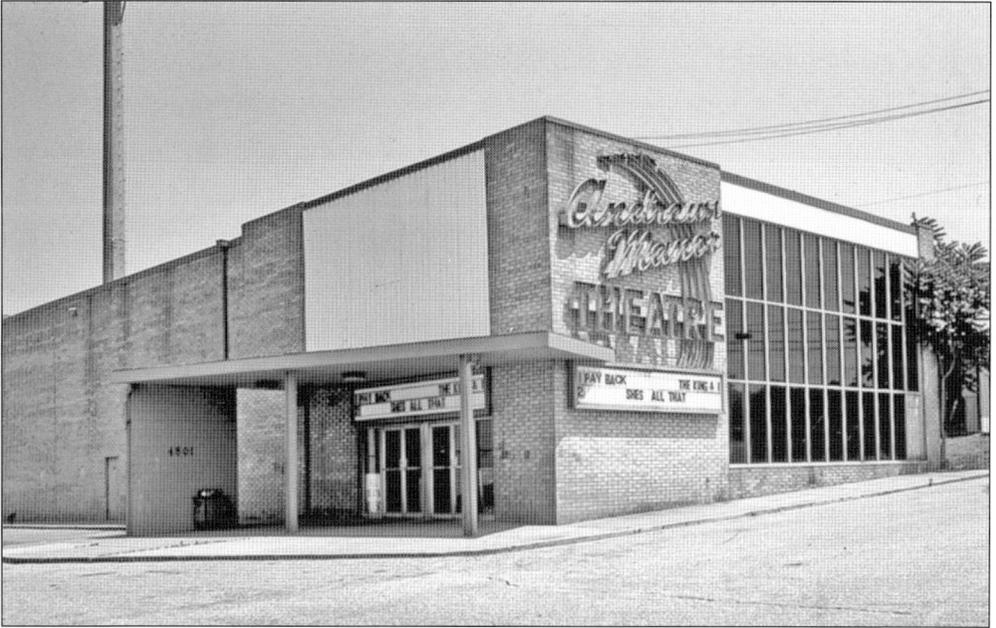

The Andrews Manor (4801 Allentown Road, Camp Springs, Maryland) opened on May 19, 1965, with the 1965 John Wayne Western *Circus World*. Staggered seating accommodated 1,000 patrons to watch a screen that was one of the widest in the state. The theater was twinned in 1984 but closed and has been demolished.

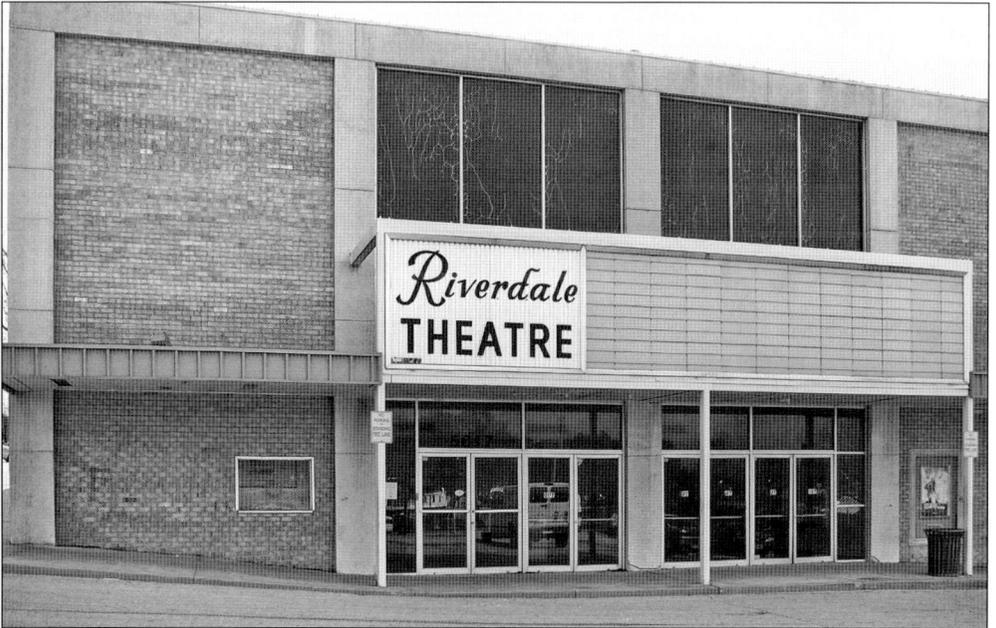

Typical of the big-box theaters constructed in the 1960s, the 815-seat Riverdale Theatre (5617 Riverdale Road, Riverdale, Maryland) was designed by Donald N. Coupard & Associates. It opened in 1968 with the George Peppard private eye thriller *P.J.* The theater was twinned in 1993 and closed in 2001. It remains one of many vacant spaces in the once-thriving Riverdale Plaza Shopping Center.

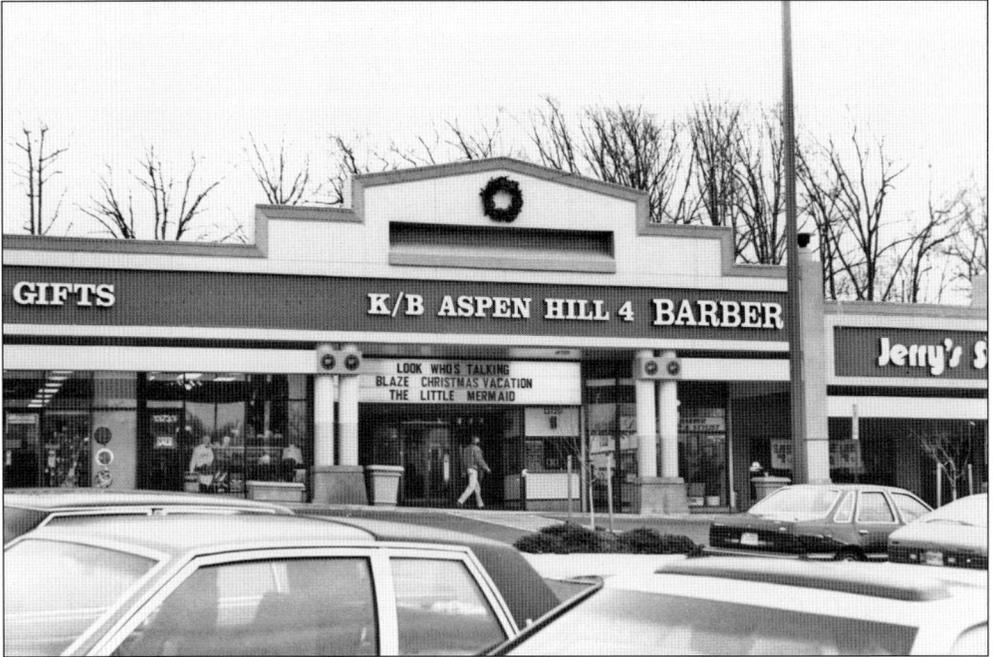

Victor Smolen designed the Aspen Hill (13729 Connecticut Avenue, Wheaton, Maryland), a twin that opened in 1970 with *Bob & Carol & Ted & Alice* and *True Grit*. Two additional theaters were added in 1986. The theater closed in 2000 and is now a drugstore.

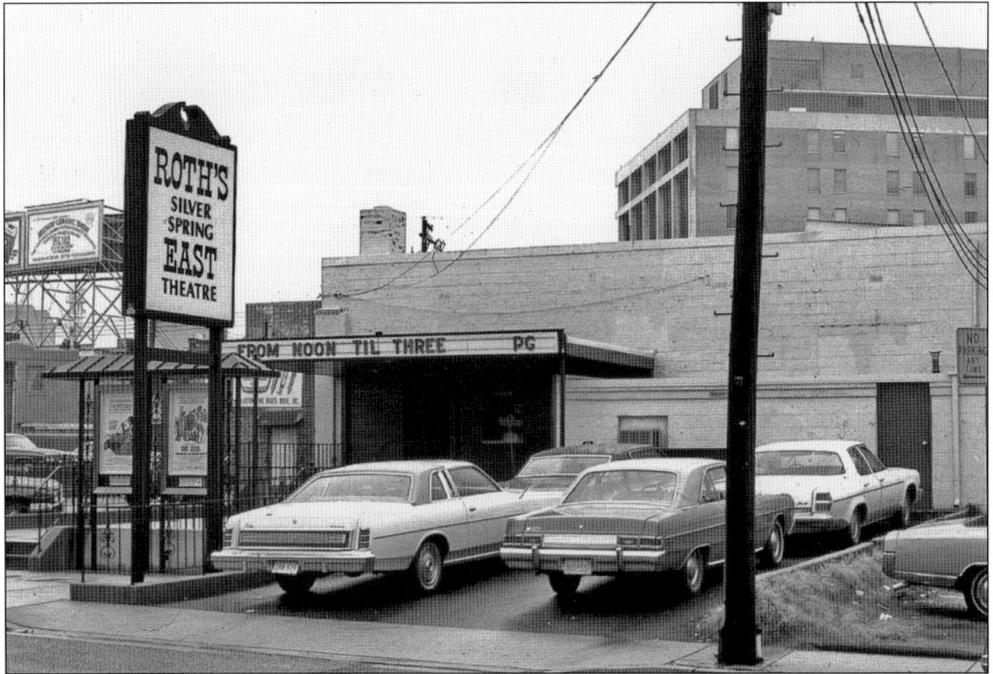

A former skating rink, the 383-seat Silver Spring East (951 Thayer Avenue, Silver Spring, Maryland) was built in 75 days as a companion to Roth's Silver Spring on Georgia Avenue. It opened in 1969 with the John Huston period drama *A Walk with Love and Death*. It closed in 1991.

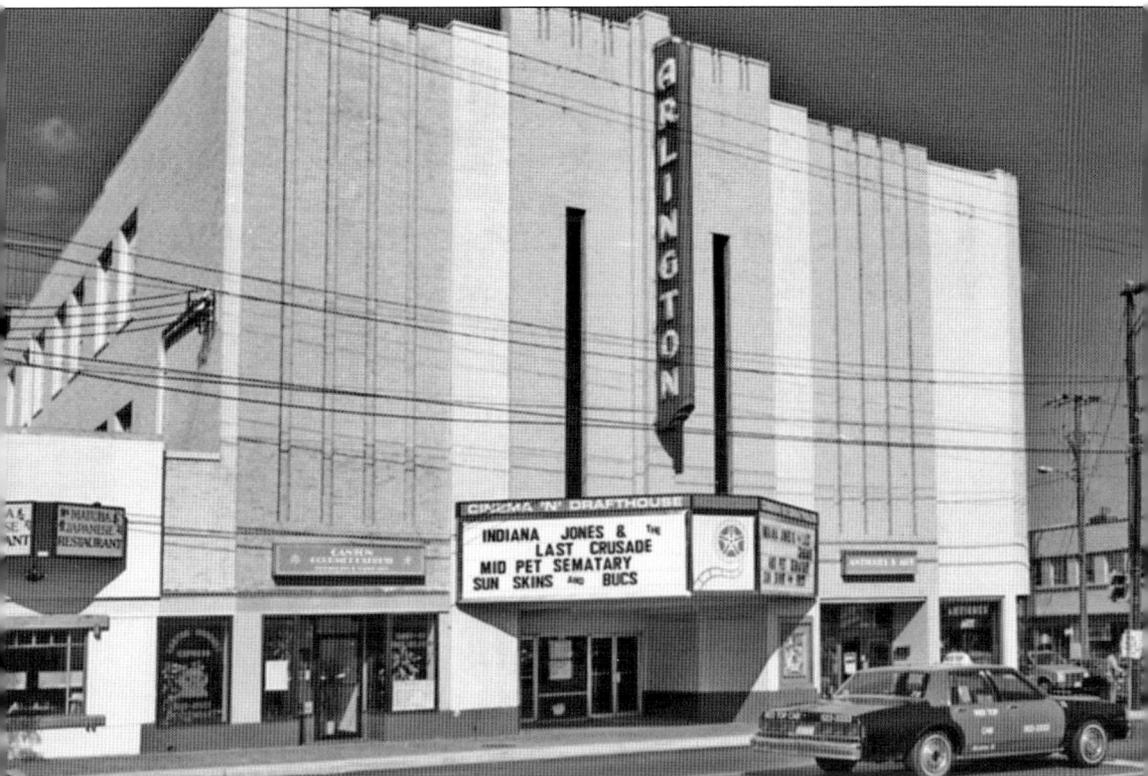

The massive front of the Arlington Theater (2901 Columbia Pike, Arlington, Virginia, 1940–present) dominates the corner of Columbia Pike and South Walter Reed Drive. It was designed by Richmond architect Fred Bishop for Neighborhood Theaters and featured a large bowling alley on the second and third floors. It was converted to the Arlington Cinema and Drafthouse in 1985.

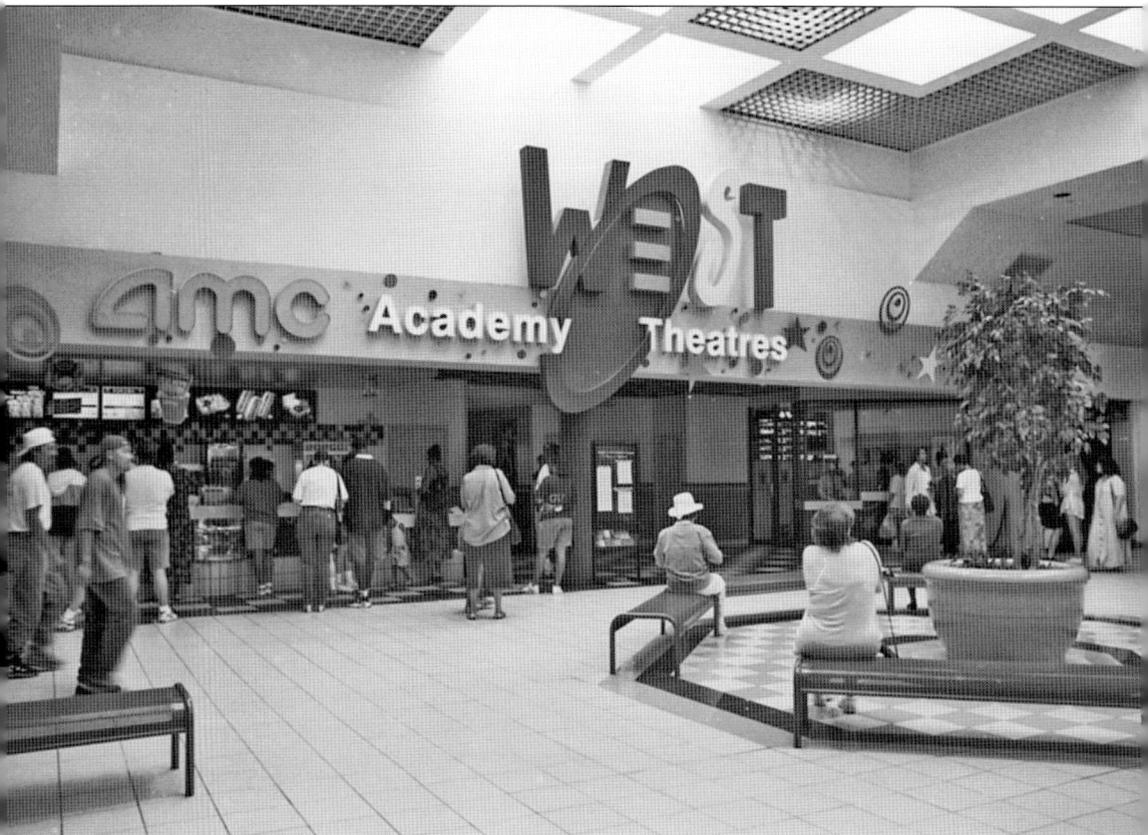

The Academy 6 (6228 Greenbelt Road) was built in 1975 as part of an expansion of Beltway Plaza. It opened on March 28 of that year with a lineup that included such art house fare as Fellini's *Amarcord* alongside Disney's *The Strongest Man in the World*. The six-plex closed in 2005. AMC then opened an eight-screen theater near the middle of the mall that it still operates.

Eight

DECLINE AND REBIRTH

The 1980s were a dark time for area movie theaters. Between 1984 and 1990, fifty-six theaters closed. Plans to revitalize downtown focused on new and often undistinguished construction, not on renovating grand, neglected theaters that still existed.

Yet despite the demise of such beautiful theaters as the Ontario and the disappearance of movie theaters entirely from such formerly cinema-friendly neighborhoods as Dupont Circle, persistence and local interest has led to a number of preservation successes. The Avalon, once known as the Chevy Chase, has become a thriving independent theater, and the American Film Institute (AFI) moved its operation from the Kennedy Center to the Silver, which has been one of the premier venues for art house films and festivals. Coming full circle from early motion pictures of dancing cats, the AFI Silver has hosted programs of YouTube cat videos.

After decades of boxy auditoriums that were plain and utilitarian, with entrances often buried deep within indoor shopping malls, eye-catching exteriors and lavishly ornamented interiors returned to movie theaters. This time, they took shape in megaplexes with more theaters than ever and bigger screens as well. Such well-appointed examples are the Egyptian, Gallery Place, and almost any Regal theater. These comfortable venues feature adjustable, overstuffed, reserved seats; digital projection; breathtaking sound systems; and stadium seating that offers excellent sight lines. Concession stands have become enormous operations that in better theaters offer beer and wine—and in some instances, artisanal popcorn.

While such theaters as the Tivoli, the Atlas, and the Howard no longer show films, each has found a resurgence as a performing arts venue. In an era dominated by consumers content to watch movies on their phones, the Washington market still inspires developers with dreams of big-screen entertainment. With a healthy offering of repertory programs in auditoriums at the National Gallery of Art, the Freer, and the Library of Congress and state-of-the-art IMAX projection at the National Air and Space Museum, institutions help keep movies alive. And with Angelika opening up a pop-up theater in the revitalized area of NoMa and Alamo planning to open up a draft house on Rhode Island Avenue, this is as good a time as any to go to the movies in the Washington area.

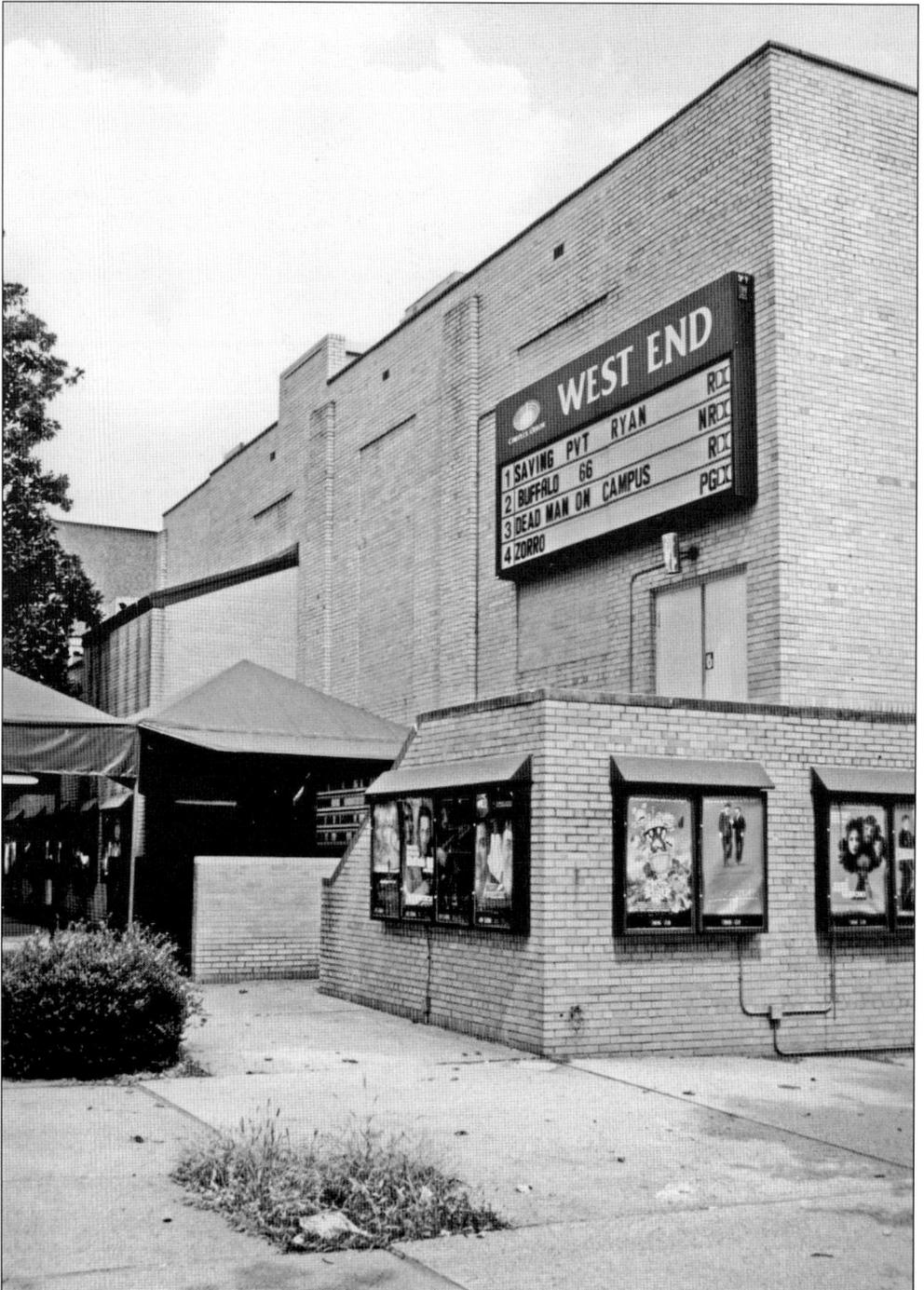

Opening in 1977, the West End 1–4 (1101 Twenty-Third Street NW) reversed a trend for shuttered movie houses; Circle Theatres purchased a space that had been converted from a church into a space used by the Washington Theater Club. It closed in 1998 and was demolished. A satellite theater, the West End 5–7, was built in 1985 and closed in early 2002. It remained vacant for years before being revived as an independent theater and in 2018 operates as the Landmark West End.

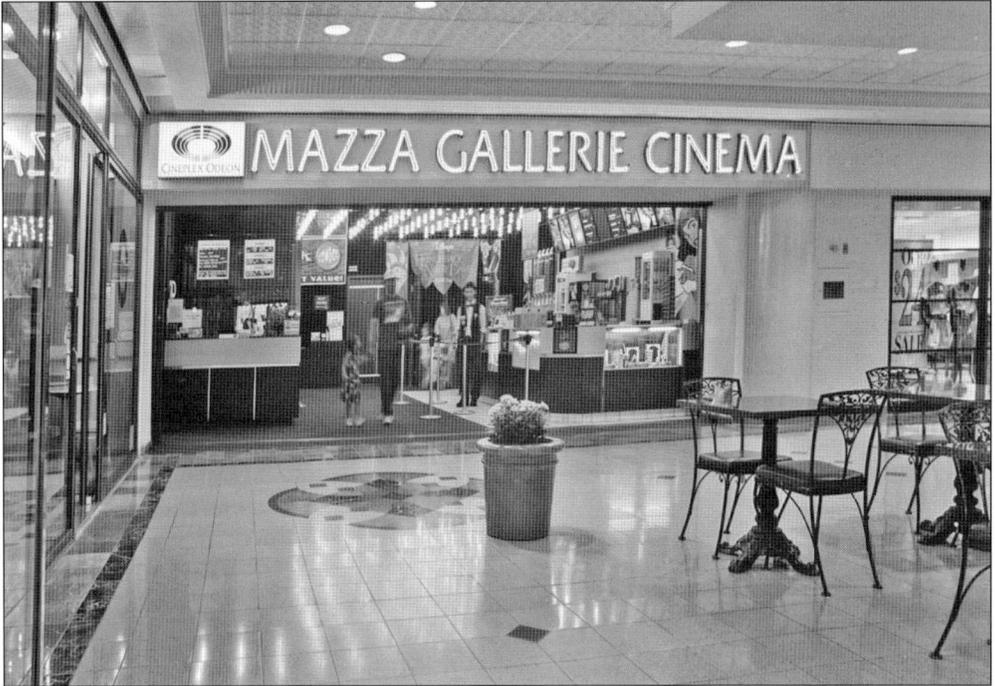

The basement-level Paris (5300 Wisconsin Avenue NW), designed by James T. Martino, was the first theater at Mazza Gallerie mall. Its three small auditoriums opened in 1985 with *The Killing Fields*, the Argentine drama *Camila*, and a rerelease of *The 400 Blows*. After it closed in 1998, a new multiplex was built on the mall's top floor, and it still operates today.

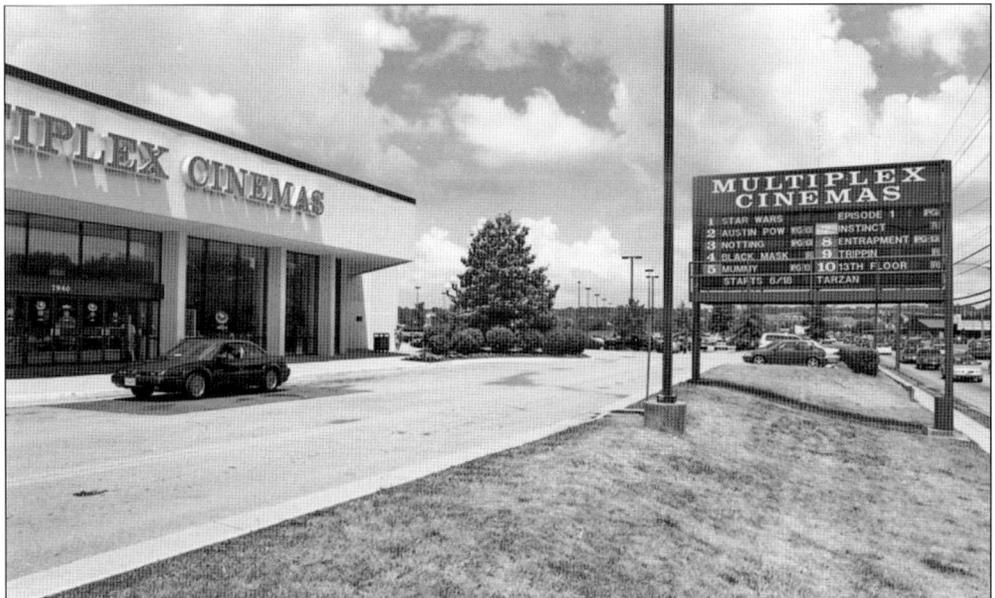

Built on the site of a drive-in, the 14-screen Lee Highway Multiplex (8223 Lee Highway, Merrifield, Virginia) was designed by William Riseman Associates and opened in 1986. The theater closed in 2009 and was demolished; in 2018, this is the site of the Mosaic, the Angelika chain's first venue in the Washington area.

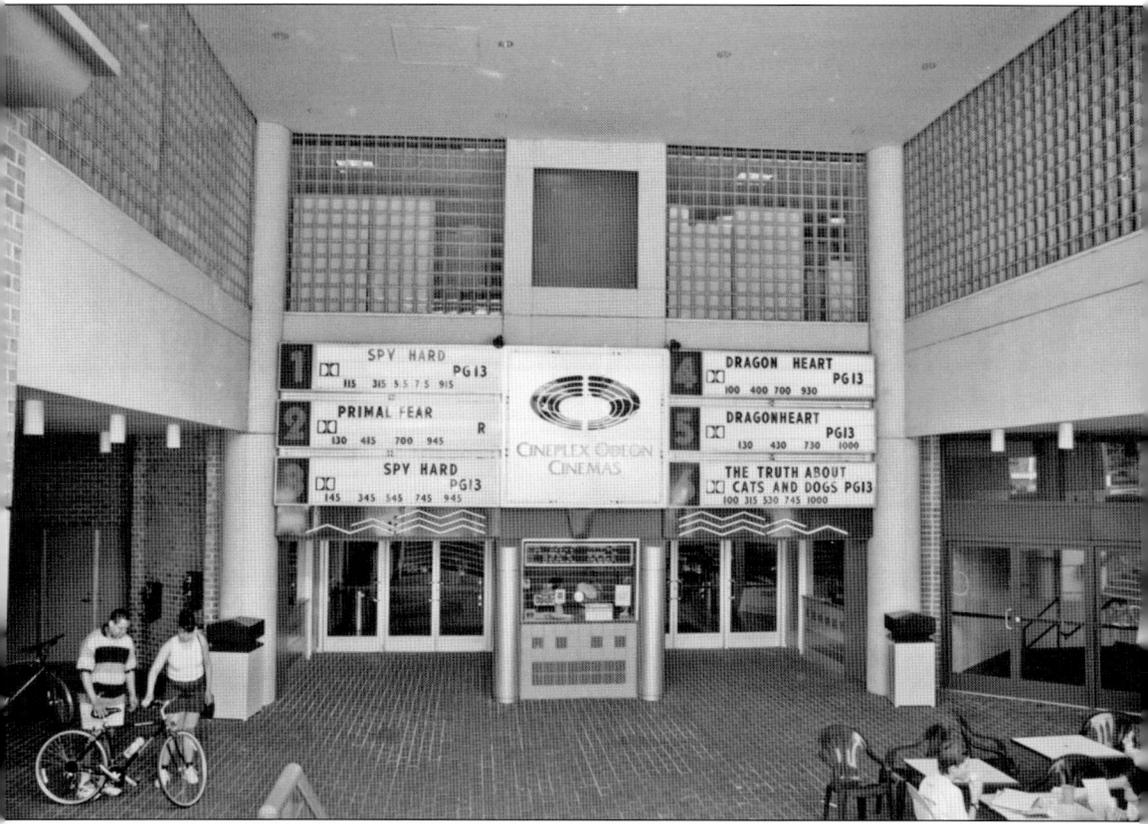

A popular multiplex in a well-to-do neighborhood, the six-screen Cineplex Odeon Wisconsin Avenue (4000 Wisconsin Avenue NW) opened in 1987 hosting mainstream fare and film festival screenings. The theater closed in 2006, and its space was converted into Fannie Mae offices.

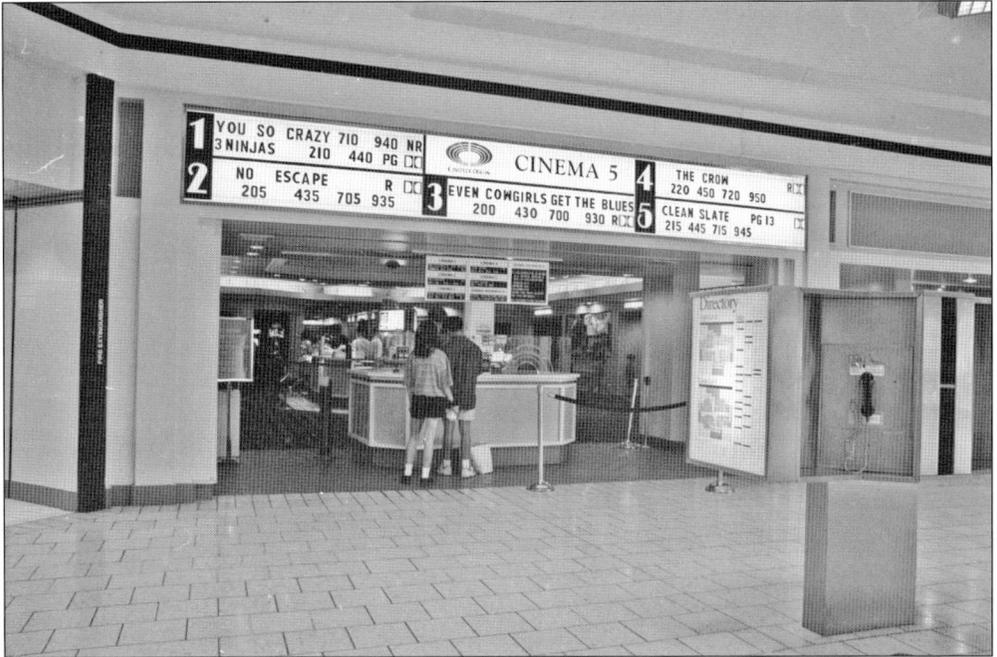

Replacing an indoor skating rink, Lake Forest Mall's five-screen multiplex (701 Russell Avenue, Gaithersburg, Maryland) opened in 1984 with *Star Trek III: The Search for Spock*, *Once Upon a Time in America*, and *Streets of Fire*. The theater has closed.

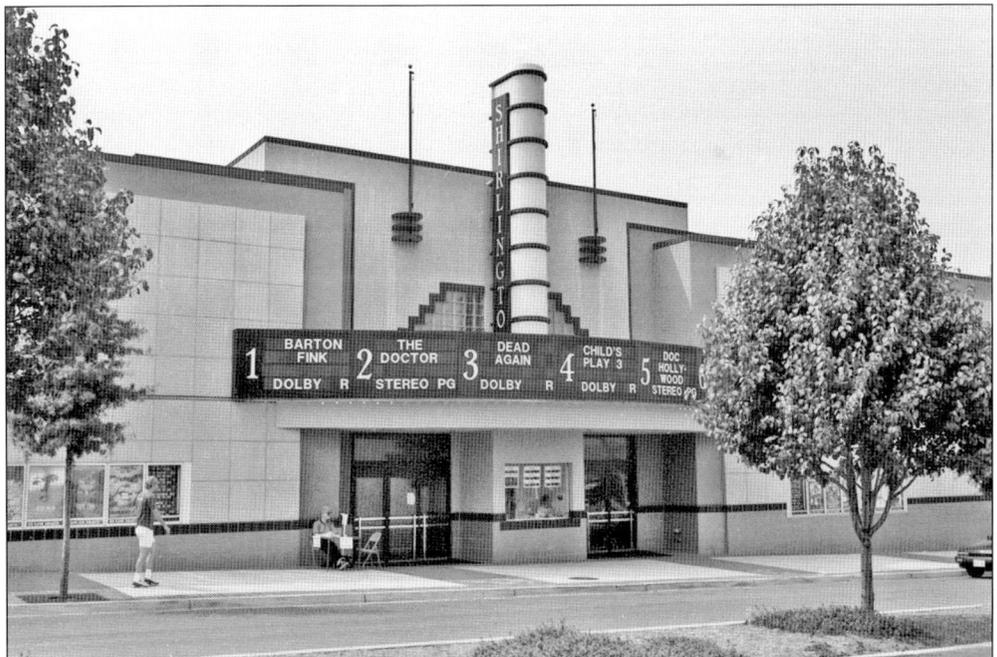

Built near the site of a short-lived John Zink–designed theater that had closed in 1957, the seven-screen Shirlington (2772 South Randolph Street, Arlington, Virginia) was designed by KressCox Associates, who were inspired to add art deco touches and an old-fashioned marquee that ran counter to the era's generic theater architecture. It opened in 1987.

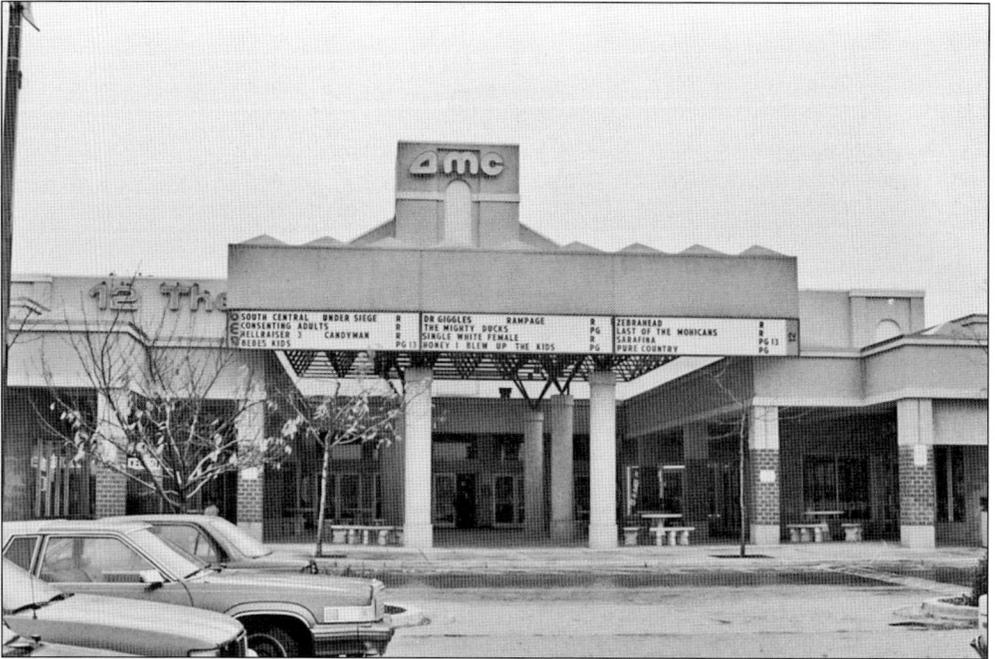

The 12-screen Rivertowne (6075 Oxon Hill Road, Oxon Hill, Maryland) opened in 1987 with such features as 70-millimeter projection, stereo surround sound, and comfortable reclining seats with built-in cup holders. The theater closed in 2006 but has since reopened as an AMC theater.

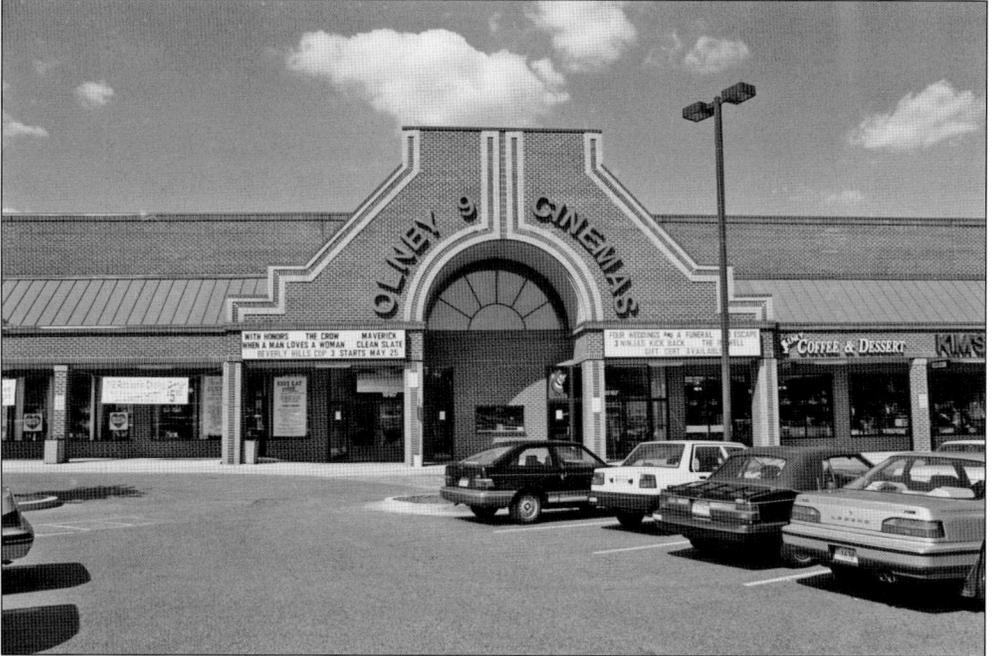

The Olney 9 (18167 Town Center Drive, Olney, Maryland) opened in a strip mall in 1988 and advertised what it called "state of the art theaters." Late in its existence, the theater's Yelp reviews frequently called it "the worst move theater EVER," complaining of damaged screens and sticky floors. The theater closed in 2008.

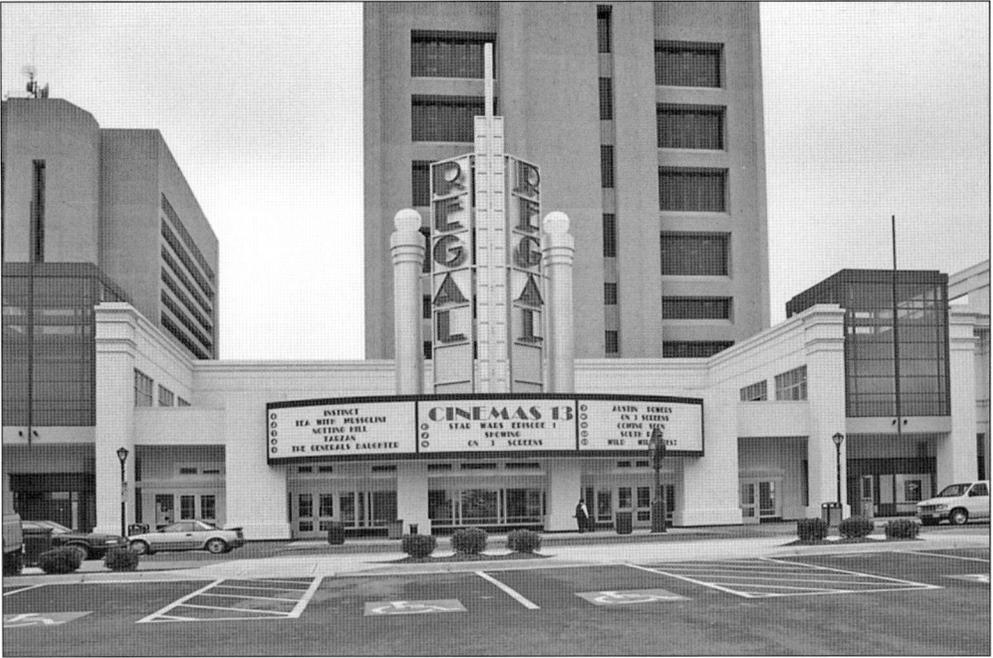

The Regal Rockville (199 East Montgomery Avenue, Rockville, Maryland) opened in 1998. In addition to mainstream Hollywood fare, the theater regularly programs contemporary Asian films, such as Stephen Chow's popular 3-D fantasy *The Mermaid*.

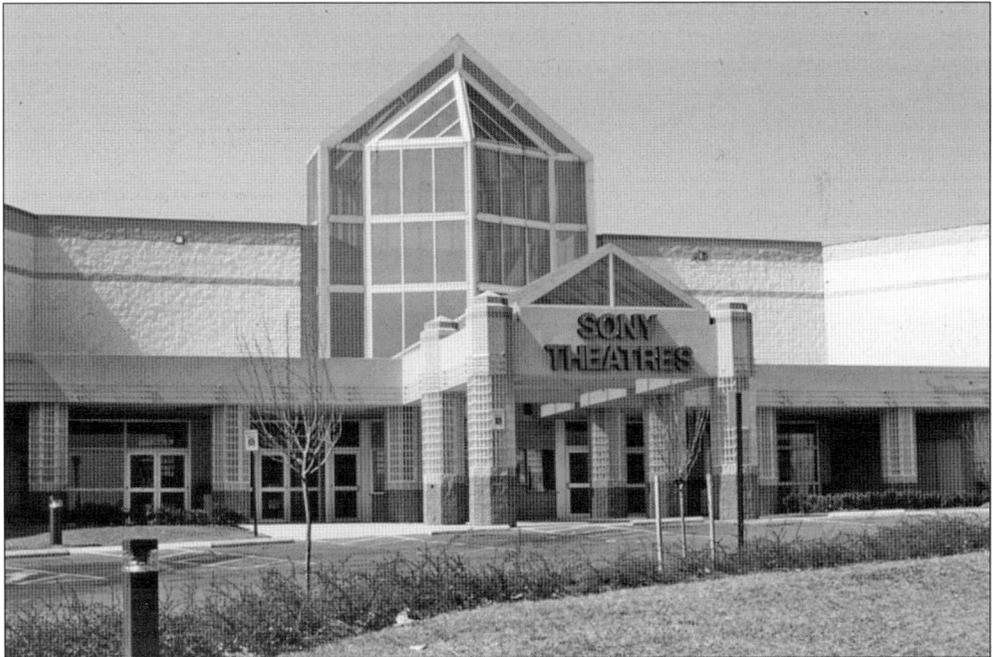

Kelly, Clayton & Mojzisek designed the eight-screen Centerpark Theater (4001 Powder Mill Road, Beltsville, Maryland), which opened in 1993. Unfortunately, the building sits back from the road, completely hidden by a stand of forest. The exterior is attractive, and the interior is well designed.

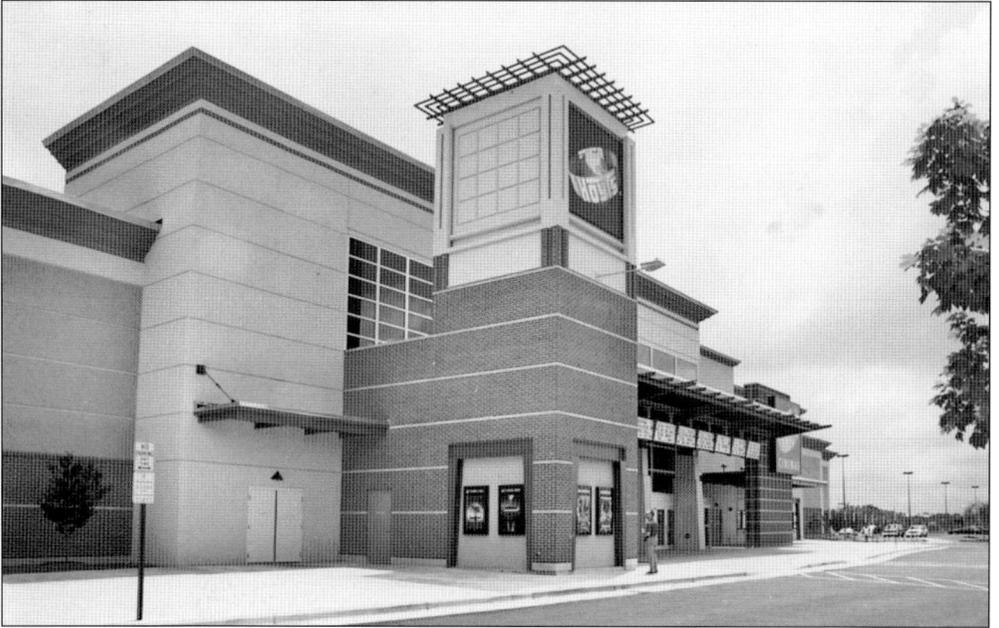

Architectural variations on the late-1990s multiplex seem minimal in these two examples, both of which opened in 1998. Hoyt's opened the 16-screen Potomac Yards (3575 Jefferson Davis Highway, Alexandria, Virginia) in the Potomac Yards Shopping Center near the Pentagon. Regal acquired the theater and other Hoyt's properties in 2004. One of the better-run multiplexes in the area, the theater has become a superior venue in which to experience the revival of 70-millimeter projection for such high-profile movies as *Dunkirk*.

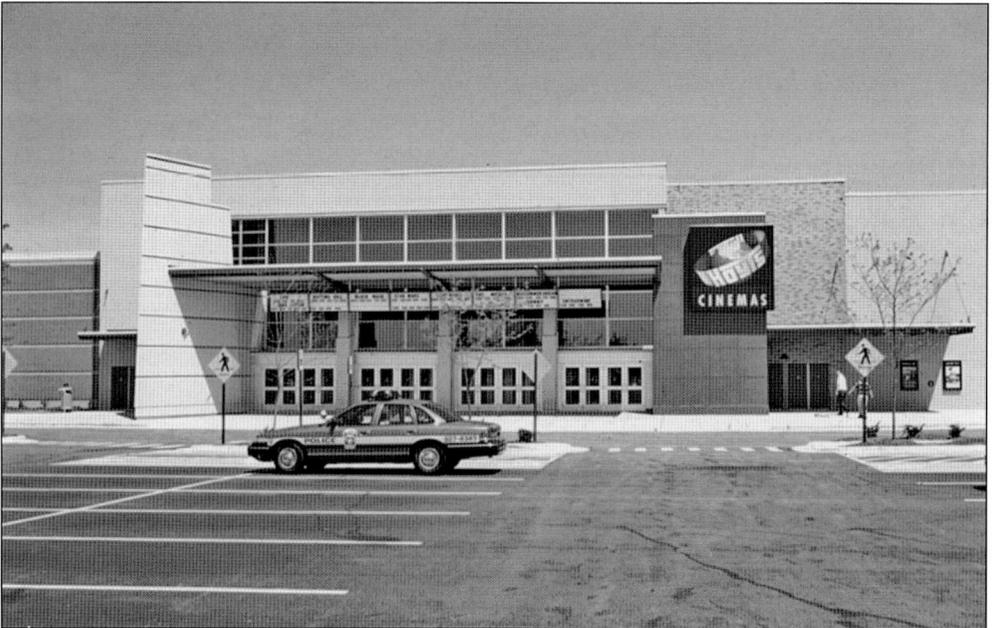

The 14-screen Bowie (15200 Major Lansdale Boulevard, Bowie, Maryland) has little to distinguish it architecturally, but it is one of the better-equipped theaters in Prince George's County. It was opened in late 1998 and is operated by Regal in 2018.

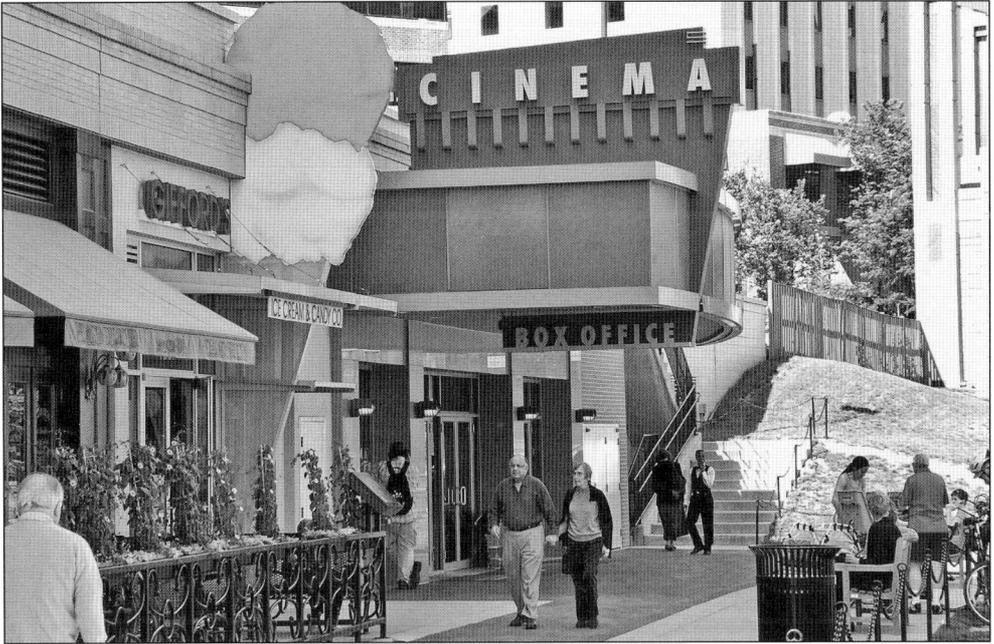

In 2002, Landmark opened the Bethesda Row (7235 Woodmont Avenue, Bethesda, Maryland), the art house chain's first venture in the Washington market. With a total of 1,600 seats in its eight comfortable auditoriums, the Bethesda Row was a pleasant upgrade for area moviegoers who had become accustomed to seeing independent and foreign movies in cramped theaters with small screens. The theater was one of the first instances of what would become a boom in the construction of new movie theaters.

In January 2004, Landmark's E Street Cinema (555 E Street NW) brought first-run movies back downtown for the first time in decades. Specializing in art house fare with typically more edge than the programs in Landmark's Bethesda Row, the eight-screen theater opened with the real-life crime drama Monster and a revival of The Battle of Algiers.

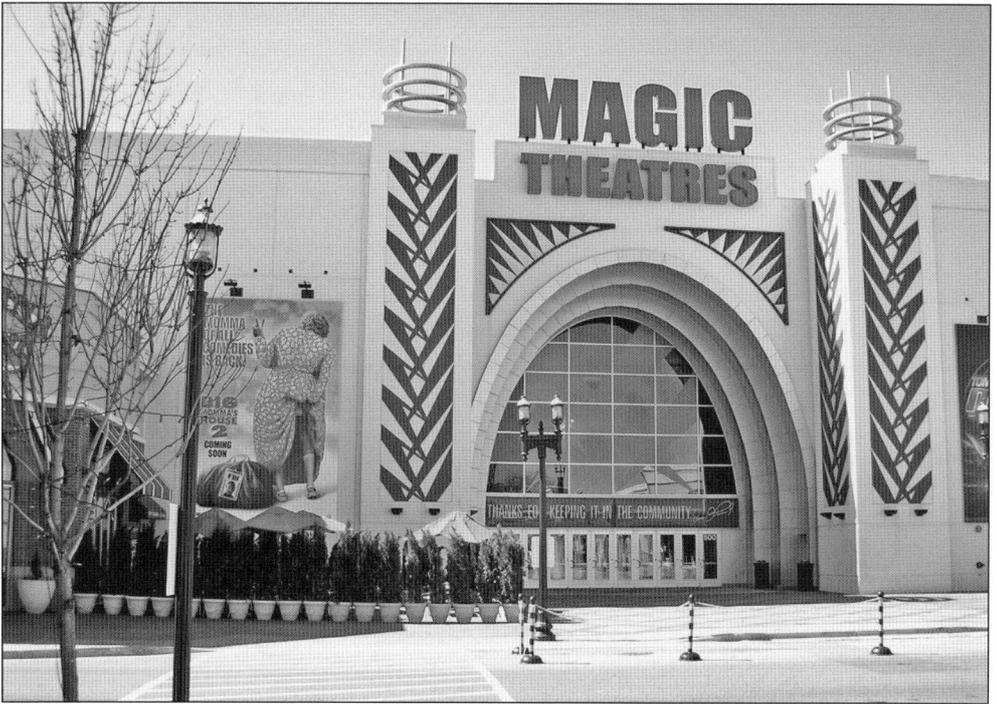

Retired Los Angeles Laker Magic Johnson opened this impressive multiplex (800 Shoppers Way, Largo, Maryland) in 2005 on the site of the popular sport and live-music venue the Capital Centre with the hopes of revitalizing an area that had been plagued by crime.

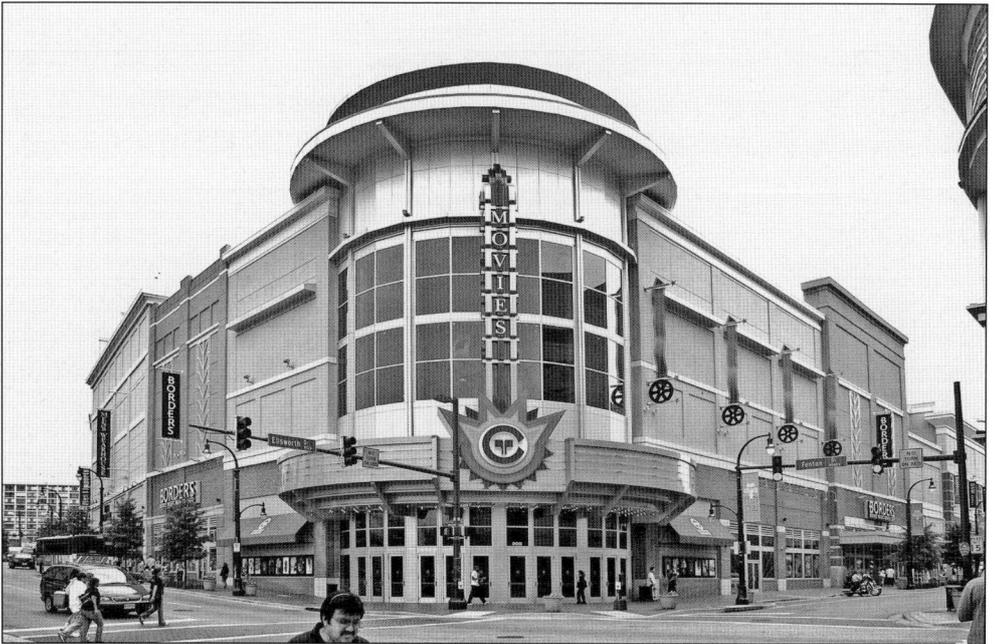

After the 2003 reopening of the Silver as a repertory and art house theater, Regal followed in 2004 with the 20-screen Majestic (900 Ellsworth Drive, Silver Spring, Maryland), which anchored major commercial redevelopment in long-neglected downtown Silver Spring.

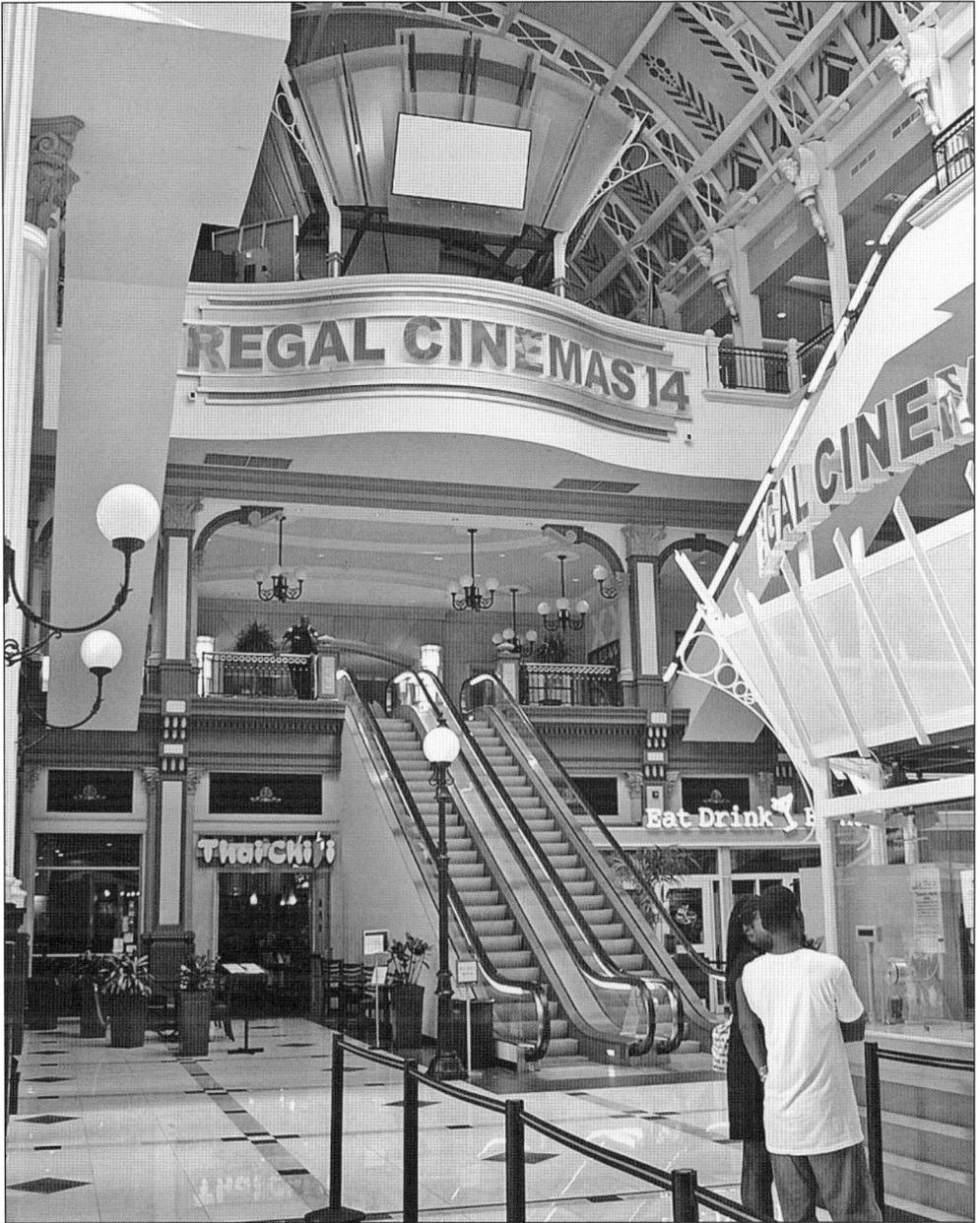

Along with what was then called the MCI Arena, the 14-screen Regal Gallery Place (701 Seventh Street NW) anchored a massive development that the *Washington Post* called "the largest investment in downtown retail in two decades." After years of urban decline, major commercial chains returned to a neighborhood that was once the metropolitan region's central shopping hub. Aging commercial structures and once-grand architecture were transformed into a city center that is once again buzzing with activity, albeit under the shadows of huge electronic billboards and modern building design that bears little resemblance to the downtown of old. Still, with plenty of restaurants within walking distance, including those of the city's small Chinatown, Gallery Place 14, which opened in 2004, became one of the most convenient places to see the latest Hollywood product.

INDEX

The Theatre Historical Society of America

For those interested in the history of movie theaters, the Theatre Historical Society of America is the place to go. The society was formed in 1969 by a group of theater enthusiasts in response to the wholesale destruction of the great movie palaces of the United States. The Theatre Historical Society is based in Pittsburgh, Pennsylvania, and maintains a huge archive. The archive has information, photographs, documents, and artifacts on over 16,000 theaters in the United States and throughout the world. It also organizes a yearly conclave that meets in different parts of the country to visit the remaining theaters in that area.

The society can be contacted at: historictheatres.org/.

Mailing address:
461 Cochran Road, Box 144
Pittsburgh, PA 15228

Archives address:
1221 Penn Avenue
Pittsburgh, PA 15222

1-877-242-9637 | office@historictheatres.org

For further reading, these works offer additional information on Washington's theaters:

Ambrose, Kevin. *The Knickerbocker Snowstorm*. Charleston, SC: Arcadia Publishing, 2013.

Gomery, Douglas. "A Movie-Going Capital." *Washington History* vol. 9, 1 (1997), pp. 4–23.

Headley, Robert K. *Maryland's Motion Picture Theaters*. Charleston, SC: Arcadia Publishing, 2008.

———. *Motion Picture Exhibition in Washington, D.C. An Illustrated History of Parlors, Palaces and Multiplexes in the Metropolitan Area, 1894–1997*. Jefferson, NC: McFarland & Company, Inc., 1999.

Jones, William Henry. *Recreation and Amusement Among Negroes in Washington, D.C.* Washington: Howard University Press, 1927.

Morrison, Andrew Craig. *Theatres of Washington. An Illustrated Historical List*. Washington: The Theatre Historical Society, 1965.

DISCOVER THOUSANDS OF LOCAL HISTORY BOOKS FEATURING MILLIONS OF VINTAGE IMAGES

Arcadia Publishing, the leading local history publisher in the United States, is committed to making history accessible and meaningful through publishing books that celebrate and preserve the heritage of America's people and places.

Find more books like this at
www.arcadiapublishing.com

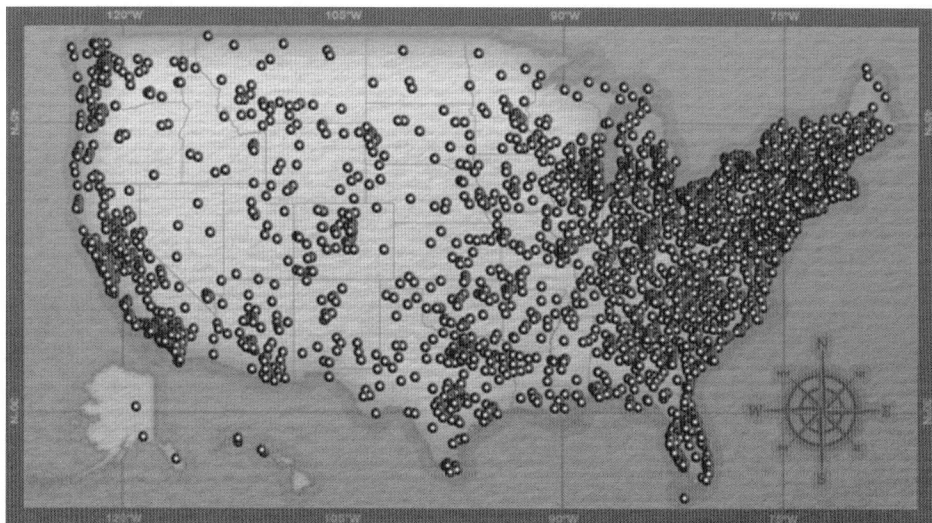

Search for your hometown history, your old stomping grounds, and even your favorite sports team.